THE MUSEUM INTERIOR

THE MUSEUM INTERIOR

TEMPORARY +
PERMANENT DISPLAY
TECHNIQUES

MICHAEL BRAWNE

with 330 illustrations, drawings and plans

THAMES AND HUDSON

First published in Great Britain in 1982
by Thames and Hudson Ltd, London

Copyright © by Verlag Gerd Hatje, Stuttgart

Printed and bound in West Germany

Contents

Introduction

It is now seventeen years since the publication of *The New Museum* in which I tried to discuss some of the architectural and display problems which are inherent in museum design. In the intervening years a number of developments have occurred which I believe make further discussion useful and which have also raised a number of new questions which were not dealt with in the previous publication. These are questions, what is more, of sufficient interest to make a new exploration worthwhile.

In the first instance the great impetus which museum design received from the contribution of Italian architects such as Franco Albini, BBPR, Carlo Scarpa and others was recognised outside Italy and its ideas accepted and modified in a number of countries. As a result, the level of museum display has greatly improved during recent years in very many places. It is important to recognise, however, that this acceptance was often of a critical kind and that the early notions were thus changed and extended.

Equally crucial has been the development of display methods which has taken place outside art museums. When material was being assembled for *The New Museum* on its appearance in 1965, there were very few examples from science museums or other museums not dealing with the arts which could be found and which were at the same time sufficiently interesting to be used to illustrate either the building or certain aspects of its exhibition. All this has changed considerably since that time.

Perhaps most important of all has been the elaboration of exhibition techniques from the idea of displaying an object to forms of display where the display itself becomes the primary object. It is an incursion into museum display which has come largely from the methods used at the great international expositions or similar national events. These have considerable relevance in many instances; equally however they can be easily misapplied and have indeed been misapplied quite often as several exhibitions have shown. Meaning has to be clarified by technique, not obscured by it. Or in other words, the methods used need to depend on the message which is to be communicated. This is one of the principal themes of this exploration.

The particular aim of this volume is therefore to look at the more detailed aspects of museum design. As on the previous occasion this has only been made possible by the ready and generous help given by museum curators and architects who have provided so much of the material and who have always been enthusiastic about guiding me around their buildings. I have also been enormously helped by having had the opportunity of putting some of the ideas I may have held into practice and of thus testing their appropriateness. Architectural concepts must depend in the last resort on being realised and sensed visually in use. I am therefore grateful to the Arts Council of Great Britain, the British Council, the Tate Gallery, the Victoria and Albert Museum and others for making it possible for me to translate ideas into built reality and to learn to adapt these ideas after seeing them in use.

A book is also always a co-operative effort. I have been very much aided by Gerd Hatje and his publishing house which has searched with patience and perseverance for photographic material and by Robert S. Simpson of Electrosonics who provided a great deal of information on audio-visual displays. I am also grateful to my architectural colleagues in the office who have helped over the years and from whom, of course, I have also always learned a great deal.

The Icon and the Route

The Object and Space

The word 'museum' will often evoke a particular character of building, rarely however, a particular space organisation. This is probably the case because museums and galleries of all kinds exist in a considerable array of buildings. Some of these were specially designed for the collections which they house at present but most were, as likely as not, built for some quite other purpose. Museums can now be found in former royal palaces, in old stables and disused kitchens, in country houses and town palaces, aboard ship, in preserved villages and of course in museum complexes of the past intended for quite different ideas of display. Nor does the success of the museum, especially as understood by the visitor, appear to depend on the relation between a particular building type and the work to be displayed. What any such catalogue would therefore seem to indicate, is that the museum as a building type is distinguished, not by well defined and characteristic spatial arrangements which we may associate with particular uses, but by attributes which are able to exist within a number of different architectural enclosures. While this may indeed be true of a great many activities for which buildings are in fact designed such an absence of architectural determinism seems to be especially obvious in the case of museums.

It is also important to emphasise that the two primary activities of any museum – preservation and display – are in a sense contradictory and thus provide no immediate clues to building form. A great many objects which are put on display suffer from exposure to light and air or are attacked by atmospheric pollution, and the dust carried in by visitors. Their conservation would be much easier and certainly more assured if they were kept in dark rooms at a constant temperature and relative humidity. It seems very improbable, for instance, that the treasures from the tomb of Tutankhamun would have survived over 3000 years if they had been on view throughout that period. Yet to have denied just over 1600000 people, who saw a small part of the treasures during the display at the British Museum in London over a period of nine months in 1972, the opportunity of seeing these objects because of some possible damage would on the other hand have totally ignored the need for objects to be seen, to be understood; for the past to make its impact on the present. All museum design must as a result help in some way to reconcile this conflict. An awareness of the problem has become much more general in the last twenty years and some ways have moreover been found which at least partly deal with it and ought clearly not to be ignored.

It is the intention of this book to analyse and illustrate the characteristic attributes of museums. Most of these have to do with detailed and largely internal aspects. They are at the scale where they appear in the foreground, or at most in the middle distance, of the field of vision of a standing observer. A great proportion is relevant to a wide variety of museums and only a few are highly specialised in terms of particular objects. They have been evolved through the understanding of the material to be shown and its need for preservation, and of the settings which contribute to its communication. They are also, of course, always influenced by our general visual likes and dislikes, by our current views of what constitutes an appropriate style. Any book showing the work of the last decade or so of museum display is, therefore, to some extent also the record of our visual preferences during that period. It could not be otherwise.

The Route

To emphasise the characteristic small scale details of museums is in no way intended to deny the fact that certain general relationships between spaces may be preferable and that such preferred organisations on plan and section may increase the range of possible museum uses; that, in other words, some building forms, but never only one, make a museum installation easier than others. Principally these preferences concern the movement of the visitor.

Except for isolated instances, the typical museum experience is one of viewing images in sequence, that sequence being sensed by a walking observer meeting static objects. It is in some way close to the way in which we experience a building or town and quite the opposite to viewing television for instance. This fact is likely to influence strongly the impact objects make on us whenever they are seen in a museum and is likely to be equally true whether those objects are paintings or specimens of natural history. E.H. Gombrich (1972) has in a characteristic example pointed out that 'we do well to remember that relationships matter in art not only within any given painting but also between paintings as they are hung or as they are seen. If we look, in the Frick Collection, from Hobbema's *Village with Watermill among Trees* to Constable's *White Horse*, the latter painting will look as full of light and atmosphere as Constable meant us to see it. Should we choose another route in the gallery and come to it with our eye adjusted to the palette of the School of Barbizon, of Corot, for instance, Constable's painting will seem to be eclipsed. It recedes behind the ridge which separates, for us, the contemporary vision from that of the past.' The same is also true where no such marked change occurs or even where notions of similarity rather than of difference are to be emphasised. The way in which any sequence is controlled or is free is thus likely to alter our awareness of objects and especially their initial impact.

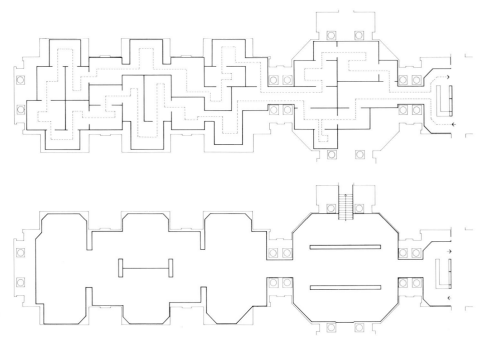

1. *René Magritte* exhibition, Tate Gallery, London. Michael Brawne & Associates, 1969.

2. *Art of the Real* exhibition, Tate Gallery, London. Michael Brawne & Associates, 1969.

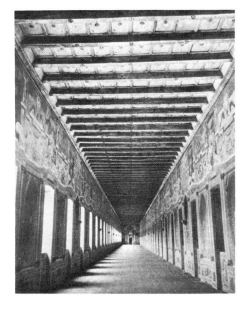

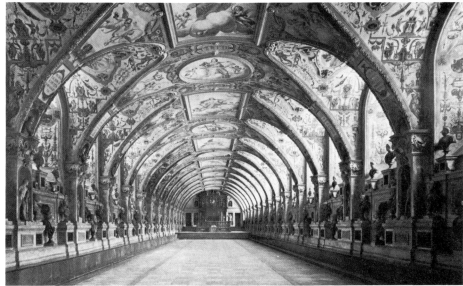

3. Long gallery, Sabbioneta. Vincenzo Scamozzi, 1583–90.

4. Antiquarium, Residenz, Munich. Wilhelm Egckl, 1569–71.

An exhibition of the work of the Belgian surrealist painter René Magritte at the Tate Gallery in London, for example, consisted of a series of small, almost claustrophobic rooms in which only a few paintings relating to each other were shown. The movement through the sequence of rooms was tightly controlled. An exhibition of American minimalist painters in the same space some months later, suggested a route but did not determine a viewing order. Each method seemed appropriate to the way viewing relationships were to be established.

Very often sequence is controlled because it can also suggest the dimension of time as in a natural history display of evolutionary development or in a museum showing the history of a town or in a gallery devoted to a school of painting. But whether the path is tightly controlled or relatively undetermined, our experience of an exhibition is nevertheless always some kind of a mosaic built up in our minds as the result of serial viewing; it is after all impossible to comprehend a whole museum or even the exhibits within one space at a glance. This is fundamental to the design of museum and gallery spaces. Significantly some of the earliest spaces which were designed specifically for display, such as the gallery at Sabbioneta or the Antiquarium at the Residenz in Munich, were long narrow tunnel-like rooms in which objects can be seen in sequence. Nor is it fortuitous that in English the word 'gallery' is used both for a particular kind of space in terms of its shape and for a room or building housing pictures or sculpture.

Because of the importance of the route in museum layout it was perhaps also fortunate that when buildings first began to be used for museum purposes, around the end of the 15th century, many of these were royal, ducal or ecclesiastical palaces of the preceding period which were planned on the basis of a series of enfiladed rooms, that is rooms opening one into another without intervening corridors. The corridor did not in fact come into common use until somewhat later. Such connected rooms can also be found in many other buildings of that period.

Although the idea of exhibiting works of art may stem partly from certain religious notions related to the veneration of objects, the opening of collections to the

11

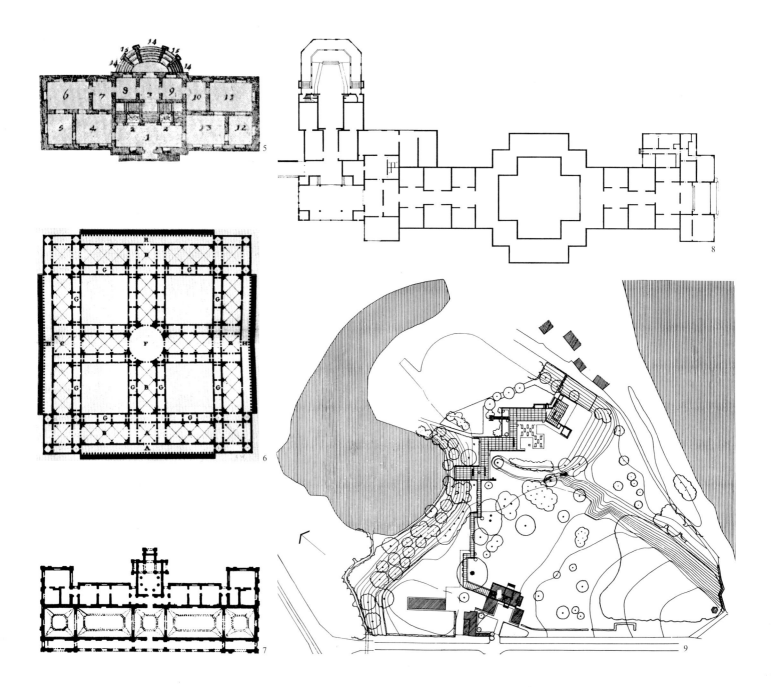

5. Design for an ideal museum. Leonhard
Christoph Sturm, 1704. Ground floor plan.

6. Design for a museum. Jean-Nicolas-Louis
Durand, 1802–09. Plan.

7. Dulwich Gallery, London. Sir John Soane,
1811–14. Plan.

8. Rijksmuseum Kröller-Müller, Otterlo. Henry
van de Velde, 1937–54. Ground floor plan.

9. Louisiana Museum, Humlebaek. Jørgen Bo
and Wilhelm Wohlert, 1958/59. Site plan.

10. Solomon R. Guggenheim Museum, New York. Frank Lloyd Wright, 1943–58. Cross-section.

11. Uffizi, Florence. Giorgio Vasari, 1570; present arrangement: Ignazio Gardella, Giovanni Michelucci, Carlo Scarpa and Guido Morozzi, 1956. Top floor plan.

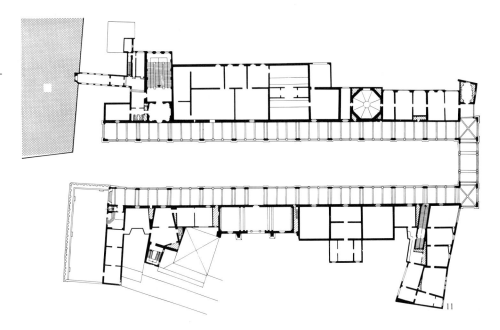

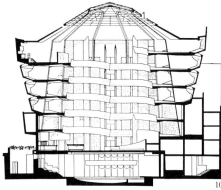

public, whether of works of art or natural curiosities from the end of the 15th century onwards was a secular activity and took place in secular buildings. And as Paul Frankl (1914) has pointed out in his essay on the *Principles of Architectural History*, the significant difference in the Renaissance between building categories was that ecclesiastical buildings were unitary spaces however composed, secular buildings were agglomerated spaces 'perceived one after the other'. It was, of course, exactly this perceiving of events one after the other which was so congruent with the essential activity of the museum. It is not surprising therefore that the plan configuration of the renaissance palace became almost the prototypical museum plan. It is already evident in Leonhard Christoph Sturm's early project for 5 an ideal museum in 1704 and Jean-Nicolas-Louis Durand's influential idealised 6 plan for a museum which appeared in his *Précis* of 1802–09 or Sir John Soane's executed design for the Dulwich Art Gallery in London of 1811–14 which, like 7 so many others of that period, takes up the theme of small and large rooms arranged in long sequences. Nor has that theme been given up since then even if it has acquired many variants.

Henry van de Velde's plan for the Rijksmuseum Kröller-Müller near Otterlo 8 in the Netherlands, which was started in 1937, organises just such a carefully controlled progression. Some of the best known post-war museums have followed the same notion. In its simplest form the sequence becomes a long strand of rooms as at Louisiana at Humlebaek outside Copenhagen where the galleries 9 become a chain of corridor-like spaces set within the gardens.

What matters in all these plans is not so much their geometric configuration as the relationship between spaces in terms of continuity and linearity; in this sense a straight line and a spiral – Louisiana and the Guggenheim – are identical. 10 It is this relationship in terms of topology which directly affects the circulation routes and thus the functioning of the museum.

Nor does this configuration have to be quite as simple as in these two examples. A plan such as that of the top floor of the Uffizi in Florence has all the essential 11

13

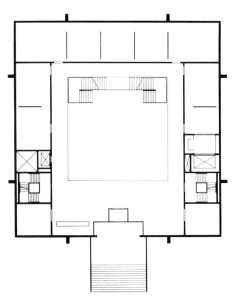

characteristics of linearity and continuity but also, for instance, allows for a variation in the route which is followed. The U-shaped glazed gallery, which at one stage becomes a bridge, defines the main route and is also visually differentiated from the other exhibition spaces by allowing continuous reference through its windows to Giorgio Vasari's elongated courtyard and the River Arno which flows at right angles to it. But what is most important is that from this main circulation space it is possible to branch off and see the rooms which lie to one side of it. What such a system allows is for either a more or less continuous viewing by going through the exhibition galleries or for selective viewing of one or two galleries by going only to these from the glazed corridor. If of course the space between the two corridors had been connected, if in fact it were a central hall for instance, the circulation system would again be identical. This is the sort of plan form which Philip Johnson has used in a number of his museum designs and perhaps most clearly at the Munson-Williams-Proctor Institute in 1960.

12

12. Museum of Art, Munson-Williams-Proctor Institute, Utica, N.Y. Philip Johnson, 1960. Main floor plan.

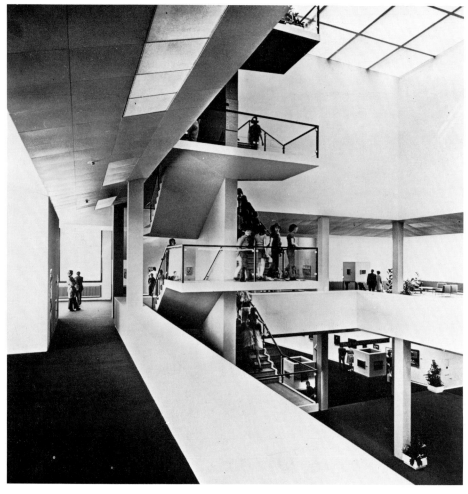

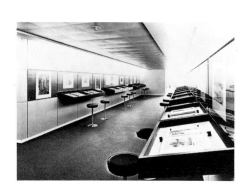

13, 14. Rijksmuseum Vincent van Gogh, Amsterdam. Gerrit Thomas Rietveld, J. van Ditten and J. van Tricht, 1963–73. Small gallery and central space.

14

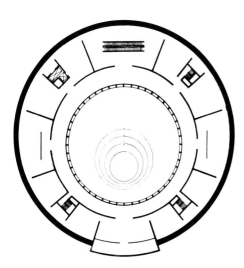

15. Hirshhorn Museum, Washington, D.C. Skidmore, Owings & Merrill, 1974. Typical floor plan.

Just as a straight line can become a spiral and keep its essential properties in terms of the movement system, so the corridor of the Uffizi can become the staircase of the van Gogh Museum in Amsterdam without doing violence to the idea of moving at will from a dominant circulation zone linked to the galleries. Gerrit Thomas Rietveld's design emphasises the connecting function of the staircase rising through a four storey void from which the various floors of the museum can be reached. Whether such an open volume is appropriate to the small and intimate paintings of van Gogh is another matter; that is a problem which can and should be solved without necessarily changing the essential characteristics of the circulation.

13, 14

Particular topological arrangements will not, as can be seen, by themselves ensure appropriate settings for a given set of objects or directly affect the appearance of a museum – the sculpture ambulatory of the Hirshhorn Museum in Washington is, for example, entirely analogous to the glazed gallery of the Uffizi in its function

15

16. Netherlands Pavilion, Biennale Garden, Venice. Gerrit Thomas Rietveld, 1954. Plan.

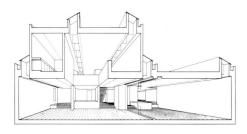

17, 18. Kettle's Yard, Cambridge. Sir Leslie Martin and David Owers, 1970. Section through gallery and isometric of house used for display and concerts.

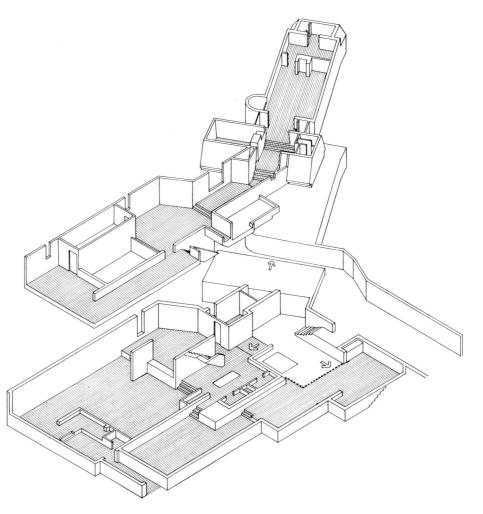

but utterly different in appearance. The way in which space is related to space will therefore only suggest the route to be followed through the museum and, as a result, also influence the way in which objects can be arranged for display. This is a relationship which is obviously crucial in any museum plan.

The usefulness of particular arrangements on plan and section will, however, be to some extent dependent on the size of the building. Rietveld's Netherlands Pavilion at the Venice Biennale or the Kettle's Yard Gallery in Cambridge are exhibition spaces which are small enough not to have to differentiate between a route through a building and a route within a display; they are both in effect single rooms in which the walls and the objects will immediately create a sequence. At the other end of the scale, the suspended external escalators of the Centre Pompidou in Paris are again very like the Uffizi corridor in the sense that they not only provide views of the city and its buildings but also allow a choice as to which floor is to be visited, though clearly they do nothing to solve the problems of how to exhibit on each floor or how to subdivide it. Only if each floor displayed, say, a couple of aircraft could that aspect be ignored. The escalator-like staircases which were inserted at the Alte Pinakothek in Munich in 1957 on the other hand, lead to a variety of enfiladed rooms which were part of Leo von Klenze's original neo-classical design and which relate to the nature of the paintings to be shown. In other words, most museums require a hierarchy of subdivision, whether permanent or temporary, and the relationship between spaces and the nature of the route will be dependent on the number of steps within that hierarchy.

19. Alte Pinakothek, Munich. Leo von Klenze, 1836; reconstruction: Hans Döllgast, 1957. First floor plan.

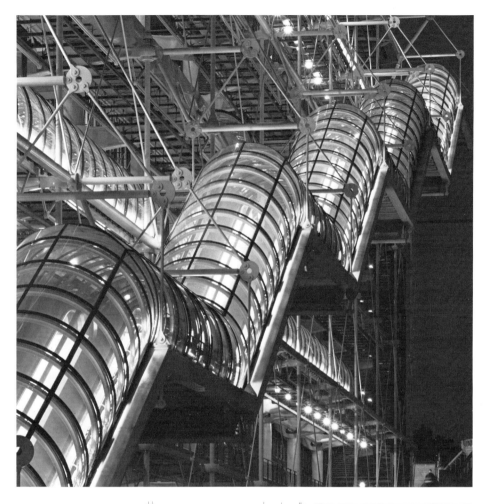

20, 21. Centre National d'Art et de Culture Georges Pompidou, Paris. Piano + Rogers, 1971–77. External escalators and section through west front showing, from left to right, the external escalators, the covered connecting galleries, the curtain wall and the deep trusses of the interior.

The Icon

It appears likely that the origins of museums are rooted in the secular ideas of wealth and collecting for its own sake, yet it is probably from the church that the ideas of display are derived.

When an object is selected for display, whether it is a sculpture or a steam engine, it immediately acquires through the action of being singled out certain attributes with which it is not normally invested. The act of selection implies a measure of specialness, of interest or value. Marcel Duchamp's gesture of signing a urinal 'R. Mutt, 1917', and submitting it for exhibition at the Independents in New York that year both ridiculed and reinforced that idea; it made out of *that* urinal something unique. By investing objects with attributes which separate them from their kind, we also imply that they are of more than personal interest, that they have a message which is of more than individual concern. We make out of them an icon.

The icon has traditionally been accorded its special setting. This is true whether we look at the statue of the Virgin Mary within its niche or the statues in a courtyard of a Buddhist shrine in Patan in Nepal. What is important when we look at these sculptures is not so much their visual resemblance to some outdoor art exhibition, as the fact that in both cases the objects are approached with a measure of attention – possibly of reverence – that stems from the attributes with which we have imbued them. Most cultures have recognised that objects acquire special meanings by their setting and through their placing within a particular context. This applies as much to the siting of Greek temples within the landscape as to the placement of objects within the Tokonoma recess in a Japanese house or the seating arrangements at table which are devised for a dinner party.

22

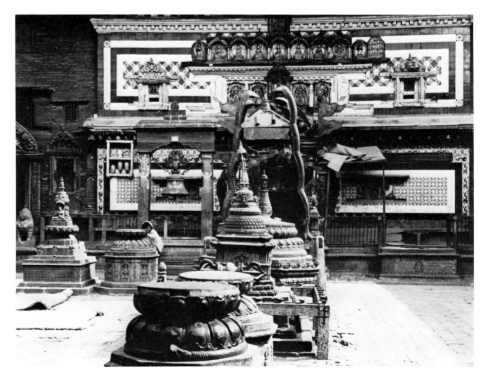

22. Shrine in Patan, Nepal.

18

The museum is only a particular example of this very widespread cultural trait; its extensive ramifications have interested both anthropologists and architects (Amos Rapaport 1969).

The special setting of the icon has most often, and particularly in the West, been an aedicular space, a scaled down architectural enclosure which created for that singled out object its own spatial world. In view of the enormously long tradition of creating some kind of a 'House of God', this is hardly surprising. That aedicule took on the stylistic attributes of each period and thus varies over time. Perhaps the most basic 'aedicule' devised for art objects has been the picture frame. It defines and separates the painting and acts as a kind of immediate enclosure. Its early forms were remarkably architectural in character and at times completely mirrored existing building forms. The frame to the Florentine altar piece showing *The Adoration of the Three Kings* painted in 1423 is 23 closely related to the cross-section of Florence Cathedral of about a hundred

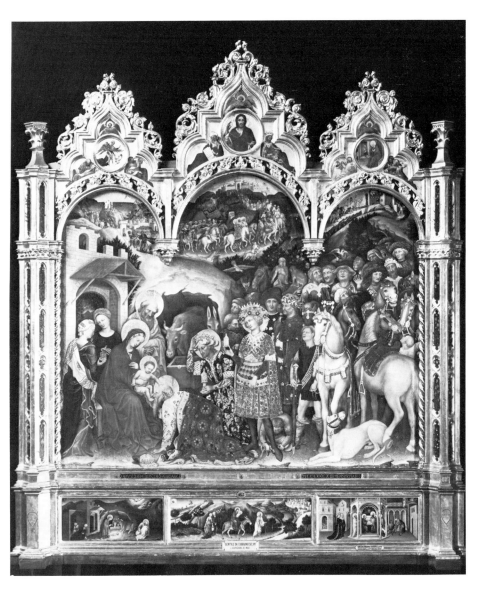

23. *The Adoration of the Three Kings.* Gentile da Fabriano, 1423. Original frame.

years earlier. The frame of Giovanni Bellini's *Madonna and Child* is equally architecturally explicit mirroring a different prevailing style. Later frames begin to take on more the motifs of the decoration of the room rather than the form of buildings and this is particularly true of the great gilt frames of the Baroque and Rococo or the dark wooden carved frames which enclose the work of Dutch and Flemish painters and which often appear on the walls in Vermeer's paintings of domestic interiors. Some 19th century frames such as that for *Josef Pembaur* by Gustav Klimt were painted by the artist and are merely intermediary between the object and the wall (Henry Heydenryk, 1964; Claus Grimm, 1977). Rather similar kinds of frames were done by the painters of the Pont Aven Group. Many artists of the present century have thought it important to abandon the picture frame and they were certainly partly motivated by a desire to lessen the iconic qualities of their work. They have looked for a direct relationship between canvas and wall so much so that in some of Morris Louis's large works the acrylic paint is made to flow around the corner of the canvas so as to virtually meet the wall.

In a possibly somewhat parallel way there have been a number of efforts during the last half century to popularise museums and many of these have taken the form of trying to desanctify the objects on display. If indeed these help to make

24. *Madonna and Child,* Santa Maria Gloriosa dei Frari, Venice. Giovanni Bellini. Frame signed by Jacopo da Faenza, 1488.

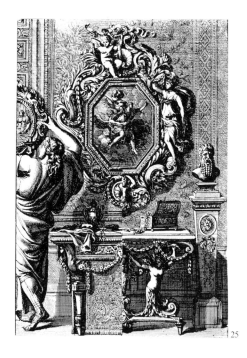

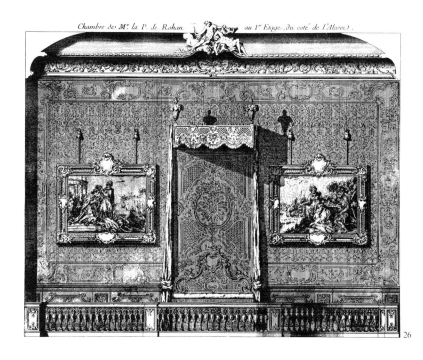

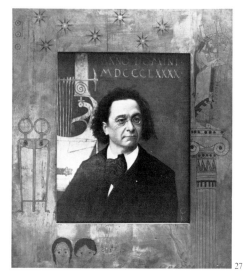

museums more accessible or in any way help to make their message more readily understood, they are undoubtedly to be welcomed. It is worth remembering, however, that any object removed from its original surroundings or no longer put to its intended use – a triptych taken from an altar and placed on a gallery wall, a windmill no longer grinding corn but open to view – will acquire different connotations. These changes can at times be subtle, at others quite radical as when, for instance, primarily religious and ceremonial tribal artifacts are displayed as abstract art. What seems to be important is to recognise the essential differences and to act in terms of design on that basis. There is of course nothing new about all this, it is something which the Gestalt School of Psychology has been at pains to make clear in general terms for a considerable period; the museum is only a particular case. To some extent, therefore, the museum object will always retain, however, vestigially, the qualities of an icon.

The crucial question in relation to the design decisions which always have to be made, is to what extent those attributes of an icon are relevant, are to be retained, are to be modified or are to be submerged in a new and perhaps altogether different communication. It is perhaps by establishing a hierarchy of this sort that exhibitions can to some extent be classified and arguments for particular design decisions developed. Such a classification may not be easy to establish and will certainly not be clear cut but may nevertheless be a useful way of looking at the problem of exhibiting a large range of objects in a variety of settings with different aims in mind.

Perhaps four examples can make the extent of such a spectrum and some of its repercussions clear.

25. Design for a picture or mirror frame. Abraham Drentwett (1647–1729).

26. Hotel de Soubise, Paris. Gabriel Germain Boffrand, 1735. Room of the Princess de Rohan.

27. *Josef Pembaur*. Gustav Klimt, 1890.

1. In terms of concept what perhaps distinguishes such categories most clearly from each other is the extent to which the message of each exhibition can be closely defined and therefore to what extent each aspect of the display technique should make such an aim explicit. An exhibition of the work of Piero della Francesca, for instance, may with advantage place the painter in his historical setting and explain the symbolic content of the work or describe the technical means available to a painter of the second half of the Quattrocento, but it must, in the last resort, leave an understanding and an awareness of the nature of these paintings to the visitor. The work of Piero della Francesca may thus for some groups need a certain measure of help through extraneous devices of some kind but its message cannot in any way be predetermined or defined in any sense which is not trivial; ambiguity is here a virtue. This is not to suggest that the degree of design involvement is as a result insignificant but only that its nature and intent needs to be adjusted to the characteristics of a design problem in which the measure by which an object is deliberately left evocative is crucial. In many ways it makes the design problem more difficult rather than less so.

What is true for a painter of the past like Piero may hold to an even greater extent when showing the work of a painter of this century, such as Fernand 28–33 Léger. In either case the paintings must in the last resort communicate in their own right.

28

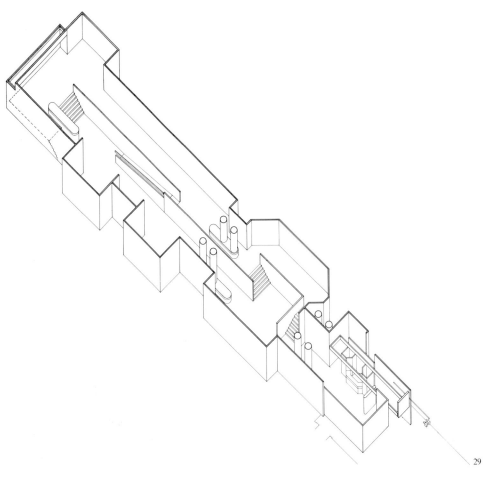

29

22

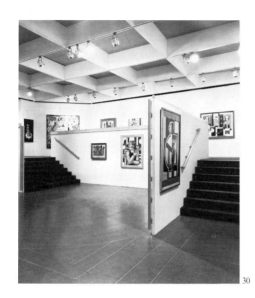

30

31

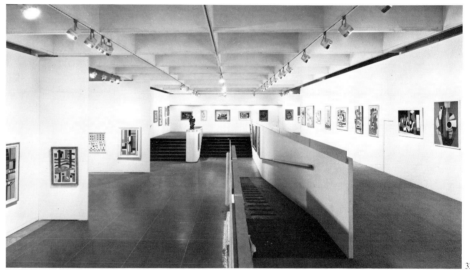

32

28–33. *Léger and Purist Paris* exhibition, Tate Gallery, London. Neave Brown, 1973. Floor plan, axonometric and views of installation; the gallery is the same as that in which the exhibitions shown in 1 and 2 were held.

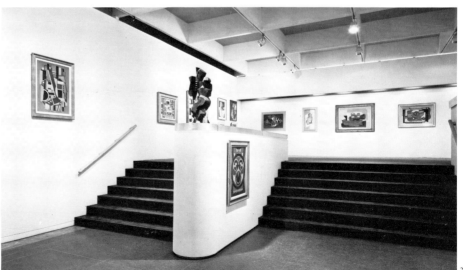

33

2. Each Piero painting remains an icon. Each of the six hundred and eighty items exhibited in *The Arts of Islam* exhibition at the Hayward Gallery in 1976 34–40 was also in effect an icon in the museum sense (though obviously in no way in the religious sense) yet some shift from the kind of presentation used for the work of an individual painter was considered appropriate. First of all most of the works were objects of use – carpets, tiles, bowls, books, trays, ewers, beams, doors – which ranked as great works of art and at the same time had both symbolic and utilitarian attributes. In addition to this they came from a tradition which was relatively unfamiliar to most visitors. Three steps were taken in the presentation in order to deal with some of these problems.

The first consisted of dividing the material into three sections which would be shown separately: an introductory group of architectural fragments and carpets which would indicate some of the components of an Islamic setting; a second group arranged in such a way as to clarify the nature of four important aspects of Islamic art – calligraphy, the use of the arabesque, of geometry and the treatment of the figure; the final group showed the entire range of objects in historical sequence in order to demonstrate the continuity of a tradition which lasted over a thousand years in an area stretching from the Atlantic to the Indian sub-continent.

The second step was to try and design the exhibition itself so that it perhaps evoked some echoes of Islamic space, not in any way as pastiche but as suggesting some of its attributes. Those which seemed important and usable concerned symmetry and repetition as well as colour.

The third step was to introduce an extraneous element in the form of a multi-screen audiovisual presentation early in the sequence of the exhibition which would describe the architecture of Islam. During twenty five minutes eight hundred or so slides were projected on to nine screens and accompanied by a spoken commentary.

Each of these measures was meant to aid an understanding of the works of art which had been collected in London as part of *The World of Islam* festival but each also to some extent defined and perhaps influenced the message.

34

35

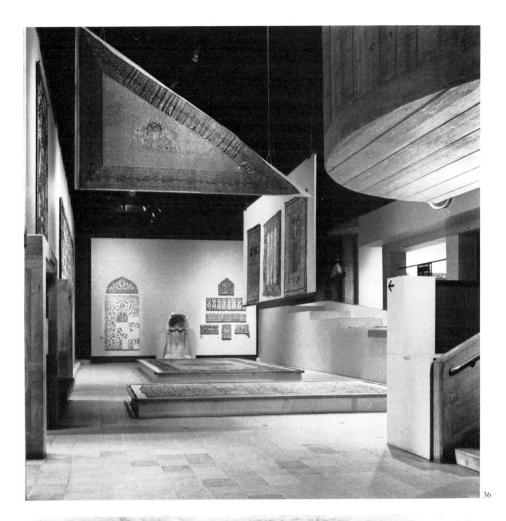

36

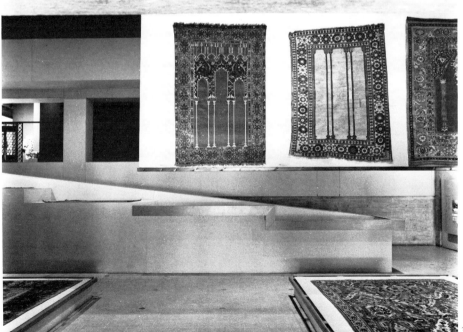

34–37. *The Arts of Islam* exhibition, Hayward Gallery, London. Michael Brawne & Associates, 1976.
34. Architectural fragments.
35. Epigraphic pottery.
36, 37. Introductory space with carpets and mihrab.

37

38.–40. *The Arts of Islam* exhibition, Hayward Gallery, London. Michael Brawne & Associates, 1976. Gallery showing the themes of calligraphy, the arabesque, geometry and the figure.

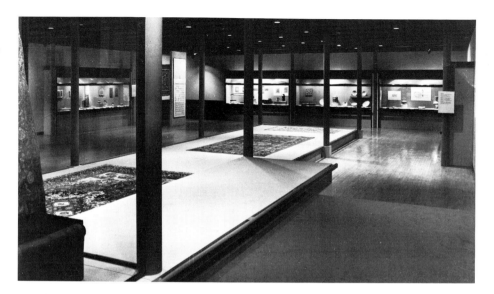

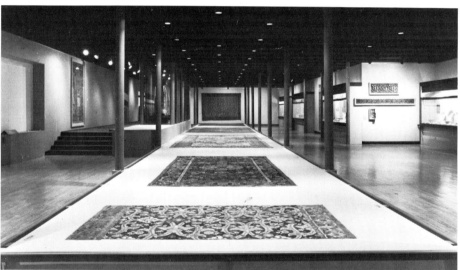

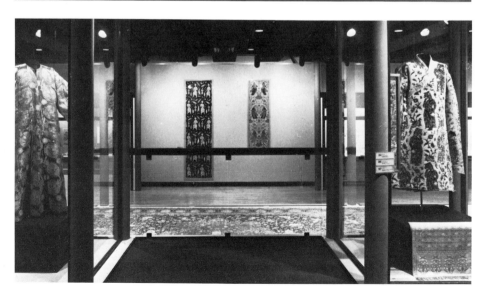

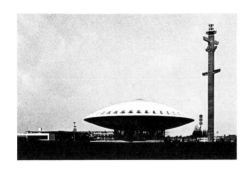

41. Evoluon, Eindhoven. Kalff and de Bever, 1966.

3. The Evoluon stands on the edge of Eindhoven in the Netherlands, the town 41–43 largely devoted to the many activities of the Philips industrial concern. It is a science museum in a rather special and new sense and was founded in 1966 as part of the 75th anniversary of the firm. The display consists of a series of thematically linked exhibitions within a very large circular space. The means used to put over a great number of ideas from the changing world of science and technology are numerous and often quite complex, but are, of course, all aimed at making these as intelligible as possible. The methods include experimental assemblies which the visitor is able to manipulate, three dimensional models, charts, slide projection, film loops, descriptive texts or brief talks given over headphones placed near the exhibits. The whole exhibition is a multi-media device which has a special story to tell and sets out to tell it by whatever means seem most appropriate in each instance. The basic contents of the message are known beforehand and the exhibition is devised in order to put these over in the most effective way possible; the aims can be stated and techniques used to make such aims explicit.

The icon, in the particular museum sense, occurs only rarely. The liberties which can be taken with the material are therefore considerable, since it is not any one part which is in any way special but the total assembly. What is unique, what acquires special attributes, is this particular idea of explaining current concepts in science and technology; the Evoluon as a whole becomes in some measure an icon. It is perhaps significant in this context that the architects of the building were clearly striving to create a very individual enclosure, a great circular form reminiscent of some space ship temporarily anchored on its stilts.

42, 43. Exhibition in the Evoluon, Eindhoven. James Gardner.

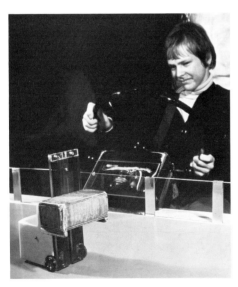

4. Charles Eames – architect, furniture designer, film maker and exhibition design-
er – has for long been interested in the presentation of ideas and at one stage
quite early in his career made a film called *A Communications Primer* (1953)
which explored the problems of communicating in a number of media. A great
many of his exhibitions have concerned themselves with putting over quite specific
themes. These have included aspects of mathematics as at the *Mathematica* exhibit 44, 45
at the California Museum of Science and Industry in Los Angeles in 1961, the
history of astronomy from Copernicus to Newton in a series of shows at the
IBM Exhibit Center in New York in 1972 and 1973 or the influence of individuals
at a particular period as in the American Bicentennial Exhibition *The World* 46, 47
of Franklin and Jefferson shown in Paris, Warsaw and London and subsequently
in the USA. Eames has also been involved with the design of exhibitions at
two World Fairs, the introduction to the US exhibit in Moscow in 1959 and
the IBM exhibit in New York in 1964.

All these, and many of the other exhibitions with which the office of Charles
and Ray Eames has been concerned, have been to some extent distinguished
by the absence of objects which needed to be shown. The theme came first
and then objects of various kinds were devised which when assembled in some

44, 45. *Mathematica* exhibition, California Museum of Science and Industry, Los Angeles. Charles and Ray Eames, 1961.

sequence would produce a message that communicated that theme. In the Bicentennial Exhibition, for example, many of the three dimensional objects varied from place to place and were dependent on what museums in each particular country could lend to relate to the lives of Franklin and Jefferson.

The exhibition on *Nehru, his Life and his India* shown in New York, London, 48–51 Washington and Los Angeles in 1965 and 1966 is typical of such a method. Nehru's life and his great contribution to the independence of India are shown by means of photographs, chronological wall charts, and a half realistic mock-up of a prison cell, the lances and uniforms of the Indian Army in the days of the Empire or the baldechino and symbolic gifts associated with a wedding ceremony. The exhibition makes a mosaic of images which like some enormous and extremely cleverly illustrated book becomes at that time and in that location a biography of Jawaharlal Nehru. But unlike the book, such an exhibition has a number of means available to put over a particular point. Nehru's imprisonment by the British, for example, is first of all recorded in words and with dates on a chart giving the main events of Nehru's life which incidentally also simultaneously gives other important events in India and international affairs. It is then

29

46, 47. *The World of Franklin and Jefferson* exhibition, Paris. Charles and Ray Eames, 1975. The exhibition was later seen in Warsaw, London and the USA and was each time slightly different.

shown visually and largely symbolically through detailed photographs of the chains and locks of prison cells. It is then further reinforced by showing the visitor a dark and confined space which, however momentarily, is meant to evoke something of the experience.

It is this totally new assembly of objects, so unlike a showing of the work of Piero della Francesca for instance, which becomes in this case the exhibition and which must of necessity be largely based on some predetermined idea of the themes to be communicated.

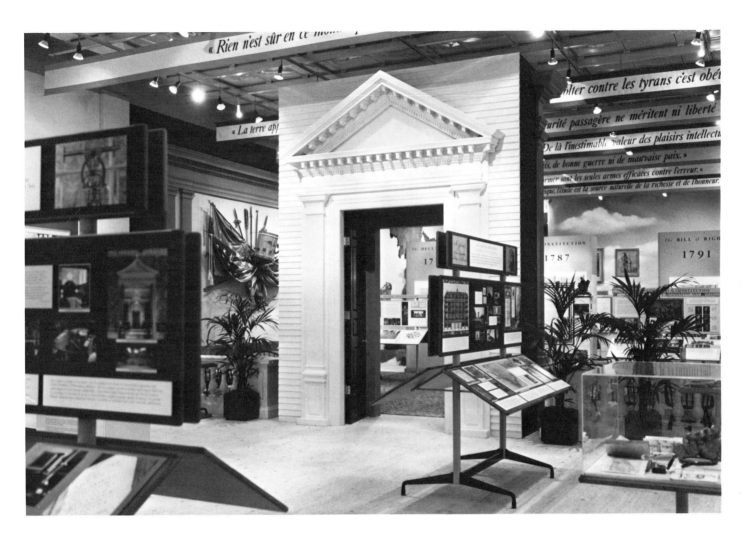

These four examples are merely meant to illustrate points along a continuous spectrum; they certainly in no way define four categories. Nor of course need the whole of an exhibition necessarily fall within a particular position along this spectrum; different parts might appropriately be dealt with in different ways. An exhibition held at the Hayward Gallery, for example, some years before that on *The Arts of Islam* dealt largely with the Constructivist art of post-revolutionary Russia under the title *Art in Revolution*. Different galleries tended to 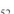52 emphasise different methods of presentation. These included a film made specially by Lutz Becker based on contemporary documentary material, the creation of spaces which had some of the formal attributes of Soviet architecture in the 1920's and the use of exhibition techniques meant to be reminiscent of those of El Lissitzky. Because of the nature of Constructivism as expounded by Tatlin and others and the absence of original material, it was also decided to duplicate some posters, to print textiles and to remake furniture. Models of buildings and of theatre sets were made and shown with photographs. On a terrace outside seen from across the Thames a 12 m (40′) metre high reconstruction of Tatlin's design for a Monument to the Third International was recreated after extremely detailed research on the original drawings and photographs of the models of the various revisions made by Tatlin. Groups of original material borrowed from

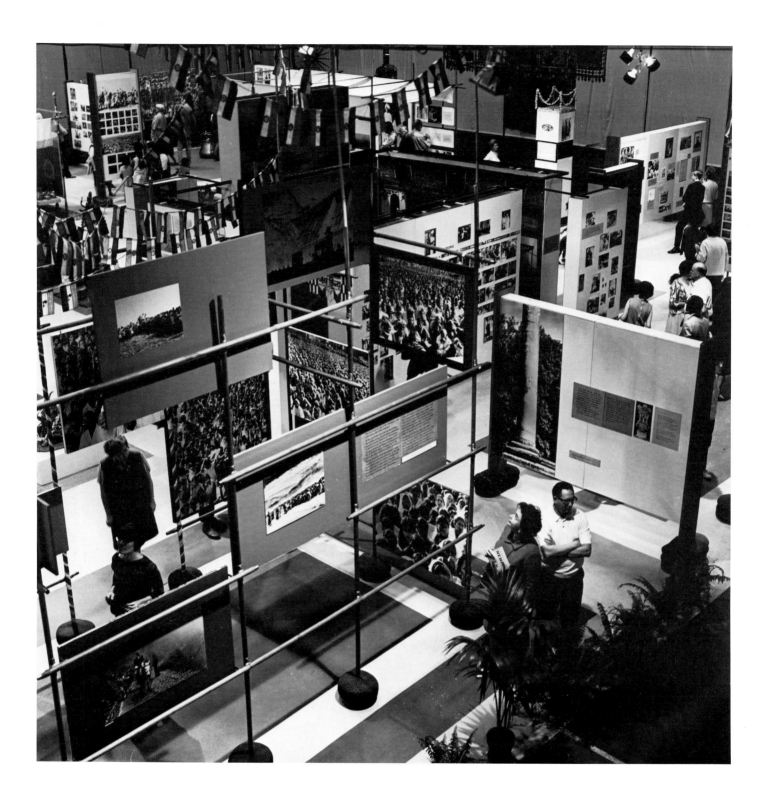

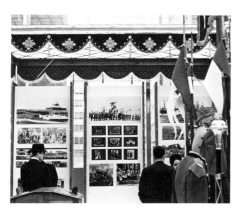

48–51. *Nehru, his Life and his India* exhibition,
New York, London, Washington, D.C., and Los
Angeles. Charles and Ray Eames, 1965.

a number of sources were displayed with these specially made objects in order to convey to a London audience some of the artistic achievements which occurred between 1917 and about 1930.

Constructivism set out to devalue the iconic qualities of works of art – Tatlin was as interested in designing boiler suits and stoves as in painting – so that the copying of objects seemed justified. It would be wrong to pretend however that the model of the Pravda building or the costume figures from Linbov Popova's designs for *The Magnanimous Cuckold* did not become, through being placed within an exhibition, icons in the museum sense. It seems very hard to escape the effects of singling out an object and putting it on view. Perhaps one should not try.

Museums of science and technology are probably even more often involved in this process of having to decide on appropriate methods for different parts of the collection. The Deutsches Museum in Munich displays many of its objects 53–57 in large open galleries and often allows visitors to press buttons to make machines move. It has however taken historical machinery and placed it in a room which, though still accessible to visitors, is made to resemble a 19th century factory so that the effect is not only of a single object but of a whole space. Elsewhere

52. *Art in Revolution* exhibition, Hayward Gallery, London. Michael Brawne & Associates, 1971. This exhibition took place in the same galleries as that shown in 34–40.

again it has recreated in greater detail whole room settings, such as a laboratory from the end of the 18th century, which are seen through an opening in the wall. The total ensemble becomes a museum icon. In the large machine halls both real machines and models, some sectioned to explain their workings, are used and both become icons as well as objects of considerable sculptural vigour. These ordinary exhibition techniques are then supplemented by lectures, demonstrations, and slide shows.

Much of the popular success of the museum probably stems not only from the intrinsic interest of its collection but also from the methods it has chosen to display various aspects. Exhibition design must thus always concern itself with judgements about appropriate techniques of presentation, related to both the nature of the material and its position within the concept of the display as a whole.

53. Deutsches Museum, Munich. An 18th century chemistry laboratory.

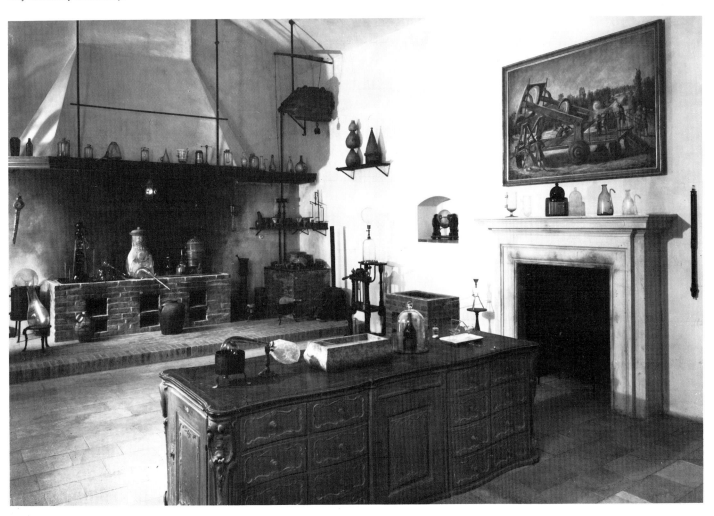

54–57. Deutsches Museum, Munich.
54. A lecture in a space adjacent to the galleries.
55, 56. Historical machines.
57. Reconstruction of an early factory.

54

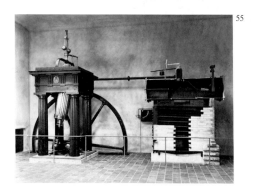
55

56

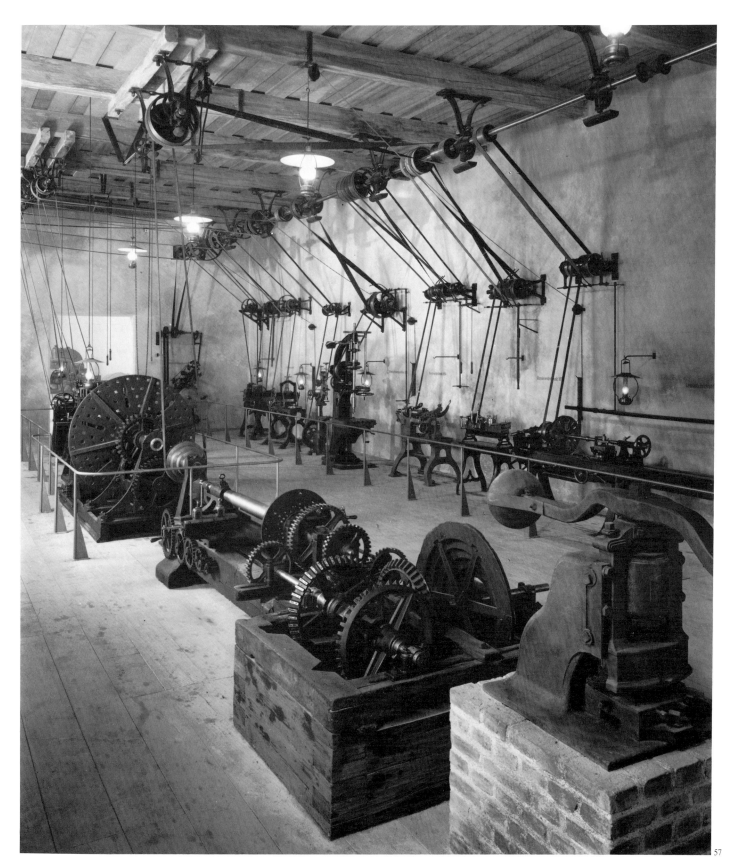

The Building Elements

The Object and its Background

In the theatre we distinguish very clearly between the building – auditorium, stage, changing rooms, foyers and so on – and sets and props. The building is thought of as highly permanent while the scenery is temporary and related to the production being staged. Perhaps it might be helpful to recognise a similar difference between the permanent envelope of the museum and the scenery which is used within it to make places appropriate to the exhibits. Such scenery may be the enclosure for a life size sculpture, a whole room setting or the installation of a complete temporary exhibition within a gallery. It should, however, equally be thought of on a much smaller scale as the mounting of a gold ring or the design of a showcase.

All analogies have of course their dangers. In this instance the differences between museum scenery and that of the stage are as important as the similarities. In the first place, the museum is rarely concerned with the creation of illusion but on the contrary tries to reveal the true nature of the object in the clearest and usually most untrammelled way. Secondly, service arrangements and especially lighting often have to form part of the scenery, as in many showcases, and cannot be left to a separate and independent element. Thirdly, the setting has very frequently to deal with the quite serious problems of security.

The elements which are most immediately involved are walls, screens, showcases, ceilings and floors. It is precisely these parts of an enclosure which make up the middle scale and which will closely affect what we see when we look at the material put on view and its surrounding surfaces. It is also these elements that need the greatest design consideration in terms of the specific and possibly special requirements of the museum.

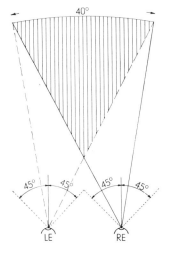

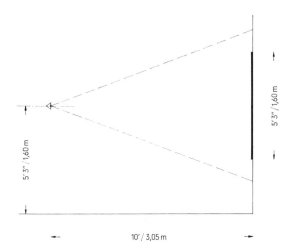

58. Normal limits of the horizontal angular sweep of the eyes without turning the head (from: H.C. Weston, *Sight, Light and Work*, London, 1962) and the size of the square which can be inscribed within the base of a 40° cone at a viewing distance of 3 m (10′).

Walls

An observer standing within a relatively small space is always likely to have a considerable part of his field of vision occupied by vertical rather than horizontal surfaces. This is a fact which results from the position of our eyes and the cone of vision. Only in large open spaces do the converging planes of floor 58 and ceiling become dominant. The wall or movable panel or its equivalent are therefore the surfaces against which inevitably a great proportion of the material on display will be seen even if it is not actually fixed to that vertical surface. The skeleton of a vertebra on a stand in a museum of natural history or a sculpture on a pedestal are still likely to be looked at against the background of a wall.

Carlo Scarpa's installation of a marble bust of Eleanor of Aragon by Francesco 59–61 Laurana at the Galleria Nazionale in Palermo may help to emphasise the point. The bust is placed on a metal pedestal at the end of a vista and is on this long view framed by the arch of a wall opening. It is thus initially seen between two wall surfaces. On the wall behind it a number of green panels have been fixed which silhouette the white delicate outline of the sculpture; the original wall above and below the panels is a raw plaster colour close in tone to that of the marble bust. The room is moreover tall and plain, while the sculpture is barely life size and appears almost fragile. The panelling behind Laurana's marble portrait thus also mediates in scale between the object and the space.

Scarpa was able to take very deliberate steps to set the scene for a particular sculpture because he was working on an installation in the Palazzo Abbatellis which was likely to remain in place for a long time to come. The panels should obviously be considered as sets which were introduced in front of the permanent walls of the room for that 'production'. Where, however, the walls of a gallery

59–61. Galleria Nazionale, Palazzo Abbatellis, Palermo. Carlo Scarpa, 1954. Sequence of three rooms terminating in Francesco Laurana's bust of Eleanor of Aragon.

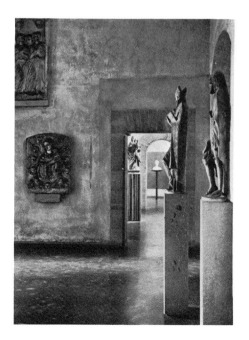
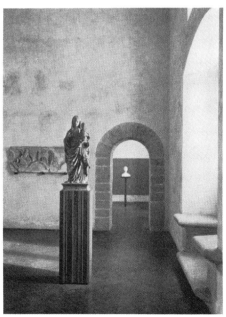

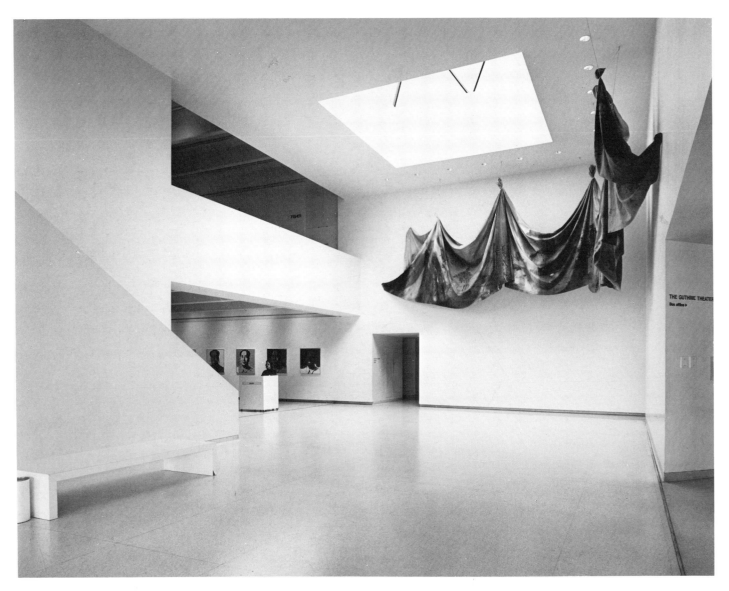

62, 63. Walker Art Center, Minneapolis, Minnesota. Edward Larrabee Barnes, 1971. Exhibition galleries.

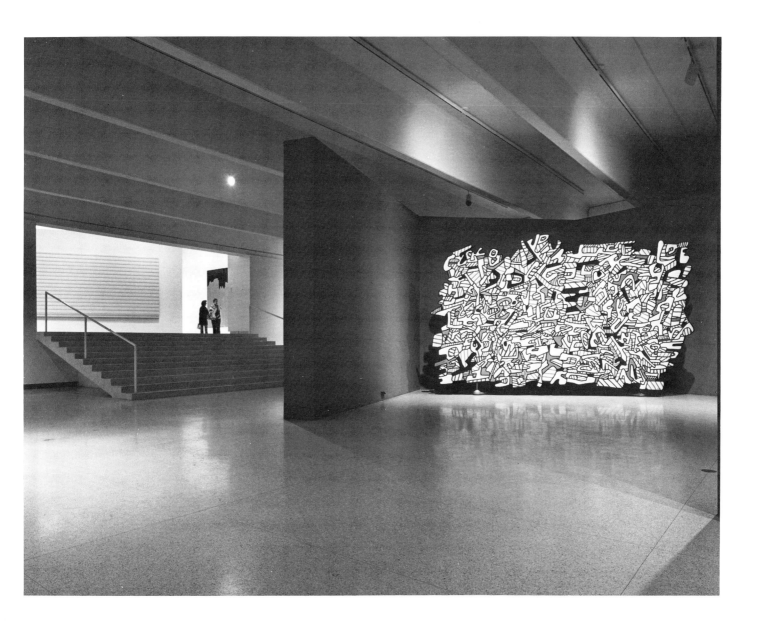

have to make appropriate backgrounds for various kinds of objects either at the same time or at different times without the possibility of altering the walls, somewhat different assumptions are likely to be valid. They would all stem from the idea of allowing those responsible for placing exhibits against the wall a considerable measure of freedom.

As a rule this means uninterrupted surfaces going from floor to ceiling with minimum visual interference from skirtings or other encumbrances at the base as well as the absence of dado rails or similar divisions in the middle. It also suggests the avoidance of vertical interruptions such as joints between panels or the placing of columns so that they show on the wall surface. In addition it seems desirable that each section of the wall is not so small – because it has been facetted or otherwise broken up – that only very small objects can be placed on it. Most new museum design has adopted such a policy. Departures 62, 63 from it are as a rule deliberate and related to very specific exhibits as well as 64 the intention to make markedly individual placings.

Interruptions can also occur from permanent encumbrances on the wall. It is important to avoid drawing attention to specific points or areas by placing light switches, security devices, clocking points and similar gear within the field of vision. These become a kind of minimalist sculpture which inevitably attracts attention and competes with the real exhibits. It is best if these are placed in a quite separate area, as can be done with light switches, or, if they must be on the wall, either high or very low away from the normal zone of display.

In any case it is essential that during the design stage each wall of every gallery is drawn in elevation to a large scale and that the position of every extraneous element is marked and agreed at the earliest stage. A great many misunderstandings between architects and museum directors have occurred through a failure to do so. The architects of the neo-classical period frequently drew the walls and 65

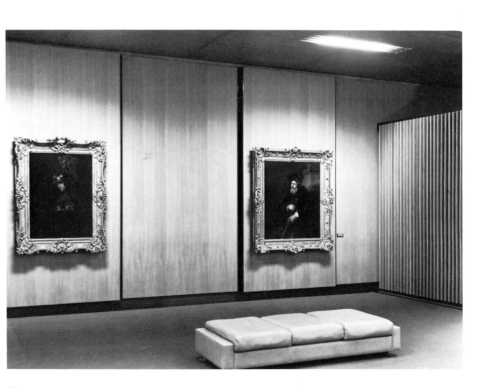

64. Museu Calouste Gulbenkian, Lisbon. José da França Ribeiro, Alberto Pessoa, Pedro Cid and Ruy Athouguia, 1961–69. Gallery showing paintings by Rembrandt.

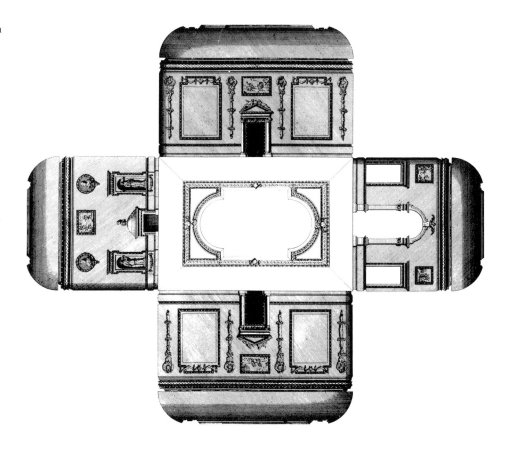

65. Design of a new garden room at Hall Barn
near Beaconsfield, Buckinghamshire. Colin
Campbell, 1724.

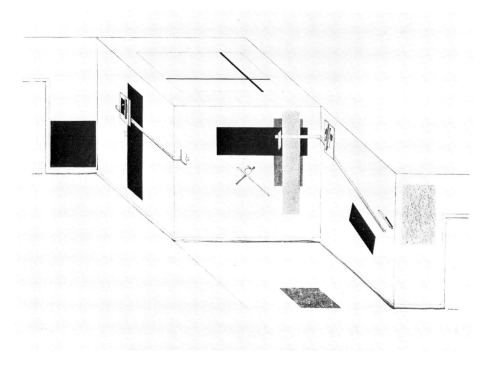

66. *Proun* room. El Lissitzky, 1923, Design for
the *Grosse Berliner Kunstausstellung*.

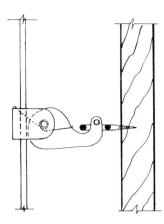

67. *Multiform* hanging rod and hook. An eyelet at the back of the picture frame goes over a hook which can slide up and down the rod; the weight wedges the pivotting section against the rod; the hole in the brass hook allows a split pin to be inserted preventing the picture being lifted off.

ceilings of a room like a folded out box, and it is a method which might well be copied today. When Lissitzky composed the elements of his *Proun* room he used a variation of the same idea in order to be able to show those important surfaces which do not appear on a plan. In terms of museum display, the conventional plan omits a great deal of crucial information.

The wall is not only a surface against which objects are seen but also one onto which so many are fixed. It must support and retain. It therefore requires to be constructed in a way which allows for various attachments and which also makes it possible to repair rather easily any damage that may occur from these fixings.

The simplest arrangement for hanging pictures consists of an overhead rail which may be either a metal rod of some kind or a protruding moulding on to which chains are hooked. The back of the picture is fastened to a pair of chains. Both the position of the chains along the wall and their length is adjustable so that there is complete flexibility both laterally and vertically.

A simpler and more recent variation consists of thin aluminium rods which carry hooks that slide up and down the rod. The hook goes into an eye on the back of the picture and the weight of the picture wedges the hook in position. Both methods allow for pictures of various sizes to be hung at different heights quickly

68. Imperial War Museum, London. Horizontal aluminium rails let into the wall.

44

69. *Picasso Sculpture* exhibition, Tate Gallery, London. Michael Brawne & Associates, 1967. Shelf with barrier rail.

and also of course to be taken down easily. The wall is, moreover, unaffected except possibly for a 'dust shadow' which in any case always builds up after a picture has been in the same place for a long time.

Both methods also, however, produce vertical lines on the wall surface which may be visually obtrusive and thus unacceptable. This is particularly true if the pictures are small and the hanging device as a result assumes undue importance. The effect can be lessened if the rods are painted the same colour as the wall. The pictures are potentially also readily unhooked and may therefore not be thought sufficiently secure unless additional measures are taken.

An alternative system of hanging assumes continuous horizontal lines of fixing at normal picture height. These consist, as a rule, of an aluminium extrusion let into the wall. A small bracket fastened to the picture fixes into this extrusion. The problems are very much the same as with rods only here the lines are inevitably always within the normal field of vision and can never be taken away.

Much more secure and often less obtrusive fixings can be provided if objects are screwed directly to the wall. One of the simplest methods consists of screwing a small metal plate to either side of the picture frame or to the canvas stretcher and then screwing those plates to the wall. The protruding section of the plate should then be painted to match the wall.

An alternative method often used for heavier paintings employs short lengths of chain fixed to the back of the frame. The top of the chain is screwed to hooks fixed to the wall within the area of the picture. The way of hanging is thus entirely obscured. Very large and heavy paintings require further support and this is usually provided by brackets coming out of the wall at the base of the picture frame. All these methods assume of course that the wall construction is capable of taking such loads. Direct fixing to the wall is also extremely useful when it comes to objects other than paintings. Small sculpture, *bas* reliefs, farm implements and a great array of similar objects can be supported by brackets

68

45

70. Dorset County Museum, Dorchester. Michael Brawne & Associates, 1971. Wall with removable fabric covering.

71. Marlborough Gallery, New York. Edward Larrabee Barnes, 1973. Plasterboard and plywood wall.

72. Central Art Gallery, Rochdale. Conversion and restoration: Michael Brawne & Associates, 1977. Plasterboard and blockboard wall on metal frame.

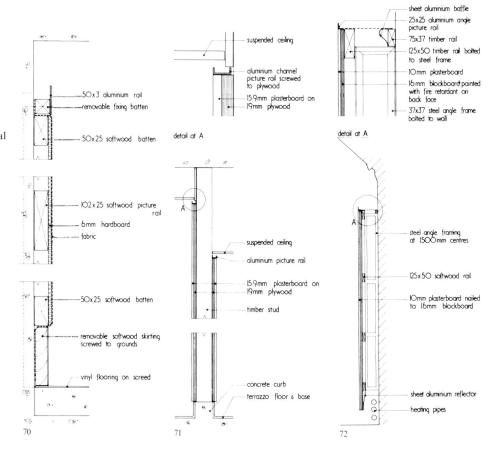

or clips fixed to the wall. The same is true of shelves which in turn become 69 supports for a considerable variety of material. Direct fixing is equally useful when it comes to holding large surfaces flat against the wall. This is the case with wall charts, photographs, some kinds of textiles and such coverings as acrylic sheeting which are used to protect displays that have been pinned to the wall. Despite certain difficulties, it is obvious that methods of fixing direct into a wall allow for considerable flexibility in use and can be made visually discreet.

One of the difficulties is clearly that such a way of installing an exhibition is likely to be slower than using rods or rails. Another is that it is probable that holes will be left in the wall which are likely to need repair before the next show is put up. The degree to which the hole is actually visible can of course be altered by the nature of the wall surface. The traditional gallery wall of hardwood boarding covered in a heavy fabric, often silk damask, took care of a number of problems including this particular one. Similar current solutions often use hessian or some other equally open weave fabric but may even cover the walls in carpet as at the Sheldon Memorial Art Gallery at the University of Nebraska in Lincoln designed by Philip Johnson. The life of any fabric is certainly limited and the wall should be designed so that the material can be removed 70 and replaced reasonably simply.

A quite different alternative is to accept that a hole is inevitable but that it might be easily repaired. This can be done most readily on a plaster wall with a filler and is a perfectly simple amateur technique.

73. Sainsbury Centre for the Visual Arts, University of East Anglia, Norwich. Foster Associates, 1977. Service wall and ceiling. The tubular steel structure spans 33 m (110′), the ceiling and walls are adjustable venetian blinds. (See also 217 and 218.)

It helps if the plaster is slightly rough, thus blurring and obscuring the patch. Plaster, however, does not provide a very good hold on its own and therefore requires plugs into the brick or blockwork behind it if strong enough fixings are to be obtained. The method is both messy and complicated. A combination of an outer face of plaster backed by a strong timber lining, as at the Marlborough Gallery in New York and now also elsewhere, provides on the other hand an 71 efficient gallery wall which gives an ininterrupted surface easily painted and capable of carrying heavy loads. The fact that the wall is fixed to battens allows for very heavy loads to be bolted to the battens or for toggle bolts to expand in the void.

Such a wall can become the inner lining to the structural shell; it is the less permanent element of the two. The space behind the wall can also be used for 73 part of the service installation: conduits for electric wiring and security alarms, air ducts or pipes. The distance between the two wall surfaces may thus be determined by the space needed for services or, in the case of a conversion, 72 by the position of existing services which cannot be removed. This kind of double skin construction also takes works of art yet another step away from the fluctuating environment of the outside. More stable conditions are likely to occur on both sides of the object.

Because of the great visual importance which the wall exerts in any building and especially so in a museum, much of the character of the environment will be influenced by the nature of the wall surface; there will be a radical change

74. Kimbell Art Museum, Fort Worth, Texas. Louis Kahn, 1972. Sculpture gallery.

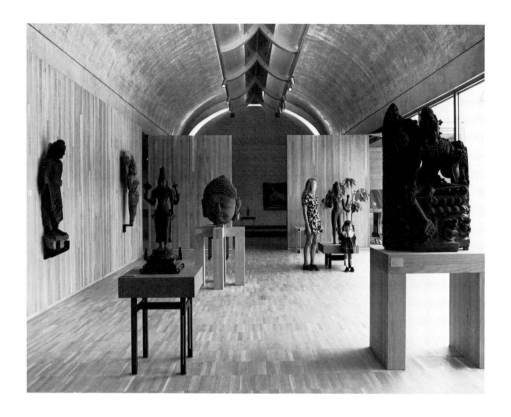

in the feel of any space if white plaster walls are altered to a lining of red velvet, to take an extreme example. Materials not only look different, reflect different amounts of light, have different textures but also have unavoidable symbolic connotations. What may be highly appropriate for a room of Rubens paintings may be quite unsuitable for Cycladic figures, even though both may depict voluptuous curved forms.

The character of the Yale Center for British Art at New Haven, designed by 289–303 Louis Kahn from 1969 onwards, but only completed after his death in 1974, depends enormously on the quality of natural light and the relationship of spaces under the skylights. Equally important, however, is the exquisitely detailed wood surface which fills the wall area between the exposed concrete columns in the major spaces. Although it does not look like the panelling of a country house, it suggests that kind of heightened domestic scale within the context of a gallery. The choice of wood as such as well as the size of the board and of the veneer, its variable nature and the light colour of white oak all play a part in the sensory impression. In the smaller spaces where pictures are hung more densely and where a more neutral background seemed appropriate, the partitions are faced with natural linen. In both cases, though, the material is a natural one congruent with the visible concrete structure and obviously the result of a very deliberate choice made from an understanding of display as well as Kahn's personal preferences within a consciously restricted range of materials.

Kahn's earlier design for the Center included fireplaces (as at his Philips Exeter Academy Library) in order to create focal positions in the building which were also suggestive of domestic interiors (Jules Prown, 1977). His design for the Kimbell Art Museum at Fort Worth in Texas of 1967–72 had again used a similarly 74

restricted range of finishes from the same family of materials: concrete, wood, travertine, natural fabric. It is important to recognise that the final decision in such choices will always be guided by personal predilections and that there is no single, inevitable correct answer.

The selection of natural linen as a background to the pictures also falls in line with a common experience in museum viewing which suggests that slightly textured and uneven surfaces seem more appropriate for paintings than entirely smooth, even ones. It is as if the eye demanded some elements on the surface on which it can come to rest. It is perhaps this need which makes fabrics, the uneven plaster of Italian palazzi or the slight texture of woodchip paper seem such an appropriate background to so many works of art. Although the reason may be entirely visual, in a physiological sense, other factors may also be involved.

David Pye in his *The Nature and Art of Workmanship* (1971) draws a distinction between the workmanship of risk and the workmanship of certainty. In the first case the outcome of the workman's action is dependent on his 'judgement, dexterity and care' and can never be known beforehand with entire certainty. In the second case it is predetermined. The attributes of the workmanship of risk are often a measure of variety, of unevenness, of something unexpected. Most works of art fall clearly into the category of workmanship of risk, the final outcome of a painting, a sculpture, a pot, is continually at risk while it is being created, and it may well be that we prefer some congruence between the object and its immediate background. Such an assumption may at least partially explain why we prefer to see a Sung porcelain bowl against Thai silk than against a sheet of melamine plastic.

The role of colour is as crucial as that of texture, in many cases even more so. Carlo Scarpa's decision to place green panels behind the bust of Eleanor of Aragon not only outlined the marble form but also drew attention to it in a view across two rooms. Kahn's choice of light natural linen at the Yale Center for British Art provided not only an appropriate background to the paintings but was because of its light reflectivity an important element in the luminous quality of the spaces.

59–61

289–303

The amount of light reflected by different tones varies of course enormously and affects not only the apparent brightness of the surface itself but also of adjacent surfaces which receive reflected light. Colour is also reflected; the sun striking an orange wall will turn an adjacent white wall a pale orange tinge, a red wall will deepen the colour of an adjacent orange surface.

The light reflectance of the objects on the wall also naturally varies a great deal. This is especially important in the relation between the colour of paintings and that of the wall on which they are hung.

Dark pictures will reflect relatively little light and will appear in sharp contrast if placed on a white or extremely light surface. The tones of the kind of silk brocades against which Old Masters were placed in 19th century galleries – and still often are – avoid that contrast and are as a rule much kinder to dark pictures. Nor need such galleries in any way look gloomy or unpleasant. The walls of a number of galleries displaying Italian, French, Spanish and other paintings at the Fitzwilliam Museum in Cambridge were recently refurbished using quite pronounced green, brown and deep yellow material against which the paintings glow and appear entirely right without any conflict between picture and background.

Reflectance of some paint colours

Nearest Munsell Reference	description	approximate reflectance (per cent)
	brilliant white	93
5 Y 9.25/1	off white	77
N 8.5	silver grey	64
5 Y 8/2	vellum	56
7.5 R 8/4	rose	56
10 YR 7/6	sand	42
2.5 GY 8/8	apple green	30
5 PB 5/6	lupin blue	20
10 B 4/10	gentian blue	12
7.5 R 3/10	burgundy red	6
8.75 YR 2/2	dark brown	2

Reflectance of some building materials and finishes
(from IES Code 1968)

white emulsion paint on plaster	80
plaster, pink	65
brick, light grey concrete	40
concrete, smooth	30
concrete, rough	20

Colour has, for most people, symbolic meanings, especially within recognisable contexts. The design of the setting for a Council of Europe exhibition of the art of *The Age of Neo-Classicism* at the Royal Academy, London in 1972 attempted 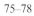 to exploit such commonly accepted meanings. The walls of the largest gallery

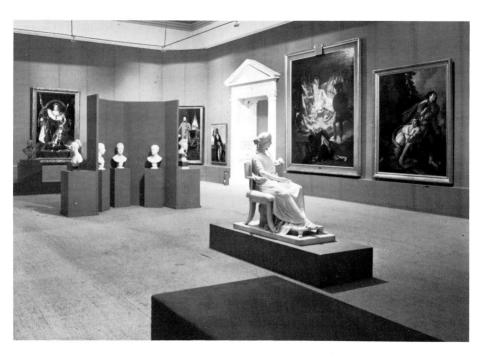

75–78

showing the paintings and sculpture of the Revolutionary and Napoleonic periods in France were covered in red fabric, while the introductory room dealing with the thinkers of the century from 1750 to 1850 was a deep green to act as a background for the marble busts and the leather bindings of the books on show, but also to evoke the feel of a library of the period. The sculpture of Canova was shown in a brightly lit rotunda where the walls were a pale blue, reminiscent of the sky. The walls were, what is more, painted rather than covered in fabric in order to increase the sense of a place that might be out-of-doors.

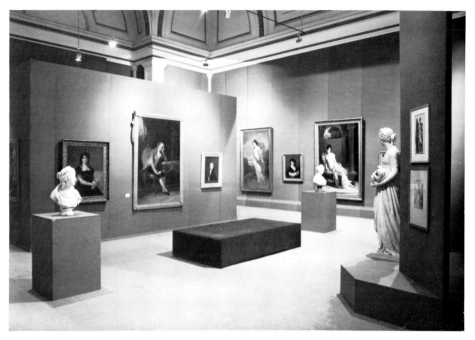

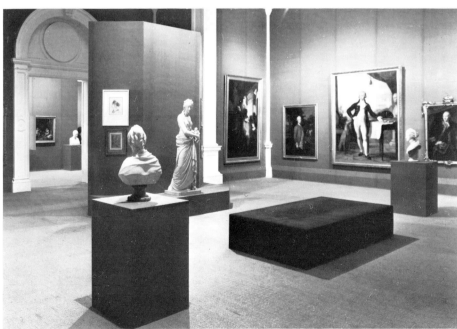

75–78. *The Age of Neo-Classicism* exhibition, Royal Academy, London. Michael Brawne & Associates, 1972.

79. *Word and Image: Posters and Typography from the Graphic Design Collection of the Museum of Modern Art 1879–1969* exhibition, Museum of Modern Art, New York. Arthur Drexler, 1968.

80. *The Architecture of the École des Beaux-Arts* exhibition, Museum of Modern Art, New York. Arthur Drexler, 1975.

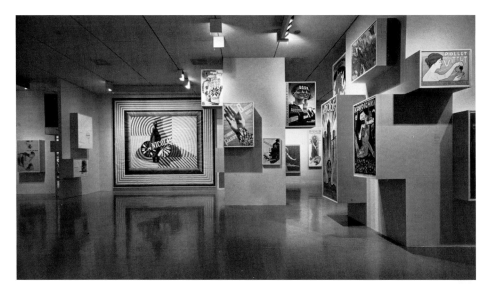

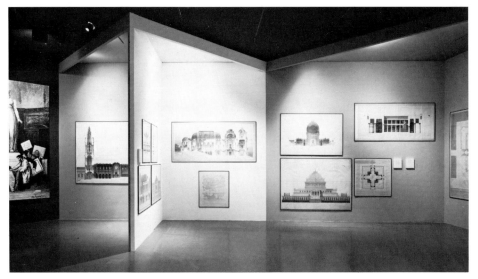

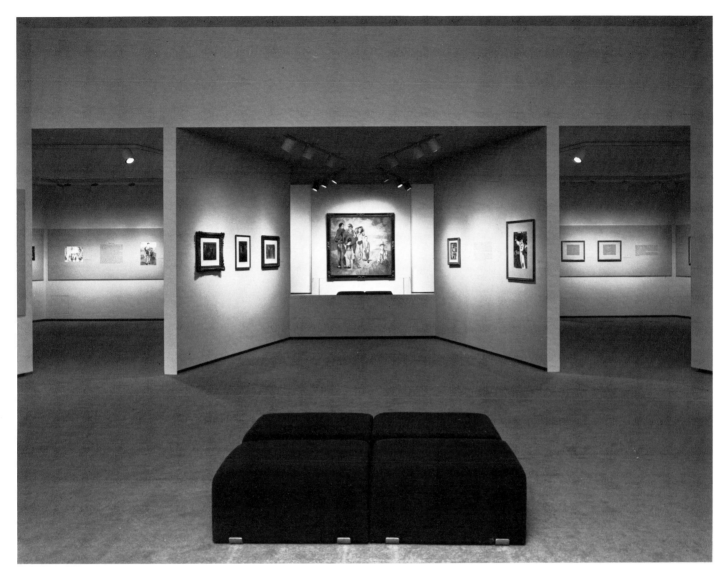

81. East Building, National Gallery of Art, Washington, D.C., I.M. Pei & Partners, 1976–78. Picture galleries.

82. *Bang & Olufsen: Design for Sound by Jakob Jensen* exhibition, Museum of Modern Art, New York. Arthur Drexler, 1978.

Screens

These have many of the characteristics and probably all the problems which we associate with walls and in addition to this have the need to be movable. This is an extremely difficult specification for any component to be able to meet and there are hardly any examples of exhibition screens which could be said to be satisfactory in every respect. The choice of the most suitable screen for any particular exhibition will not only depend on its technical and visual properties but also on the skill and number of people who are available to carry out the work of moving and assembling as well as the amount of money which can be allocated to such jobs.

The need to distinguish between permanent walls and temporary screens arises from the desire for flexibility in the layout of exhibitions as well as the occasional need to use the space for quite different purposes; a room which is sometimes a gallery and at other times a space for concerts or lectures will require a system of movable screens. Most often, however, screens are used in order to gain more surface for hanging and at the same time subdivide a space in a way which seems most appropriate for a particular viewing sequence. Screens are a means of organising the route within the given permanent shell of an enclosure.

The moment there is a decision that screens will be used and that their position can occur over large parts of the floor area, a number of other design decisions are simultaneously implied. The major implication concerns lighting: a fixed geometric relation between object, viewer and light source is no longer possible. Natural lighting in particular has to be able to cope with walls which cannot run parallel to a linear light source in the roof. Roof light construction which as a rule becomes necessary and can hardly be avoided, and which is discussed at greater length in the sections on ceilings and lighting, normally provides higher lighting levels in the horizontal than the vertical plane, that is to say, not where they are usually wanted. Other repercussions affect the degree to which ventilation systems have to deal with localised conditions.

The visual difference which is frequently noticeable between the permanent walls and the less fixed screens – and which is, as often as not, deliberately emphasised – can also be part of the intellectual concept of the spatial organisation. It is used to create a hierarchical distinction between the major volume and its minor sub-divisions. Such a distinction is already clear for instance, in Leo von Klenze's design of 1839 for the museum which was to be an extension of the Hermitage 84 in what was then St Petersburg. An interior view of a picture gallery on the first floor, lovingly depicted in great detail in a coloured drawing by Klenze shows timber screens coming out at right angles from the walls. Both screens and walls have dados, only those of the wall are marble, those of the screens timber panelling. The screens have never been moved, and Room 249 of today's museum looks, except for the arrangement of paintings, exactly like the original drawing. Nevertheless the different appearance of wall and screen is important to our understanding of the space and its architectural intentions.

This section describes only relatively simple screens which can be taken down and assembled by two, or at most, three people and which do not need any special skills. More elaborate and often individually designed screens which are frequently put up for particular exhibitions are really rather more walls than movable screens in the true sense; they are walls which just happen to have a rather short life.

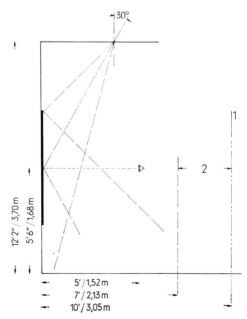

83. Diagram of picture lighting angle and room dimensions related to the size of the painting. It is suggested that the horizontal dimensions be increased by 350 mm (1'2'') for every 300 mm (1') increase in the height of the painting; the position of an overhead light is likely to produce the least reflections if it is at an angle of 30° from the vertical measured from the centre of the picture. Key: 1 nearest suggested position of a wall, 2 minimum circulation width.

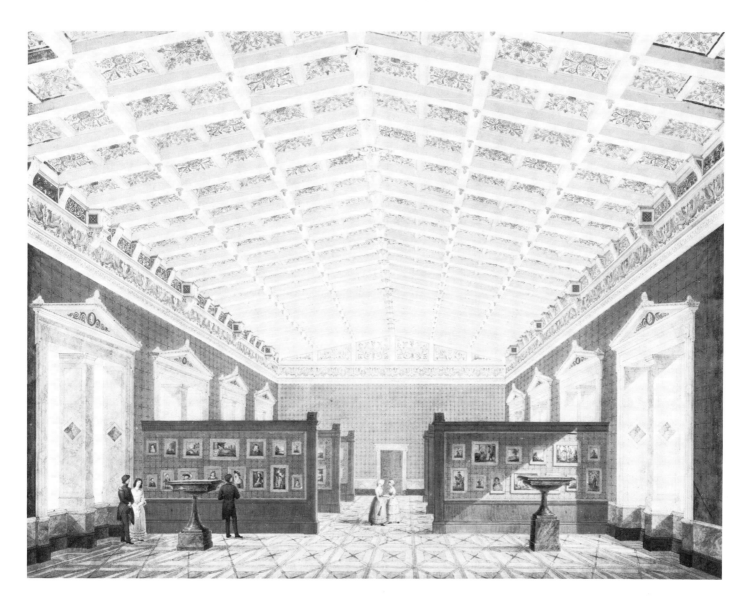

84. New Hermitage, Leningrad. Leo von Klenze, 1839–51. Picture gallery on the first floor.

Three characteristic screen systems are readily recognisable:

1. Screens needing top and bottom fixing either directly or by means of posts. 85, 86
2. Screens which are stable because of their geometric arrangement in relation 89
to each other.
3. Large cupboard-like units which are stable because of their width. 94

In the first case a floor and ceiling grid is required which consists of some kind of a housing for top and bottom fixings. The layout of any exhibition is obviously controlled by the lines of this grid which in turn is determined by the module which was chosen for the screens. The sockets which occur on the floor must be capped when not in use so as not to be dangerous. It is also possible for such sockets either in the floor or ceiling to include electrical 98 outlets so that wiring can be taken down a post. This overcomes the difficulty of providing an electrical supply within the open floor area of a gallery. Such sockets can of course also be used to provide lighting within a showcase which straddles any of the floor outlets or to drive motors for displays.

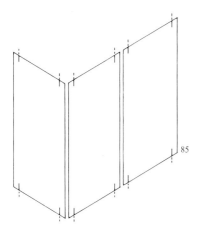

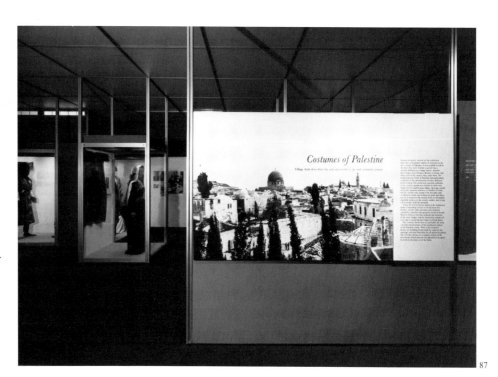

85. Screens fixed into sockets top and bottom or wedged between floor and ceiling.

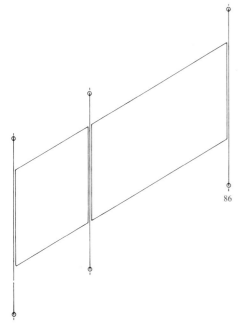

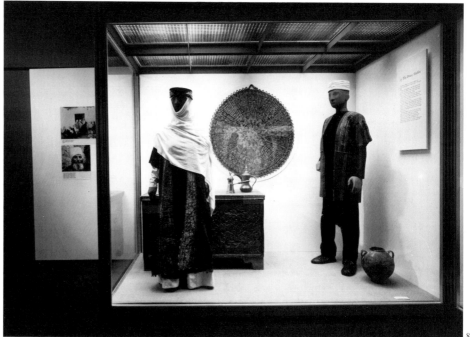

86. Screens attached to posts which are fixed top and bottom or wedged as shown in 99 and 100.

87, 88. *Costumes of Palestine* exhibition, Department of Ethnography, British Museum, London. Margaret Hall, British Museum Design Office, 1970.

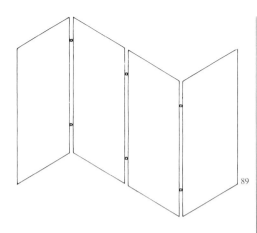

89. Screens attached to each other, often by means of a hinge mechanism, which are stable because of the support provided by the angled returns.

90. *Collingwood/Coper* exhibition, Victoria and Albert Museum, London. Stefan Buzas and Alan Irvine, 1969.

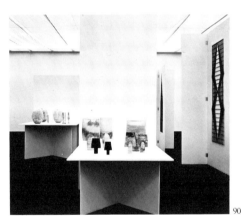

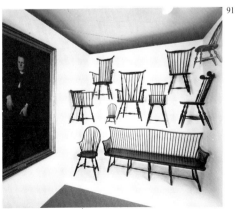

91–93. *American Arts and the American Experience* exhibition, Mabel Brady Garvan Galleries, Yale University Art Gallery, New Haven, Connecticut. Cambridge Seven Associates, 1973. Historical furniture displays and introductory collage.

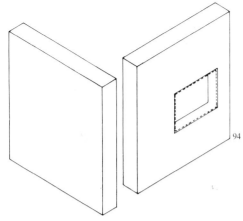

94. Screens of box-like construction which are stable because of their depth; these can also be hollowed out for display or storage.

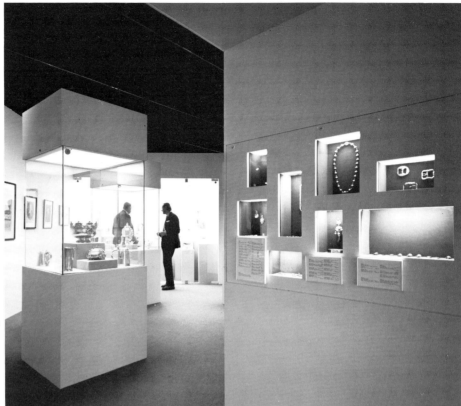

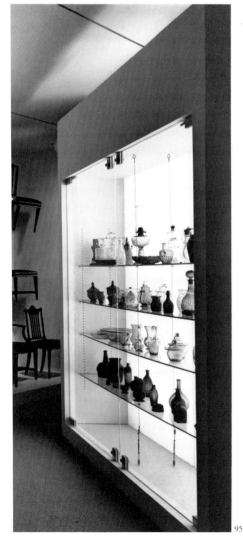

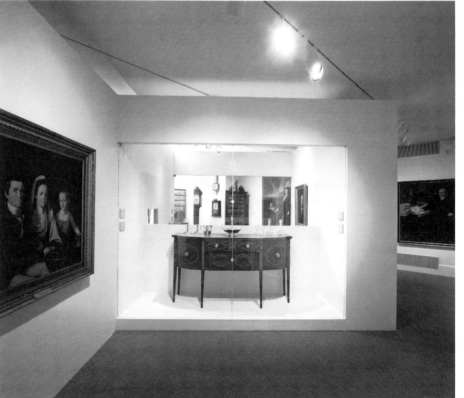

A variant of this category is a system in which there is no direct top and bottom fixing but screens are wedged between a rigid ceiling and floor plane. This does away with the need for a grid and its planning limitations. The original screens in Kahn's Yale University Art Gallery of 1953 belonged to this group. A great 260 deal of scaffolding used by builders and particularly the patented 'Acrow' principle is an illustration of such a method, as are several shop display framing systems. In these there are usually pads at the top and bottom which are fixed to threaded bolts going into the post. When these are turned the post is tensioned between 99, 100 a strong ceiling or beam and the floor.

The second category can perhaps include the simplest of all possible screens. The only difficulty is that long straight walls are impossible, frequent returns or angles are always necessary in order for a group of screens to be stable, and no single screen can ever be used on its own since it cannot support itself. On the other hand no established grid needs to be followed in the layout and no orthogonal arrangement needs to be adopted.

This ability to fit rather free layouts may be particularly useful if the screens form part of a travelling exhibition which is to be shown in a wide variety of spaces. To take a specific example a small exhibition on the occasion of John Constable's bicentenary was to display various aspects of the painter's work and particularly to relate his landscapes to his favourite localities and the sketches he made there. It was to be seen in various cities in South America, Europe and India.

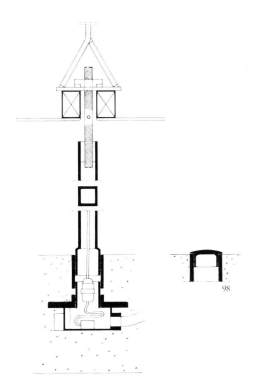

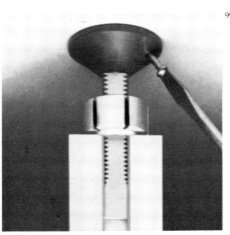

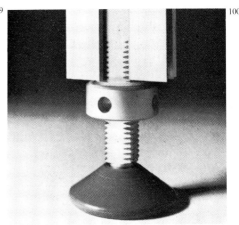

95–97. *American Arts and the American Experience* exhibition, Mabel Brady Garvan Galleries, Yale University Art Gallery, New Haven, Connecticut. Cambridge Seven Associates, 1973. Screens as showcases.

98. Forestry Museum, Gävle. Sven H. Wranér, Erik Herløw and Tormod Olesen, 1960/61. Section through a square metal support bolted at the top and recessed into a socket in the floor which also includes an electrical outlet; when not in use, the socket must be capped.

99, 100. Top and bottom pads of a metal post able to carry screens; turning the circular nut pushes the bolts outwards and thus wedges the post between floor and ceiling.

101

102

103

101–103. British Council travelling exhibition on the occasion of John Constable's bicentenary. Michael Brawne & Associates, 1977. Elevation of a pair of screens (the lines at the side of the screens show the position of clamps, shown in 106, and at the bottom of rubber feet) and two possible layouts.

The exhibition consisted of two kinds of panels, one 900 mm (3′0″) wide containing large reproductions and photographs and a narrower panel 300 mm (1′0″) wide for notes, quotations or sketches. Both were 2134 mm (7′0″) high. A few possible layouts were illustrated in the handbook which travelled with each set of panels. The hardboard panels were connected to each other by a patented system of clamps. These consist of two aluminium castings and two plastic inserts which can be varied according to the thickness of the panel. These inserts are rotated into the correct alignment and then the clamp is screwed tight. These clamps are in effect a kind of hinge and can be used for a wide variety of screens. They are only a more sophisticated version of the webbing which joined the folding Japanese screens which decorated so many 19th century rooms.

The third category is much less frequently used since it is much bulkier and therefore more difficult to move and store. It has however the very considerable advantage that each unit is stable on its own and that its depth can be used for other purposes.

For instance an opening flap at the end of the narrow ends would allow pictures to be slid into the cupboard and stored there. Alternatively, the thickness of the screen can be used to create a showcase; an opening needs to be cut in one or both sides and the opening lined. Glass fitted quite simply onto the face of the screen, or recessed within the 'window' which has been made, will convert such a cupboard-like screen into a showcase.

101

102, 103

106

95, 96

104

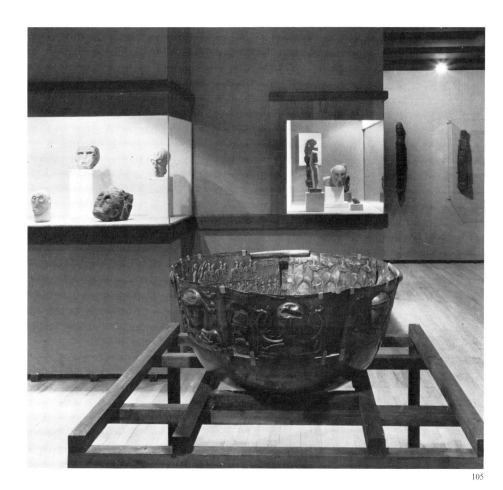

105

104, 105. *Early Celtic Art* exhibition. Hayward Gallery, London. Michael Brawne & Associates, 1971. Section through showcase let into the wall and view of two corner cases with internal lights.

106, 107. Proprietary systems for holding screens able to take different panel thicknesses. Key to 106: 1 aluminium casting, 2 insert with width of groove dependent on panel thickness, 3 display screen, 4 Allen head key for turning bolt joining two parts of the clamp.

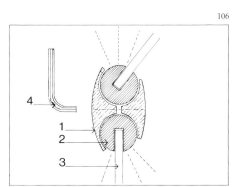

106

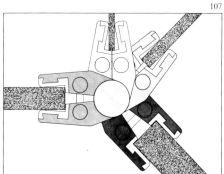

107

108. Central Art Gallery, Rochdale. Conversion and restoration. Michael Brawne & Associates, 1977. Movable screens (A detail at end, B detail at typical junction, C section Y–Y, D elevation Z). Key: 1 aluminium extrusion capping at end, 2 barrel bolt, top and bottom, 3 wood inserts, 4 expanded polyurethanel infill, 5 plywood facing with textured paint, 6 baffle suspended from trusses, 7 suspension rod for picture hanging, 8 aluminium extrusion framing, 9 felt pad, 10 socket with spring closure.

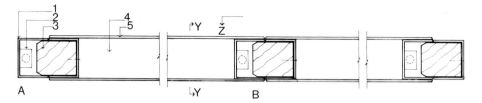

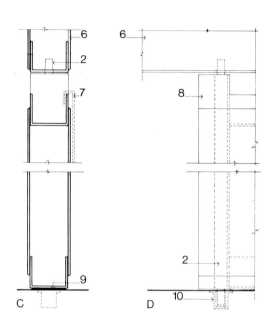

It is also important to remember that whatever screen system is chosen, storage space must be provided for all the units if ever a clear space is required in the galleries. Moreover all openings on the route between the store and the galleries must be large enough to take the biggest units and especially to allow them to be taken around corners. It is even more difficult if they are to be taken into a lift. Although small mechanical handling devices make moving less arduous they do not alter the need for adequate clearance, on the contrary they usually increase the space needed.

The material from which screens are made must be stable and not prone to warp and at the same time be lightweight. The kind of composite construction of blockboard and plasterboard which has been used for gallery walls is certain to be much too cumbersome for movable elements. Blockboard or plywood on their own are likely to be more suitable for screens up to about 1.2 × 2.4 m (4′0″ × 8′0″). Larger units may have to be made with a metal frame on to which plywood or hardboard is fixed. It is also possible to use certain kinds of metal or plastic sheet for screens but it is really not feasible to nail or screw into these.

As a rule screens are used to support objects on display and have to be able to do so. Occasionally however they are simply a background to an object, a

108

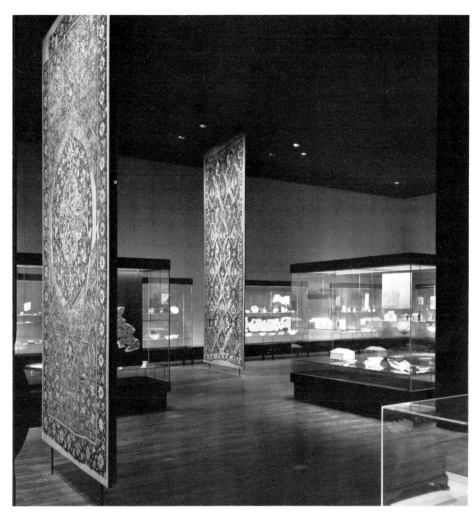

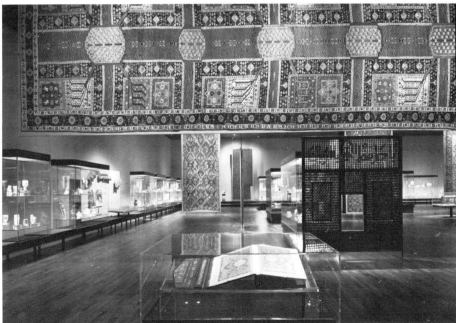

109, 110. Museum für Islamische Kunst, Berlin-
Dahlem.

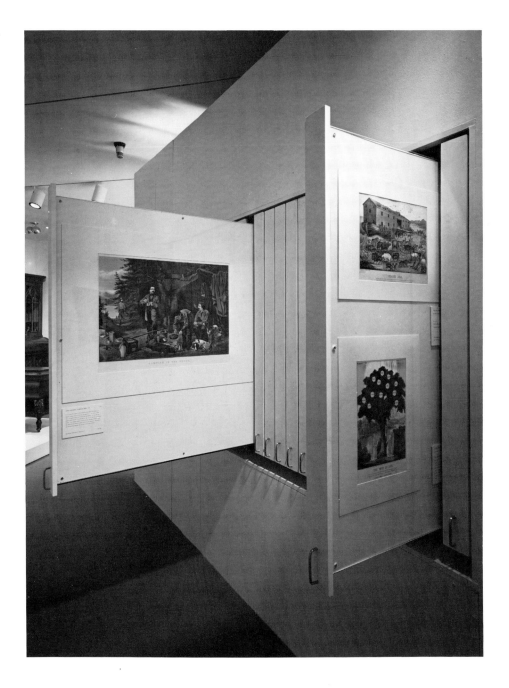

111. Mabel Brady Garvan Galleries, Yale University Art Gallery, New Haven, Connecticut. Cambridge Seven Associates, 1973. Print racks pulled out by visitors.

way of providing a suitable surface against which a thing is to be seen, or a 109 way of obscuring parts of the space and the activities in it. Spatial continuity is often very disturbing when there is an attempt to concentrate vision on an object and the eye has focussed on an area; movement or a large number of other visual incidents behind the object make such concentration difficult. In such cases the screen can be a panel or even a length of fabric suspended from 110 the ceiling. Its function is simply to control the space within the cone of vision of the visitor on the museum route.

In any museum the term 'screen' requires a wide interpretation of meaning and can perhaps most usefully be applied to all vertical surfaces which are not part

of the permanent enclosure of the room. There is a considerable range of special display problems which is best solved by very specific screens.

One very obvious example of such a need for specific solutions is the frequent necessity to show a considerable number of flat objects in a small space and perhaps also at the same time to protect them from continuous exposure to light. As a result postage stamps are for instance very often shown on small screens which slide on runners and which can be pulled out of a cabinet to 111 be viewed. A larger version of a very similar arrangement occurs in the Östasiatiska Museet in Stockholm where floor to ceiling height sliding screens hold Chinese 112, 113 paintings and scrolls.

Another example of the moving screen can be seen at the American Museum in Britain just outside Bath where part of an extensive and important collection of quilted bedspreads is shown on hinged panels fixed to a central drum. It is like turning the pages of a very large book. The identical principle was used in the design of Philip Johnson's private gallery next to his house at New Canaan, 114–116 Connecticut. Here paintings are hung on very large screens fixed to a drum at one end and hung from an overhead rail at the other. The intention is that a seated viewer can be shown a sequence of pictures which, through the rotation of the panels, are brought into view one after the other. It is of course a method which may be appropriate to a private collection only seen by a few people at a time but which is unlikely to be applicable in a public gallery, not least since it suggests that an attendant and not the visitor is responsible for moving the panels. If the movement of the panels is mechanised new complications of timing the sequence arise; in any case any such system assumes that the rate of viewing is set by only one person and that only a few pictures want to be seen at any one time. The principle is an inversion of the accepted way of looking at a museum in which fixed objects are seen by a walking observer.

112, 113. Östasiatiska Museet, Stockholm. Per-Olof Olsson. Chinese collection. General view and plan of room containing paintings mounted on screens stored in cabinets and able to be drawn out by visitors.

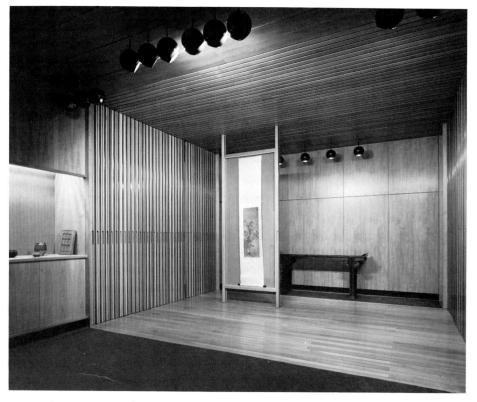

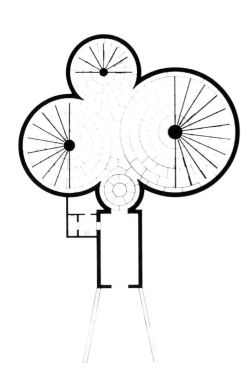

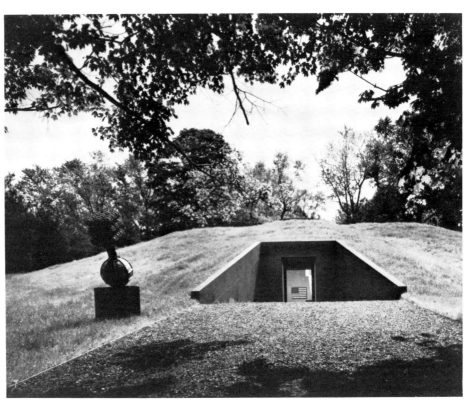

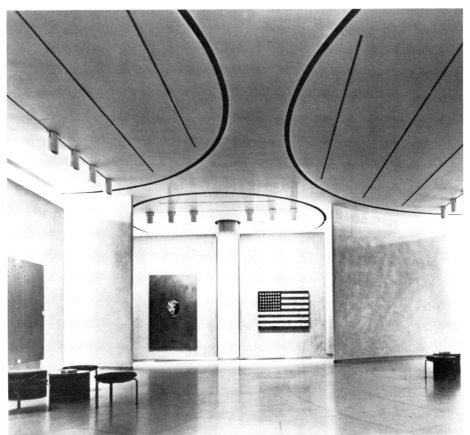

114–116. Private gallery, New Canaan, Connecticut. Philip Johnson, 1965. Plan, entrance and view of inside showing the three drum-like sections with paintings hung on screens suspended from circular overhead tracks on the outer and inner edge.

The Floor

In the museum, as in so many other building types, this is an extremely difficult surface. No ideal material appears to exist which is at the same time comfortable, quiet, hardwearing, allows for heavy loads, provides some fixings and is light reflective. It has to be admitted, of course, that this is an impossible specification under any set of circumstances but especially so in a gallery where heavy use may be involved and the point loads from sculptures or machines, for instance, may be quite considerable. Some compromises will therefore have to be made and these will depend largely on what is crucial in specific circumstances.

The floor is, moreover, not only the surface on which the museum visitor walks, or on which pedestals and showcases are placed, or over which trolleys are moved, but also the plane against which many objects are seen. It can often be as important a display surface as the wall and thus requires the same kind of consideration. A great many objects are often placed directly on the floor without a pedestal 117–122 or platform and the floor surface becomes the immediate background. Low platforms for carpets or furniture may only slightly differentiate between the floor 123, 124 intended for walking on and the floor which is a display zone and certainly also draw attention to the surface underfoot.

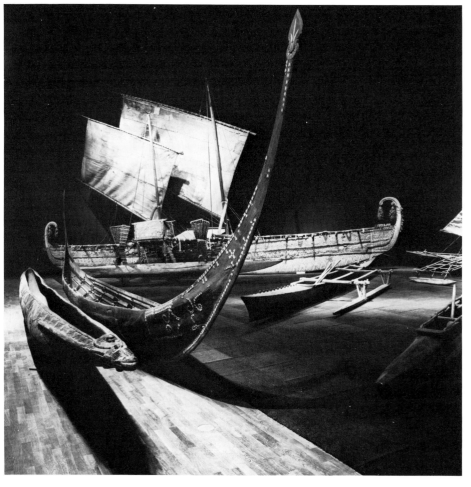

117, 118. Museum für Völkerkunde, Berlin-Dahlem. Boats from the South Sea Islands.

68

119

120

121

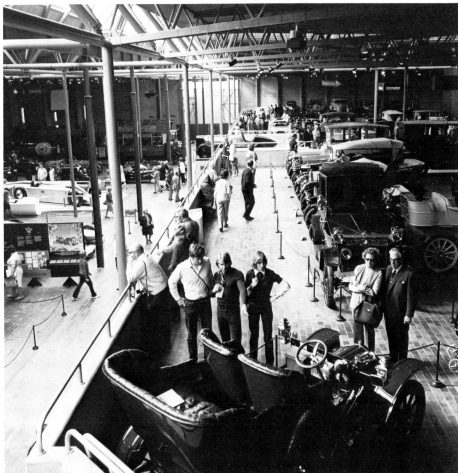

122

119, 120. BMW-Museum, Munich. Karl
Schwanzer, 1972. A series of intersecting circular
platforms.

121, 122. National Motor Museum, Beaulieu,
Hampshire. Leonard Manasseh & Partners,
1972.

123, 124. Museu Calouste Gulbenkian, Lisbon. José da França Ribeiro, Alberto Pessoa, Pedro Cid and Ruy Athouguia, 1961–69. Galleries of 18th century French Art and of Islamic Art.

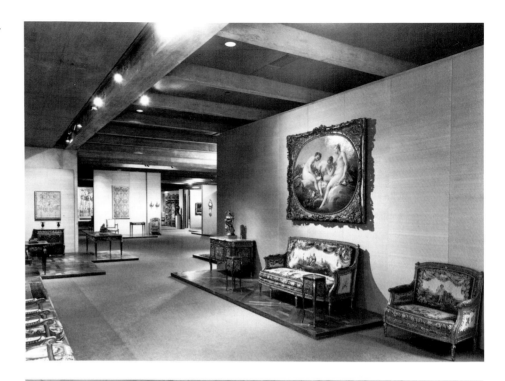

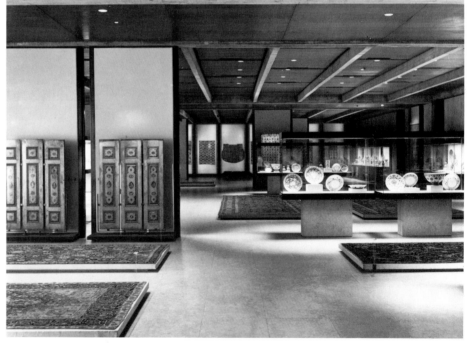

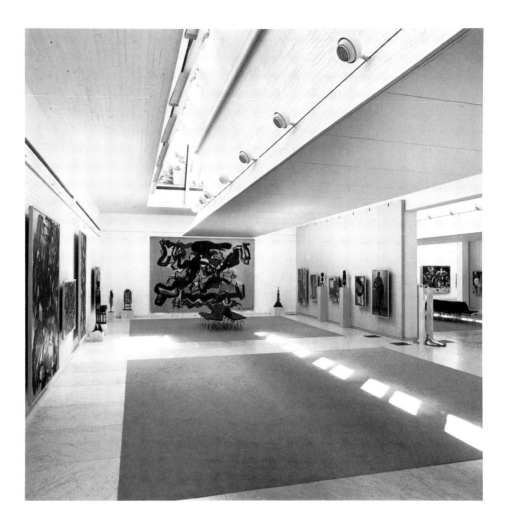

Because of this, highly patterned floor finishes or the juxtaposition of different kinds of surfaces within a small area are rarely successful. They often also limit the way in which objects can be disposed on the floor. In the new Museum of Art at Aalborg by Elissa and Alvar Aalto and Jean-Jacques Baruël the floor 125 consists of two materials: pale grey carpet for the main areas and white marble for the outline of a square grid on which walls and screens stand. The logic of the arrangement appears to be clear. In use, however, it seems that sculpture looks much better when placed on hard, solid marble than on carpet and as a result tends to be positioned near the walls rather than to be left free-standing so that it can be seen in the round. The choice of floor finishes seems in such a case to restrict the possibilities of display. Heavy objects on the carpet may in any case leave indentations which do not recover readily. Kahn's Yale Center 289–303 for British Art has a similar floor pattern but keeps the bank of travertine much narrower.

Architecture is sensed primarily through the eye and through bodily movement, and these sensations also play a key role in the way in which the contents of museums make their impact. Touch and sound should however not be neglected and both are immediately relevant in the case of floors. In an earlier description of the Museo Correr in Venice it became clear how important the change from

71

126. Electrical floor sockets with removable covers.

hard surfaces to carpet was in drawing attention to specific rooms (Michael Brawne, 1965). In Carlo Scarpa's design for the museum three rooms were carpeted rather than tiled and in each case this was a signal that these spaces contained rather special paintings. Yet this message was conveyed by means which in no way conflicted with the visual communication of either the works of art or of the spaces of the museum.

Such tactile and aural impressions can be used to provide subtle changes in the progress of a museum visitor and to provide clues as to the character of a space and its position within a museum organisation. A centralised plan with a hall floored in marble surrounded by rooms with hardwood floors will not only distinguish between two kinds of spaces but also suggest perhaps a museum installation in which the objects in the central hall were of a kind which might also appropriately be seen out-of-doors or in a courtyard. At the Yale Center for British Art for example three principal floor finishes are used: travertine for the first four storey high internal court which acts as the entrance vestibule, parquet for the second three storey high exhibition court and beige carpet for the galleries which surround these two vertical shafts which act as pivotal daylit spaces.

The three floor surfaces which Kahn used at Yale also belong to the three most 289–303 common categories found in museums: marble, stone or tile; hardwood; carpet. Each has very specific and useful characteristics both in terms of performance and visual effect though none has all the qualities which an ideal specification might list. The same is true of the fourth category – plastic, rubber, cork or linoleum – which is more common in houses and offices than in museums. No single finish is durable, does not dent under heavy loads or shows wheel marks from trolleys, is quiet underfoot, can be specified in a wide range of colours and tones, is easily maintained or is cheap enough to be readily renewed when showing the marks of wear.

Since, even ignoring the question of cost, no one material answers all the criteria which can so easily be listed as being desirable for a museum floor, all that can perhaps be said is that the final design decision is inevitably part of the general design vocabulary of the museum or the exhibition and that it therefore reflects the taste of the person making that set of decisions. Tradition also creates certain expectations of what is appropriate: we would, one suspects, expect a room exhibiting the Crown Jewels to be floored in marble or carpet but not with softwood boards.

The floor has frequently to be more than a surface on which we walk or a visual background to exhibits. Because it is inevitably a rigid element of the building it often acts as support, either directly or by having recessed within it fixings for pedestals, screen poles or showcase legs. A unit which provides both an electrical connection and a threaded fixing was designed for the Forestry Museum at Gävle in Sweden, and variations of such floor sockets can be found 98 in many museum buildings. They always create a grid pattern on the floor and therefore also suggest a visual order in the layout which should somehow relate to that grid.

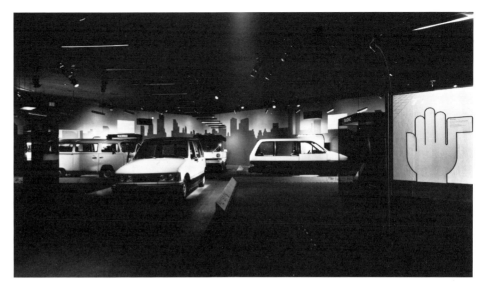

127. *The Taxi Project: Realistic Solutions for Today* exhibition, Museum of Modern Art, New York. Emilio Ambasz, 1976.

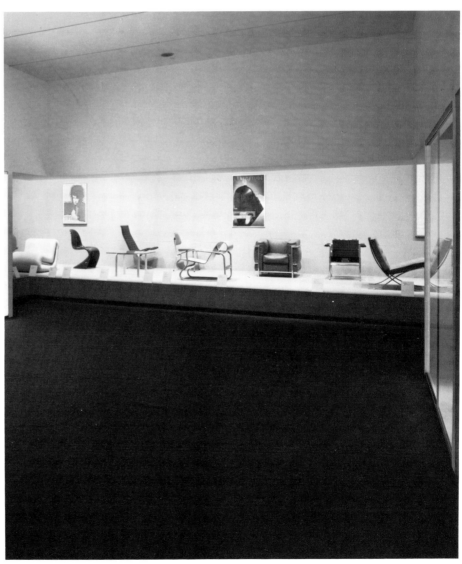

128. Philip L. Goodwin Galleries for Architecture and Design, Museum of Modern Art, New York. Arthur Drexler, 1964.

The Ceiling

Museum objects are most often seen against walls or screens or within showcases, they are occasionally viewed against the floor, but only rarely against the ceiling. Only aircraft or mobiles or the skeletons of whales are suspended from above 130 and have, as a result, the ceiling as their visual background. The ceiling is thus a building element which can perform a number of functions, several of which, if placed elsewhere, would make considerable visual intrusions on the display. The frequent and unfortunate result is that the ceiling becomes an overburdened surface.

It may have to deal with natural and artificial lighting and its control, with ventilation, heating and cooling and with fire and security alarm systems. In addition, it may have to carry the top fixings needed for movable screens and provide suspension points for hanging objects. It may also be the only available surface for sound absorption. The ceiling must, moreover, be able to cope with these diverse functions without becoming an overwhelming element within the visible space of a gallery as happened rather too often in some designs of the 1950's. The design problem is very much one of how to subdue services and lighting control in the interest of museum display.

It is perhaps also a question of how to create sensibly different spaces out of a set of repetitive units which tend to make up the normal highly serviced ceilings. The problem has exercised architects designing other building types and especially offices where the ceiling is an equally burdened surface. The difficulty also becomes more acute as the size of the room increases; the longer the uninterrupted view, the more the ceiling becomes visible as a plane receding in perspective. In both offices and museums where there is a demand for changeable spaces, the tendency is to design larger and larger uncompartmented volumes and thus to make the surface overhead more obtrusive. The visual dominance of the ceiling is very evident, for example, on such large floors as those of the Centre Pompidou 131 in Paris.

129, 130. National Air and Space Museum, Washington, D.C. Hellmuth, Obata & Kassabaum, 1972–76. The tubular steel trusses are capable of taking a hanging load of 3629 kg (8000 lbs) at each intersection of the web members with the bottom chord.

131. Centre National d'Art et de Culture Georges Pompidou, Paris. Piano + Rogers, 1971–77.

132. East Building, National Gallery of Art, Washington, D.C. I.M. Pei & Partners, 1976–78. Inner court.

129

130

131

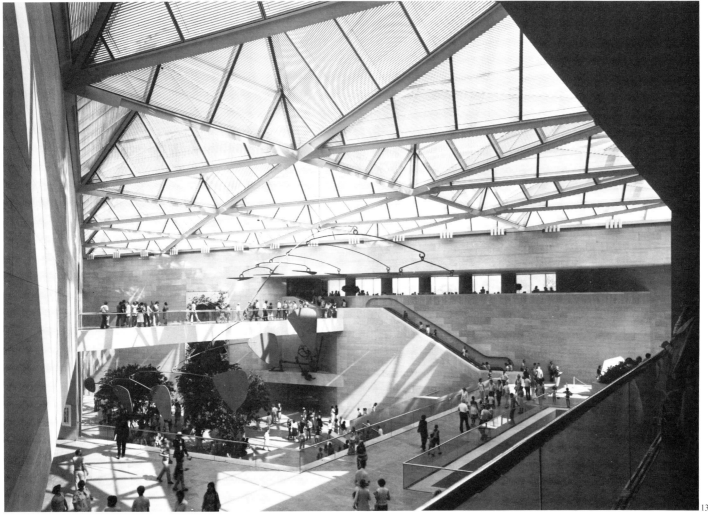

132

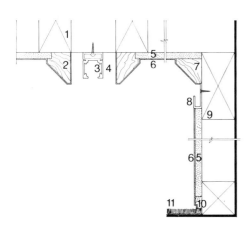

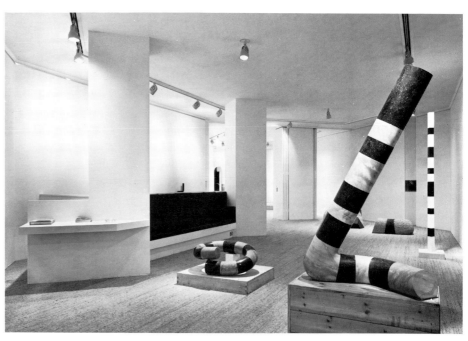

133, 134. Gimpel Fils Gallery, London. Michael Brawne & Associates, 1972. Section through wall and ceiling and view down the main gallery displaying sculpture by Isamu Noguchi. Key to 133:1 sw trimmers to suspended ceiling, 2 sw fillets, 3 light track screwed to sw bridging members, 4 mechanical ventilation slot with air-handling units above suspended ceiling, 5 plasterboard on sw frame, 6 washable plastic compound (white) sprayed over plasterboard, fillets and skirting, 7 sw fillet as cornice, 8 aluminium picture rail screwed to plate, 9 sw plate, 10 sw skirting, 11 carpet and underfelt.

If only a few of the functions normally placed in the ceiling have to be catered for, the problem is relatively simple; if, for example, only artificial lighting and air extraction have to be included. The serious difficulties arise when the number of functions increases and, in particular, when day-lighting is to be controlled to meet the stringent criteria set by the demands of conservation. What happens in such cases is not only that the design problem is highly complex, but that the volume which is allocated to these tasks, becomes a high proportion of the building total.

The ratio of usable space to servant space needed for control may best gauged from three recent examples built in London. On the top floor of the Hayward Gallery on the South Bank used by the Arts Council for temporary exhibitions, the floor to ceiling height in the larger of two galleries is 4.9 m (16′0′); the distance from the ceiling to the topmost part of the roof is another 5.8 m (19′0″). A very similar relationship in which the control volume exceeds the usable volume occurs at the extension to the Tate Gallery. The ratio becomes a little more favourable in the additions made to the National Gallery where the services occur in the walls and the floor as well as the space between the ceiling and the outer roof. When daylight does not have to be controlled quite so stringently and when ducts used for distribution are, with considerable ingenuity, also used to act as light baffles, more compact solutions become possible. There has recently been a considerable reaction against the elaborations which are obvious in the three London examples and James Stirling's prize-winning design for the extension of the Staatsgalerie Stuttgart of 1977, for example, adopts a much simpler detail. Many of these complex solutions are provoked by the demands set on the control of daylight and will be discussed further in the section dealing with natural and artificial lighting. Aspects particularly related to environmental control – heating, cooling and ventilation – will also be discussed separately in a section devoted specifically to those problems.

133, 134

135

136, 137

138, 139

140–142

135. Hayward Gallery, London. Greater London Council, Department of Architecture and Civic Design, 1963. Section through top floor gallery showing roof lights, sun baffles, diffusing panels and egg crate louvres.

136, 137. Extension to the Tate Gallery, London. Llewelyn-Davies Weeks Forestier-Walker & Bor, 1979. Section through a typical square bay and general cross-section. Key to 136: 1 adjustable sun control louvres, 2 double glazed roof with ultra-violet filter, 3 service access, 4 acoustic plaster, 5 air supply ducts, 6 air extract ducts, 7 fluorescent lighting with double diffuser, 8 adjustable lighting, 9 partition.

138, 139. Extension to the National Gallery, London. Department of the Environment, 1974. Section showing lighting and services and general cross-section. Key to 138: 1 roof glazing, 2 ventilation fan and filter, 3 service access, 4 electrical distribution, 5 sun control and blackout blinds, 6 security light, 7 service access, 8 fluorescent lighting with ultra-violet filter and diffuser, 9 air supply duct, 10 air extract duct, 11 lighting service access.

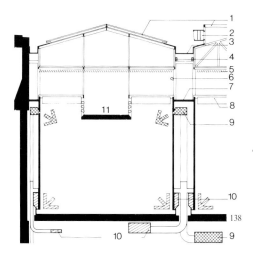

140–142. Extension to the Kunsthaus Zürich. Erwin Müller, 1970–76. Section through roof and view of galleries. Key to 141: 1 double glazing, 2 air duct, 3 fire alarm, 4 lighting.

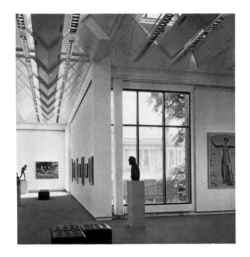

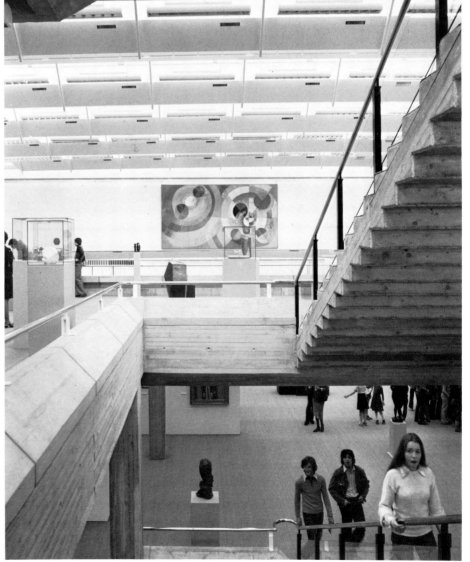

The problems this section is trying to examine have largely to do with the constructional and visual effects which lighting and services pose on the overhead surface, whether this is below a roof or a floor. And, as always, the solutions to such design problems of the museum interior are influenced by the general visual choices that are open to us and from which we select specific answers.

Because the ceiling is from the point of view of display, the least used of the surfaces surrounding a gallery, it can also conveniently become the most permanent looking. This is clearly the attitude taken by Kahn in the first museum he designed 260 for Yale in 1953. Here a complex concrete structure houses service runs, provides recesses for lighting, carries the floor and gives a rigid overhead grid against which to wedge movable screens. It moreover provides a solid, visually strong plane which reveals the bones of the building. It totally avoids the flimsy and non-structural appearance of the normal suspended ceiling which was alien to Kahn's architectural vocabulary. In a similar way, the radial and circumferential

143. Hirshhorn Museum, Washington, D.C. Skidmore, Owings & Merrill, 1974. The plan is shown in 15.

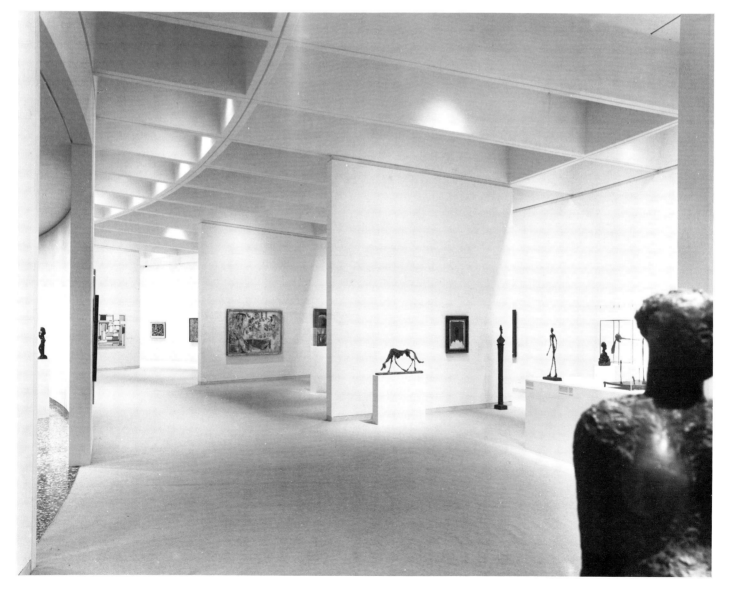

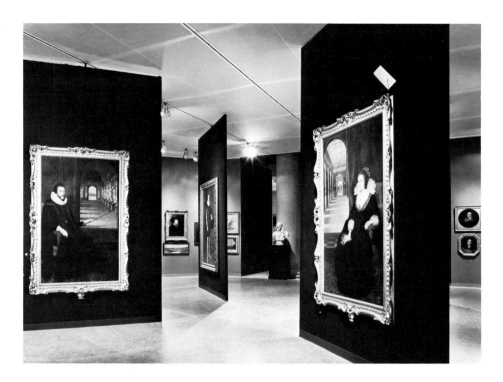

coffering of the ceiling of the Hirshhorn Museum in Washington reflects the 143
plan and structure and at the same time shields the artificial light sources.

The opposite view is typified by temporary installations in large spaces where
not only screens, but ceilings are created to provide a particular enclosure; where
ceilings like walls are also part of the scenery. Often, these are a thin fabric,
like muslin or gauze, stretched across a framework suspended from above or 144
supported on the screens. Such a velarium can reduce the amount of light coming
through a skylight, produce a ceiling plane at the required height in terms of
the exhibition design and be of any specified colour.

Artificial lights are, as a rule, placed below this kind of fabric ceiling and generate
heat which is trapped underneath. It is important therefore, that there are sufficient
openings or fans in any suspended ceiling to draw out the heat produced by
lights, people and any heating services. The fabric itself is never sufficiently porous.
Such openings can occur around the edge or other similar zones where the upper
part of the room is least within the cone of vision, or be arranged by stretching
the velarium in a number of different horizontal planes, leaving the gap between
them open.

A textile ceiling of this kind has of course no structural strength and cannot
carry lights or provide support to the tops of movable screens. It also obliterates
the volume of the room above it which is often a reason for using it, but which
may equally at other times be a serious disadvantage. An alternative is to create
an implied ceiling plane by a series of baffles which are sufficiently rigid to 145, 146
have structural stiffness. These prevent one seeing the void above them except
on the direct upward view; an indication of what the architecture of a roof
is can still, for instance, be sensed yet the apparent volume of the gallery is
considerably reduced. The baffles being of some depth act in effect as beams
and can carry track for light fittings or house the top fixing of screens. Even

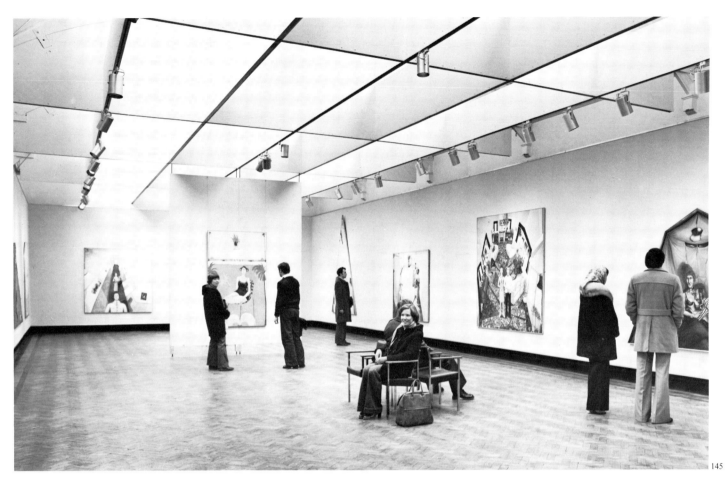
145

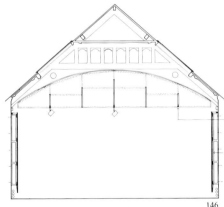
146

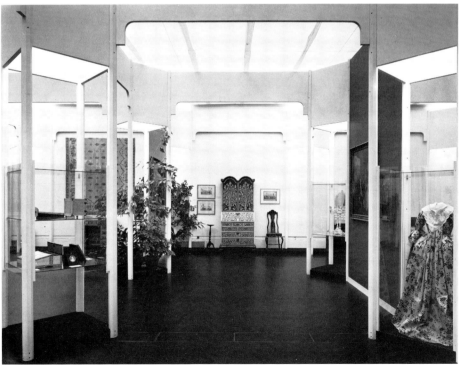
147

145, 146. Central Art Gallery, Rochdale. Michael Brawne & Associates, 1977. View of a renovated gallery and typical cross-section showing baffles. (Detail of wall shown in 72.)

147. *Art of the East India Trade* exhibition, Victoria and Albert Museum, London. Stefan Buzas and Alan Irvine, 1970.

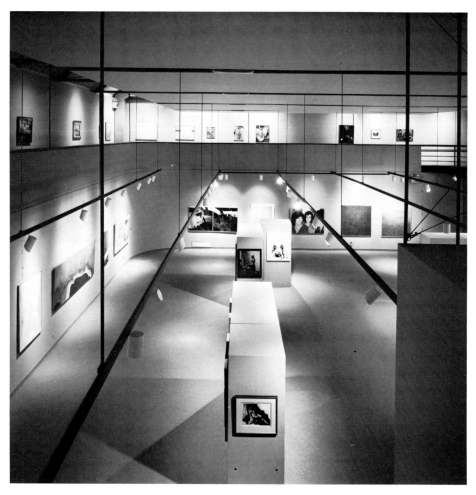

148. Gimpel Fils Gallery, London. Michael Brawne & Associates, 1972. A section through the ceiling is shown in 133.

149. Southern Alleghenies Museum of Art, Loretto, Pennsylvania. Ferri & Metzner Associates, 1977. Conversion of a gymnasium into a museum.

where a velarium is in use, it may still be appropriate to use a system of baffles 147 to avoid the view of a large expanse of fabric and to indicate on the ceiling the spatial organisation of the exhibition; to break down in some way an open space into a number of subsidiary parts.

There are many occasions when the simplest possible arrangement which preserves the room-like character of a gallery is the most appropriate solution to the design of the ceiling; when the four walls, floor and ceiling are treated as six simple rectangular planes enclosing a space. Such an effect can be achieved by recessing lights in the ceiling if the objects being displayed are not going to be moved 148, 150 or by recessing lighting track if a more flexible system is needed. 151

There are also many instances when the ceiling as a visible surface is best entirely negated. It becomes in such a design a black void within which there might be only highly directional light sources which create no spillage onto the ceiling and which only emphasise objects in the lower part of the room. The dark ceiling is often a particularly appropriate answer where there are lights within showcases 153, 155 and it is important not to raise the general level of illumination.

150, 151. Kettle's Yard, Cambridge. Sir Leslie Martin and David Owers, 1970. (An isometric of the building is shown in 18.)

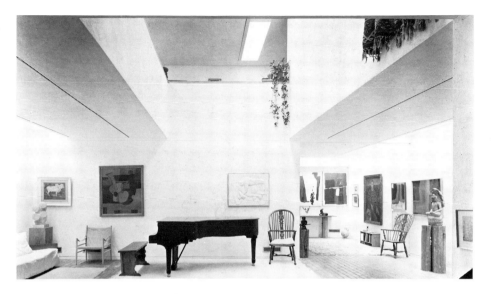

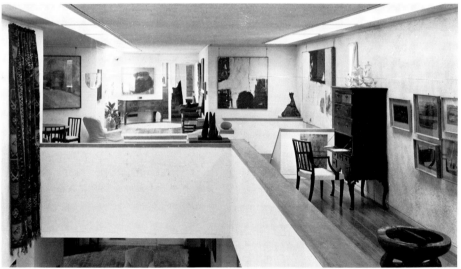

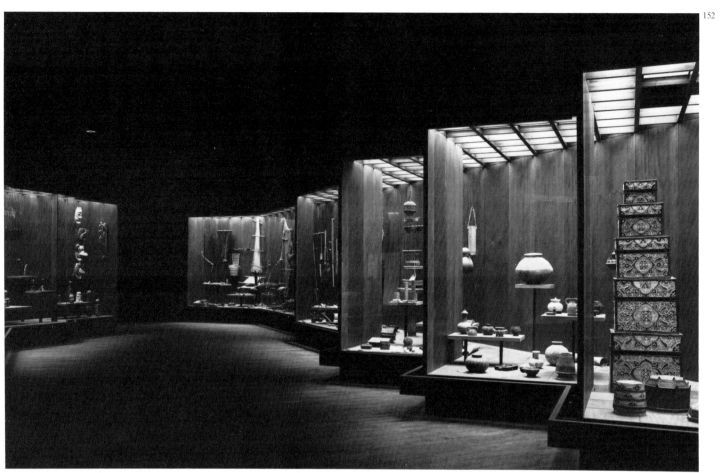

152

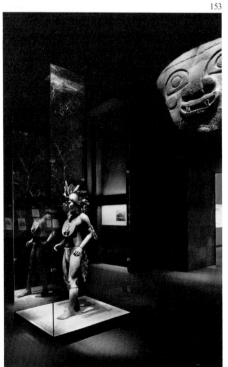

153

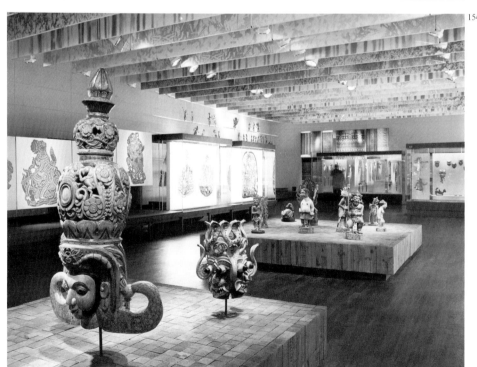

154

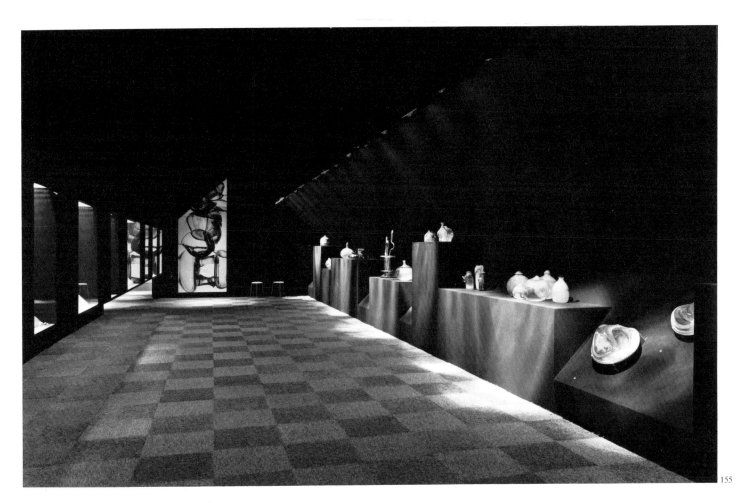

155

152, 154. Museum für Völkerkunde, Berlin-Dahlem.

153. *Gold of El Dorado* exhibition, Royal Academy, Burlington House, London. Stefan Buzas and Alan Irvine.

155. Exhibition of jewellery by Gerda Flöckinger and glass by Sam Herman, Victoria and Albert Museum, London. Stefan Buzas and Alan Irvine, 1971.

Pedestals

There are two common elements in most museums which occur within the enclosure of the gallery and which are clearly part of the more variable setting, but which are nevertheless intimately involved with the more permanent enclosure and often even acquire some of its characteristics. These are pedestals and showcases.

The pedestal, platform or similar support is in a sense a piece of the floor which has been demarcated and raised in order to bring an object to a proper viewing height. It also, however, defines and isolates that object by putting it on a delimited and separate piece of territory. It is precisely because the pedestal seems to remove sculpture from the larger and more ordinary plane of the floor that sculptors like David Smith or Anthony Caro have been so anxious that their work should stand directly on the floor. Nor is that separation much affected by the material from which the pedestal is made: a stone plinth on a stone floor isolates the object as much as a wooden stand on the same floor. It is only that the stone base looks more permanent, more built-in; it is more like the base of a statue in a public place.

The sense of definition seems also not to be greatly influenced when the pedestal, instead of being an individual and relatively small object, becomes a much larger platform, a kind of terrace for display, which itself may have several levels. The effect is mainly one of unifying into a single element what would otherwise be a multiplicity of individual events. This is of course particularly true when a large number of rather small objects needs to be shown, and when platforms assume the characteristics of tables and shelves.

It is often extremely relevant that the distancing effect of the pedestal should not only be apparent, but real; that an object should become more secure through being placed on a stand. Bases can be designed in such a way as to place objects beyond reach and certainly to prevent feet or cleaning equipment hitting them at floor level.

Pedestals are normally made of timber and then painted or covered in fabric. They must be strong enough to support the object and also sufficiently heavy to prevent the display from toppling over if one were to lean against the top part. It may be necessary to hide some sandbags or bricks in the bottom of the pedestal, especially if it is tall and narrow. Pedestals can also be made from metal sections which can then be designed specifically to support a particular object; they often make possible a more delicate way of holding an object and may thus draw less attention to the support. In a highly permanent display, it may be possible to fix pedestals to the floor or to make them out of stone or concrete.

There are visual problems with the design of supports which may occasionally demand an alternative to the rectangular box which is the accepted solution. Some of these relate to choice of material and particularly the psychological need for some relation between the weight to be supported and the construction and material acting as support. Others concern the scale of the display and that of the material put on view; the congruence of visual grain between the two. The masks in the East Asian section of the Museum of Ethnography in Berlin, for example, are held by metal rods, which themselves rise out of a low pedestal made from small wooden blocks. For similar reasons a fragile metal bowl shown at an exhibition of Celtic Art, which required both protection and lifting to

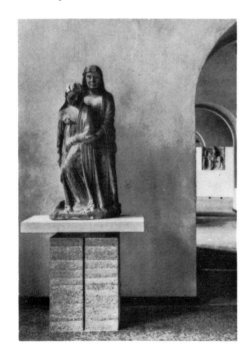

156. Musei Civici, Castelvecchio, Verona. Carlo Scarpa, 1958–61. 14th century sculpture on a concrete pedestal.

255

154

153,162

159

160, 164

156, 165

154

105

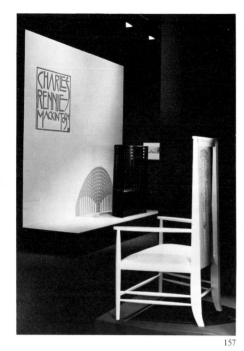

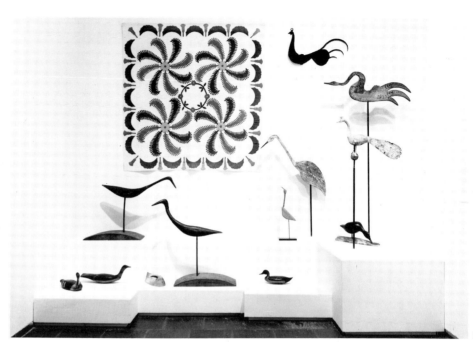

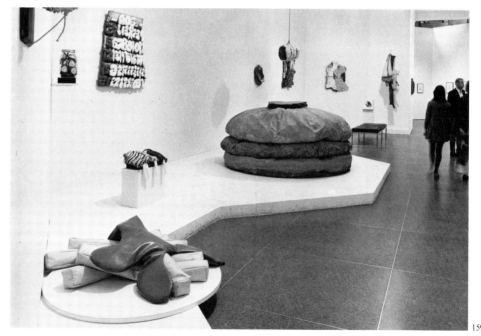

157. *Chairs by Charles R. Mackintosh* exhibition, Museum of Modern Art, New York. Emilio Ambasz, 1974.

158. *American Folk Art* exhibition, Whitney Museum of American Art, New York. Marcel Breuer and Associates, 1974.

159. *Claes Oldenburg* exhibition, Tate Gallery, London. Michael Brawne & Associates, 1970.

about table height, was cradled in a framework of timber rather than placed on a solid pedestal.

Clearly there are no formulas for the design of pedestals or, for that matter, of any other display element within a museum. The work shown tends to have very particular characteristics which always need to be studied and then related to a way of exhibiting which allows the object to speak for itself. The dangers of designing too obtrusively or insufficiently are invariably present and both can visually harm what the visitor has come to see.

160. Museo Correr, Procuratie Nuove, Venice. Carlo Scarpa, 1953–61. Statue of a Venetian Doge on a stone pedestal slotted over an iron support.

161. Römisch-Germanisches Museum, Cologne. Heinz Röcke and Klaus Renner, 1963–74.

162. *Picasso Sculpture* exhibition, Tate Gallery, London. Michael Brawne & Associates, 1967.

163. *American Folk Art* exhibition, Whitney Museum of American Art, New York. Marcel Breuer and Associates, 1974.

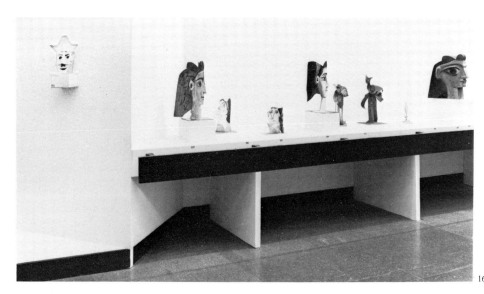

162

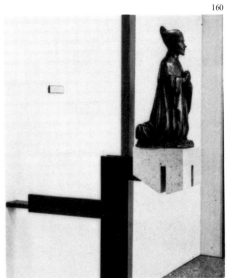

160

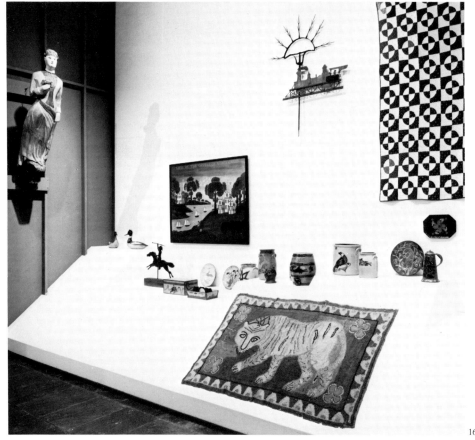

163

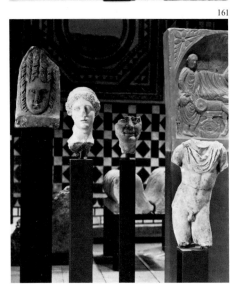

161

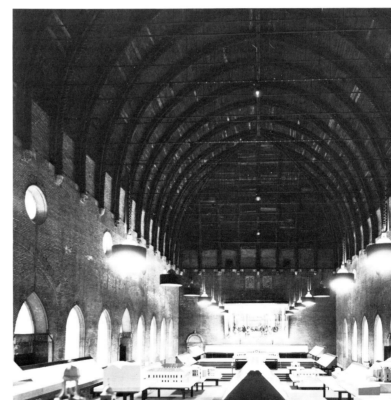

164. Badisches Landesmuseum, Karlsruhe. Dieter Quast, 1959. Statue on teak top fixed to cruciform post bolted to a steel base in the floor.

165. Museu Calouste Gulbenkian, Lisbon. José da França Ribeiro, Alberto Pessoa, Pedro Cid and Ruy Athouguia, 1961–69. Metal sculpture on marble pedestal.

166. Museum für Völkerkunde, Berlin-Dahlem.

167. *Mostra del Palladio* exhibition, Basilica, Vicenza. Franco Albini and Franca Helg with Antonio Piva, 1973.

168. Lock preventing the movement of a horizontally sliding sheet of glass.

169. *The Arts of Islam* exhibition, Hayward Gallery, London. Michael Brawne & Associates, 1976. Section through typical showcase. The fixings of the glass are hidden and the lights can be serviced without opening the case. Key: 1 adjustable light, 2 fabric covered chipboard, 3 metal plate with bolt welded to back, 4 timber handrail.

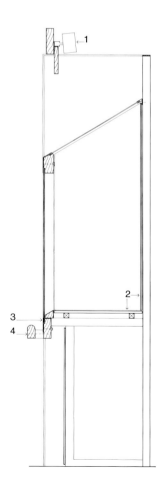

Showcases

Showcases are in a sense miniaturised and protected rooms, they often contain all the elements of a gallery – walls, screens, floor, ceiling, pedestals and services – within the confined format of a partly or entirely glass enclosed box. And their problems are in many ways similar.

Because the showcase is a kind of doll's house room, it not only acts as a safe enclosure for vulnerable objects, but it also mediates in scale between a small exhibit and the bigger space of the gallery. Very particular display methods can be used within the enclosure of a showcase which become the immediate and specific background to the small work being safeguarded behind glass. Looked at in such a way, the showcase need not always be a painful necessity but can become a useful means of display in its own right.

There are three aspects to the protection which a showcase gives and which may make it desirable or necessary to enclose an object within it: theft is made much more difficult since it demands some kind of forcible entry, dust and insects can be excluded or their effect at least minimised and local climatic conditions can be created and monitored much more readily than within a gallery. Each of these will of course depend considerably on the actual design of the showcase. However simply protected an object may be by a glass enclosure, it is at once removed from the temptation of being touched, perhaps even lifted up or handled and then eventually being pocketed. Only very little additional protection by a lock – visible or secret – will greatly increase security. The use of specially 168 heavy or laminated glass which is difficult to break will further increase the degree of protection. So will any arrangement which hides all the fixings of the glass or makes them difficult to reach quickly.

The exclusion of dust and insects will depend on a tight fit between the glass and the other components of the case. This may be particularly difficult to achieve if the showcase has to be adequately ventilated because it includes lighting within it and where it has some kind of movable part, like a sliding or hinged door for access to its interior. Such considerations may lead to a separation between that part of the case which holds the exhibits from the part used for lighting and may also, in special circumstances, suggest the use of mechanical ventilation using a very small air pump and filter. This not only brings in cleaned air but 170–172 maintains a positive air pressure in relation to the gallery and thus reduces the possibility of dust seeping through any cracks.

In less stringent circumstances, it may be adequate to seal all joints extremely well – to have doors protected with mohair pile weather stripping for instance and glass set in neoprene gaskets – and then to deliberately drill some holes for ventilation but to plug these with glass fibre, paper or some other filtering material such as active carbon.

The climatic conditions within a showcase are as a rule likely to be more stable 262 than in the larger volume of a gallery subject to thermal gains and losses through outside walls or sudden air movements from windows or doors. But what is more important is that the air trapped within a case can be modified with little effort because the volume involved is so small. Often this means placing a hygroscopic material in the case which will absorb water vapour and thus reduce the relative humidity. Less frequently it may be necessary to allow some moisture to evaporate from a container in order to raise the relative humidity. In either case because of the small air mass and its relative stability it is easy to measure

the actual temperature and relative humidity of the air to know that the object on display is experiencing very much the same conditions. Small thermometers and hygrometers are often seen in the corner of a showcase.

The stability of the internal environment can be improved by having materials within the case which absorb water vapour, such as wood and fabric and which will then give out moisture when the relative humidity falls. It is important to remember however that the materials within a showcase may react with the chemicals of the object and if the case is tightly sealed, there may be a build up of a pollutant within the case. This has occurred with some felt and silver for instance. Some ventilation is therefore often important (T. Padfield, London Conference, 1967).

Completely airtight cases can be made under exceptional circumstances: the US National Bureau of Standards has made a case from metal and glass in which the Declaration of Independence and the Constitution are kept in an atmosphere of helium and water vapour. A leak detector shows whether any of the extremely carefully detailed joints should have failed. For normal museum use, however, such extreme precautions are not only very costly but often not even convenient since such a case cannot be opened without destroying the seal which has been so laboriously constructed.

Cases have to be opened in order to arrange the display occasionally, to remove objects for study or to be sent away on loan. Because of the need to see the effect of any arrangement and because so often the solid back of cases which are viewed from the front is actually used to hold some of the exhibits, it is highly inadvisable to have this back panel as the means of access. Cases should normally be openable at the front or sides and it should not be necessary to reach over large areas of the display in order to get at an object; it is far too easy to knock over fragile exhibits under such conditions.

170–172. Exhibition of legal costume, Royal Courts of Justice, London. Michael Brawne & Associates in association with Colin St.J. Wilson, 1974. Plan of first gallery, detail of opening doors and section through louvres for clean air units. Key to 170: 1 aluminium covered plinth with space for clean air units, 2 lockable glass doors, 3 slot in removable cover for access to air probe, 4 access cover.

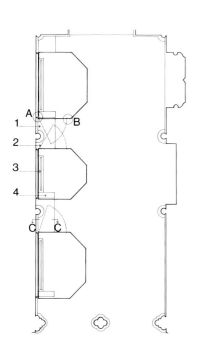

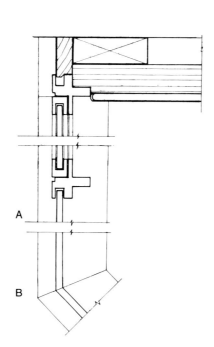

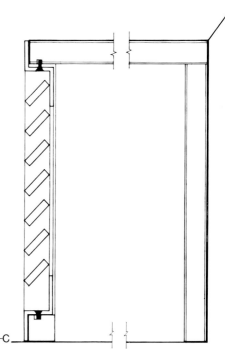

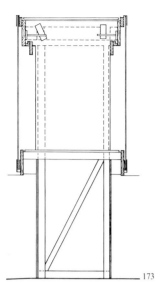

173

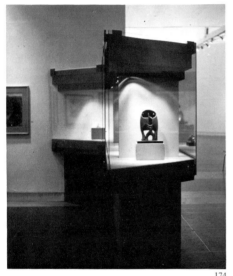

174

175

173, 174. *Henry Moore* exhibition, Tate Gallery, London. Michael Brawne & Associates, 1968. Section through showcase and view of a splayed end.

175. Waterford Glass showroom, Waterford, Ireland. Stefan Buzas and Alan Irvine, 1972. Glass shelves are cantilevered from slots in the back of the case.

The major decision to be made as regards lighting is whether this is to be incorporated within the case or located outside. To a very large extent this will depend on what is shown and the problems of conservation. It was possible to place a group of Henry Moore maquettes in a case which included small spotlights 173, 174 to bring out the sculptural qualities of the bronzes because neither the light nor heat were likely to damage the metal. Many of the objects which were to be shown in the Arts of Islam exhibition on the other hand, were made of organic material – paper, vellum, leather, cotton, wool, silk – and had, therefore, to be displayed under low light levels and many were, moreover, as in the case of bound Korans, sensitive to high temperatures. It was essential to have the light sources outside the case and preferably also individually controllable. Such 169 an arrangement also makes it easy to replace light bulbs during an exhibition without entering the showcase, frequently a very important consideration from the point of view of security. In fact, certain museums will only lend if one of their members of staff is present when the case is sealed or opened.

176. Zoology Museum, University of Cambridge, Cambridge. Arup Associates, 1964–71. Glass shelves supported on brackets cantilevered from an aluminium channel fixed to the wall.

177. Exhibition of national faience from Moravia, Folk Museum, Prague. V. Hora, 1974. Glass shelves supported on metal studs fixed to holes in glass verticals, plate glass enclosures fixed to each other by clips top and bottom.

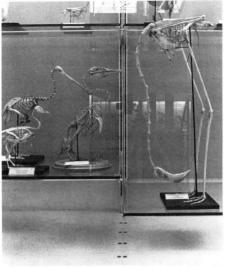
176

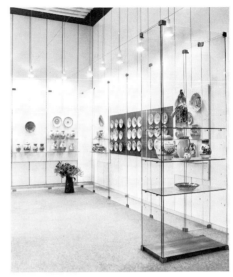
177

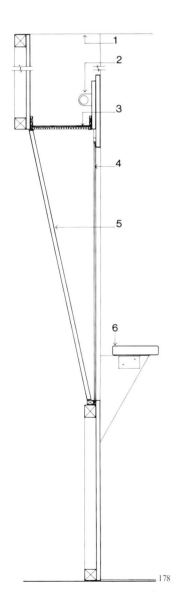
178

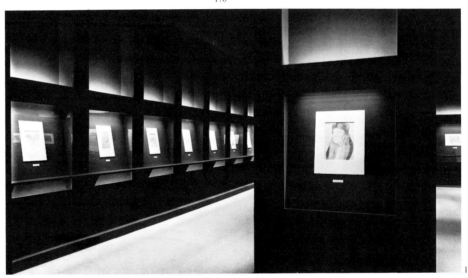
179

178, 179. Old masters' drawings section, *Europalia* exhibition, Brussels. Stefan Buzas and Alan Irvine, 1973. Section through wall case and view of a gallery. Key to 178: 1 black cloth ceiling, 2 fluorescent tube, 3 ultra-violet filter and egg crate, 4 polycarbonate glazing sheet, 5 felt covered panel, 6 felt covered handrail.

180. *The Arts of Islam* exhibition, Hayward Gallery, London. Michael Brawne & Associates, 1976. This is the same construction as that shown in 169 except that the bottom of the case has a diffusing glass surface with fluorescent lights below.

180

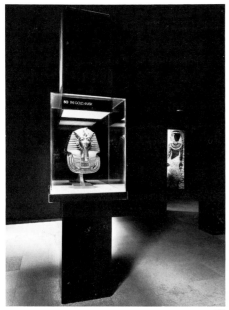

181

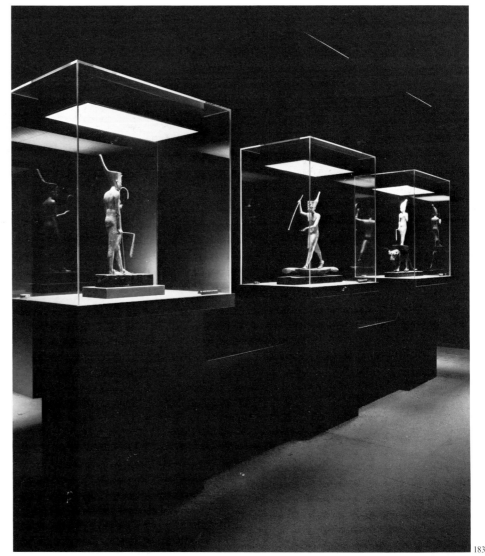

183

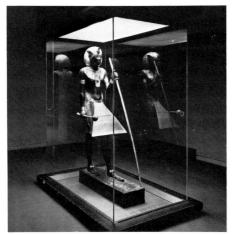

182

181–183. *Treasures of Tutankhamun* exhibition, British Museum, London. Margaret Hall, 1972.

184. *The Genius of China* exhibition, Royal Academy, London. Robin Wade Design Associates, 1973. Showcases of 10 mm clear acrylic sheet bonded at the edges.

184

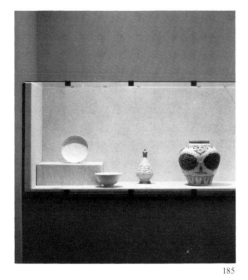

185

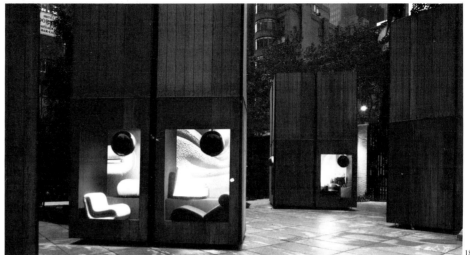

187

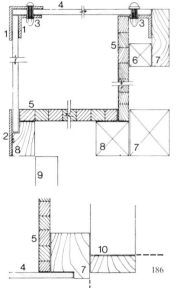

186

188

185, 186. *The Ceramic Art of China* exhibition, Victoria and Albert Museum, London. Michael Brawne & Associates, 1971. View of showcase and section. Key to 186: 1 ms angle painted, 2 ms plate fixed with non-reversible screws to softwood frame and painted, 3 unslotted dome-headed bolts with acorn nuts, 4 plate glass, 5 chipboard covered with fabric, 6 softwood section to carry lining, 7 softwood section screwed to screen, 8 softwood framing, 9 enclosure below showcase covered in fabric, 10 screen with softwood lipping.

187, 188. *Italy: The New Domestic Landscape* exhibition, Museum of Modern Art, New York. Emilio Ambasz, 1972. An outdoor exhibition in which the boxes were both display cases and shipping containers.

The problems of lighting the showcase have many of the attributes found in larger spaces and are discussed in the section on lightin. Several of these however make a direct impact on the design of the case itself. A typical problem, for example, is the need to bring light onto objects which are arranged vertically within a case and which thus need to be placed on glass shelves if the light comes from the top or which need to be lit from the side if this is possible. Obviously this will only work if the case is not too wide and if the light source is shielded from view. In certain special instances, as in the case of the display of glass, it may be advantageous to light from below.

Even when all these stringent and often conflicting requirements are taken into account, visual choices still remain open and the design will be guided by personal preferences and the intentions of the exhibition as a whole. For instance, the cases may be part of some integrated design of screens and light baffles in which the cases and their associated surfaces make the display setting or the cases may be more isolated, perhaps free-standing elements like pieces of furniture

189. *The Shakers* exhibition. 1975. A travelling exhibition assembled in different localities seen here at the Victoria and Albert Museum, London.

190. Philip L. Goodwin Galleries for Architecture and Design, Museum of Modern Art, New York. Arthur Drexler, 1964. Wall cases with sliding glass doors.

191. *Ancient Art from Afghanistan* exhibition, Royal Academy, London. Michael Brawne & Associates, 1967.

which at times however can become so important that they are again the architectural elements which control space, as in the Museum of Modern Art exhibition of Italian design held in New York in 1972. 193 187, 188

An important and early decision to be made is whether the case is to be glazed on all four sides or whether one or more sides are to be opaque. To some extent of course this depends on whether an object has to be seen in the round or not. Even so, quite a considerable number of sculptural objects – ceramics, metal bowls, model trains, natural specimens – are sufficiently symmetrical not to need seeing completely from all sides and a case glazed on three sides may be entirely adequate. This has the very great advantage that the solid side could be used structurally and that, moreover, one side can be controlled as regards 191 colour and surface and can thus be chosen as the preferred background. It also means that from at least one point of view the object can be seen against this selected backdrop rather than against faces and moving figures; for many people often a very disturbing situation.

192, 193. Museum of Glass and Ceramics, Tehran. Hans Hollein with Franz Madl and Gerhard Köttig, 1977–79. Axonometric of ground floor and view of free-standing showcases also acting as lighting columns; the display is kept away from walls and ceilings so that these remain in their original state.

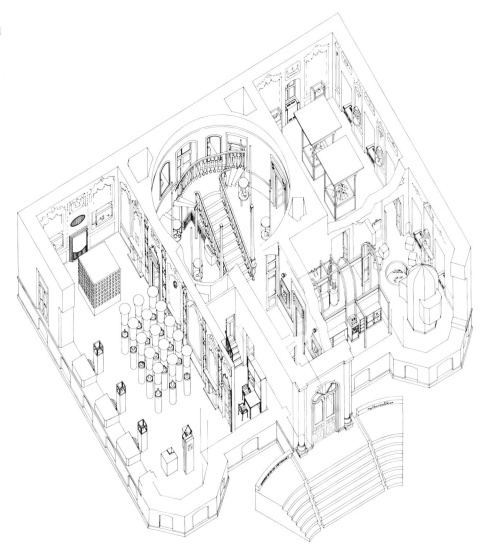

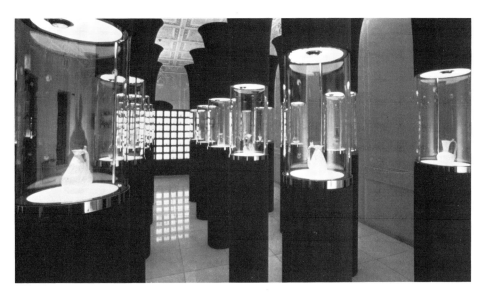

97

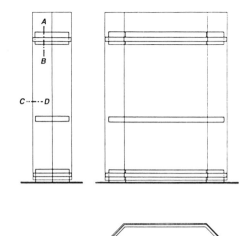

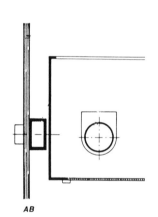

AB

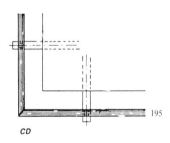

CD

194

195

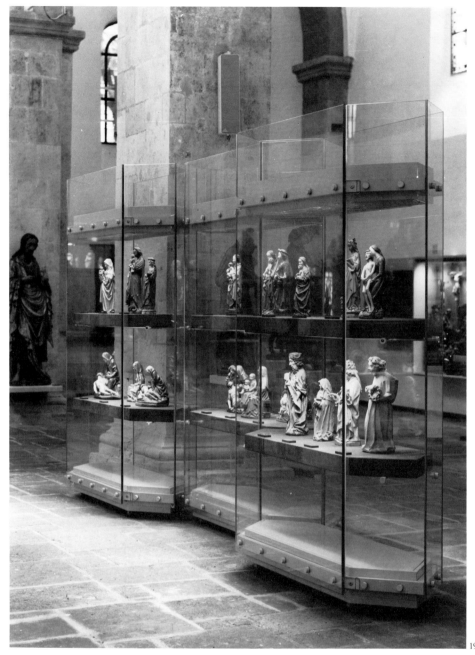

196

194–198. Schnütgen-Museum, Cologne. Heinz Micheel, 1979.
194–196. Hexagonal showcases in which the glass sides are used structurally. The details (195) show the lighting unit and the security glass sides with metal dowels to support adjustable shelves.
197. Wall hung cases in which the adjustable shelves also include a fluorescent tube shining on the objects below; the rear of the shelf opens into a hole in the back wall for ventilation.
198. Sliding racks for the display of textiles which should have the minimum exposure to light.

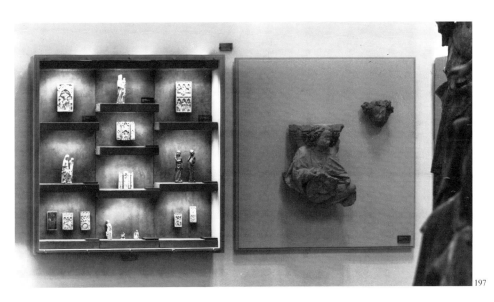

197

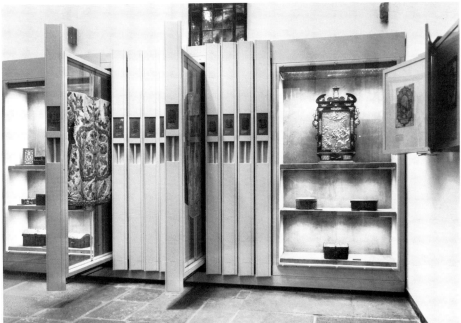

198

Preservation and Communication

Object and Environment

All museums are involved in preserving and communicating and the two roles are often in conflict. Both are equally important and both make their impact on design.

Preservation and conservation are in a sense private museum functions for the public benefit. The kind of spaces in which they occur are akin to workshops and laboratories and these are, for very good practical reasons, rarely seen by the public. Occasionally a conservation department may put its work on special 199, 200 display, but this is not the same thing as placing its laboratories on the normal route of the museum visitor. The problems of maintaining the accumulated artifacts of the past are of course very much a highly specialist concern with its own literature which need not be taken up in this discussion which is primarily concerned with display. References to current problems will be found in Unesco's quarterly *Museum* and other publications, particularly those of many national museum associations or institutes.

The space requirements of conservation departments can be extensive and are often exacting in the demand for daylight and the provision of services. These were described in diagrammatic form in *The New Museum* and have probably not changed greatly since its publication (Michael Brawne, 1965). It is a zone in which specialist and detailed advice and consultation with the potential users is absolutely crucial. It is also a zone which can on no account be neglected and which with other service areas – storage, exhibition assembly, packing and unpacking, loading, staff facilities and offices – is likely to take up a great deal more space than is at first obvious. Of the five floors of the Kunsthaus in Zurich, for example, almost the entire two lower levels are taken up by servant spaces.

Conservation has of course also a very immediate impact on the actual methods of display and particularly on lighting and the repercussions of some of these have already been described. Clearly any responsible attitude to exhibiting valuable and often irreplaceable objects must make certain that they suffer the least possible harm through being put on view and yet ensure that they are seen and properly understood by the visitor.

The relation between the museum environment and its effect on vulnerable objects is always complex but vital to any understanding of museum architecture. It has already been discussed briefly in a number of previous sections in connection with specific problems. The fullest discussion can be found in what is probably the most authorative textbook and to which frequent reference will be made, Garry Thomson's *The Museum Environment*. This is the first volume in a series on *Conservation in the Arts, Archaeology and Architecture* and deals with both the scientific background and the actual damaging effects of light, humidity and air pollution. Quite precise numerical limits are set for certain kinds of exposure in the case of a range of museum objects. The interpretation of these limits must however always be less precise and their translation into particular building forms invariably allows a number of alternative solutions; the demands of conservation do not produce a single recipe for museum design.

Any attitude to the conservation of works of art or of any other irreplaceable object must in the last resort depend on certain cultural, perhaps even moral, responsibilities which we assume. The dilemma is most often between current and future use; to what extent are we entitled to walk across an easily damaged

199, 200. *The Workings of the Gallery*, 150th anniversary exhibition, National Gallery, London. Christopher Dean, 1974. Mock-up of old conservation studio and present-day measuring instruments.

hillside in large numbers or place a carpet below a window in an apparently normal position within a room setting or run a delicate old piece of machinery so that its movement can be demonstrated, if these actions will prevent future enjoyment? The dichotomy between these values need not, however, always be as sharp as it may at first seem and in many cases it can actually be resolved by means which involve the design of the building and especially of the elements affecting the objects on display. Our visual acuity will for instance not only depend on actual light levels and therefore on the amount of possibly damaging energy reaching an object but also on the quality of light as sensed through the absence of glare, the range of illumination within a space and our adaptation to it. In a quite different way it may be possible to reveal the actions of a machine by showing a film of it working without necessarily having the machine itself running throughout the time the museum is open. What may at first therefore seem to be extremely difficult choices between impossible alternatives might, in fact, frequently be resolved through design, especially if there is an awareness of the seriousness of the problem at the outset. A not entirely uncharacteristic, even if extreme, example may illustrate the point. A carpet lying on the floor below a south facing window in England or Northern France will in a typical year be exposed to about 1300 million lux hours; the same carpet in a room lit at a level of 50 lux with the light switched on only as a visitor enters but with a permanent security light of 10 lux, will in a year receive something like one million lux hours (Garry Thomson, 1978, p. 39). In other words it will take over a thousand years longer for the carpet to fade the same amount; a disparity which cannot be easily ignored.

Lighting

Museum going must always be a primarily visual experience; hearing or the sense of touch, even if relevant, are likely to play a secondary role. Light is therefore a vital part of any design; never, however, the only part as was assumed in the design of some buildings during the 1950's to the detriment of the experience as a whole. The need for light and its control also stems from the fact that, unlike the projected image in the cinema, we are in a museum, as a rule, looking at objects which are not themselves luminous and which must therefore be lit in a way dependent on their characteristics; the need is thus not just for light but for appropriate light.

What constitutes appropriate light is for a great category of museum exhibits, however, not just the outcome of considering how much light is needed in order to see but also the result of taking into account the damaging effect of light energy. This is true both of natural and artificial light and affects particularly those objects listed in the following table:

Recommended Maximum Illuminances

Exhibits	Maximum illuminance
Oil and tempera paintings, undyed leather, horn, bone and ivory, oriental lacquer	150 lux
Objects specially sensitive to light, such as textiles, costumes, watercolours, tapestries, prints and drawings, manuscripts, miniatures, paintings in distemper media, wallpapers, gouache, dyed leather. Most natural history exhibits, including botanical specimens, fur and feathers	50 lux

Notes

1. Although objects insensitive to light (e.g. metal, stone, glass, ceramics, jewellery, enamel) and objects in which colour change is not of high importance (e.g. wood) may be illuminated at higher levels, it is rarely necessary to exceed 300 lux. Large differences in illuminance between rooms give rise to adaptation difficulties.
2. Dust and dirt on lamp and reflectors reduce illuminance. Also the light output drops by about 25% during the life of the fluorescent lamp. Therefore in taking measurements under new installations up to +50% allowance can be made.
3. Lighting for restoration, technical examination and photography is not limited by the above Table. 1000 lux is a reasonable upper limit for those relatively brief periods of exposure.

Museum design must, if it is to be responsible to the present and the future, take account of both seeing and conservation.

The amount of light needed to see most exhibits is a great deal less than that required to perform many tasks for which tests have been carried out; lighting levels should therefore not be confused with those recommended for offices, factories or laboratories. There is no need to co-ordinate muscular movement with seeing in order to perform a task; the amount of light needed in order to sew a black cloth with a black thread is quite different from that required to look at a picture or a model boat or a natural history specimen. This difference is

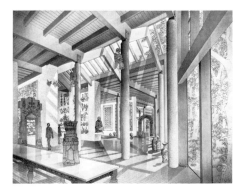

201, 202. Museum for the Burrell Collection, Glasgow. Barry Gasson, 1972–82. An attempt in a part of the museum to make natural lighting and a sense of the outdoors relate directly to exhibits.

clearly recognised in Thomson's table which shows very much higher light levels in conservation studios (Note 3) where delicate tasks have in fact to be carried out.

Museum design has traditionally paid a good deal of attention to overhead lighting through skylights in order to create reasonably even natural light; to some extent it tried to recreate the north light glazing of the painter's studio even when the exhibits were not pictures. Natural light is, however, a variable and certainly difficult to control source. This is especially so when low levels such as 50 lux are thought necessary. Only specifically designed artificial lighting is likely to prove satisfactory in such instances. In addition to this most museums are likely to be open in the evening and certainly on dull winter afternoons when artificial light sources will be needed. It is extremely probable, therefore, that museum design will have to consider both daylight and artificial light and frequently the two in combination.

We consider daylight to be natural, to be the source which is in some sense correct when it comes to seeing colours properly and which in some way can be assumed to be the touchstone against which we gauge other light sources. It could also however be claimed that all light emitted by a hot body like the sun is 'natural' and that a glowing tungsten filament lamp is thus also such a natural light source. To some extent this is true since both sources, unlike a fluorescent tube, have relatively smooth curves for the distribution of the power of different wavelengths within the visible spectrum. It is also true that the eye, unlike a colour film, adapts to both these sources and recognises the colour 'white', for example, in each situation despite the fact that the spectral curves of the light reflected for a white surface would differ between one light source and another.

The eye and brain are a complex organisation also highly adaptable to wide ranges of light levels: at midday in summer in London a horizontal surface will receive over 60000 lux while in the evening when we are just able to make out colours the light level reaches only $^{1}/_{10}$ lux.

Some Correlation Colour Temperatures
(from: Garry Thomson, *The Museum Environment,* London, 1978)

	CCT
Clear blue sky	15000–30000 K
Overcast sky	6500
Zenith sun (in clear sky)	6200
Sun 10° above horizon (in clear sky)	4100
Tungsten halogen lamp	up to 3500
Normal gas-filled tungsten lamp	2700–3100

Note
The term Colour Temperature should strictly be confined to black body radiators, and the term Correlated Colour Temperature used for all other sources.

Because the eye and brain together function effectively through such an extended range of illuminance and of colour temperature, what is as a rule significant in our ability to perceive objects is not so much any absolute level but the

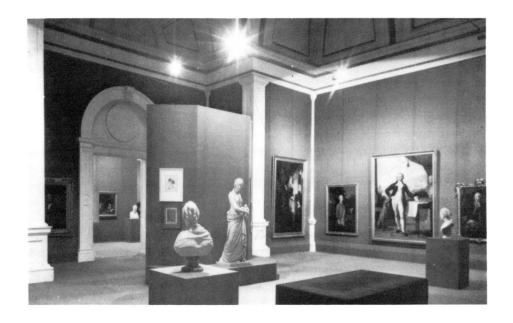

203. *The Age of Neo-Classicism* exhibition, Royal Academy, London. Michael Brawne & Associates, 1972. Brown walls, overhead tungsten lighting.

qualitative aspect of light and especially the relation between sources – between bright and dark areas or between light of different spectral distribution. That this should be so is extremely fortunate for museum lighting, when conservation plays an important role, as it becomes feasible to make the apparently low levels visually acceptable. A number of aspects become as a result immediately important: adaptation, glare control, the relative brightness of objects within the field of vision and the colour temperature of the source.

Adaptation is our physiological ability to adjust to different light levels by altering the size of our pupil; adjusting like a camera the size of the lens opening. Anyone who has stepped from a bright sunlit square into a dark church is immediately aware of the time it takes before detail becomes visible in what at first seems like a grossly underlit building. In a museum we similarly need time to adapt to a level of 50 lux and this therefore implies that there are no rapid changes along the route between, say, brilliantly lit sculpture galleries and highly controlled spaces for watercolours. Equally, a continual alternation between unshielded views of the outside and weakly lit walls indoors will make adaptation difficult and will thus make it harder to see objects on the walls; we are likely to complain of inadequate illumination of the exhibits not because it is impossible to see detail at such a level but because of the context in which we have to look at the display.

Glare is the often uncomfortable feeling which we experience when we look at a very bright area when the surrounding surfaces are much less bright. It is a feeling moreover which reduces our ability to see both detail and colour clearly; our characteristic action is to try and obscure the bright area as when we put up our hand to shade our eyes from the sun or a naked light bulb. An object placed at the side or below a bright window will be much less distinct if looked at while the bright source is also within the field vision. The object will also look underlit. If the source is shielded – with venetian blinds or a curtain, for instance – or if the object has additional light directed on it, the exhibit will become more 'visible'. In the first case a lowering of the level of

204–207. Dorset County Museum, Dorchester. Michael Brawne & Associates, 1971. Plan and views of extension. A sense of daylight but actual lighting by tungsten fittings in triangular coffers.

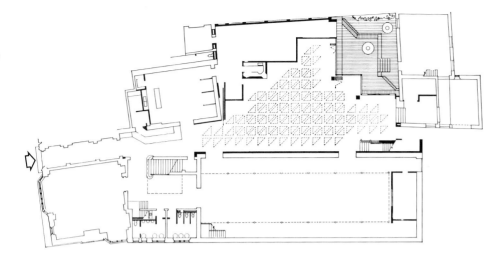

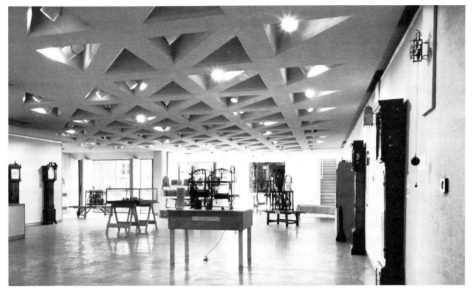

208. Civiche Raccolte d'Arte, Castello Sforzesco, Milan. Studio Architetti BBPR, 1954–64. The sockets in the wall are for the attachment of sculpture.

illuminance in fact produces an improvement in our ability to see. It is clearly this kind of action which is most often suitable in museums.

The relation between the brightness of areas also seems significant at much lower ranges of contrast. This is particularly true at the lower levels of lighting demanded by conservation. Very evenly lit rooms appear to look particularly dim when the level goes below the 100–150 lux range. Slight variations – a sense of dappled light within a space – give the impression of brightness because we presumably recognise the relative differences and if the objects on display are in the brightest area then we attach that sense of brightness to the display lighting. What matters, in view of our ability to see at remarkably low levels of light, is the relative brightness rather than the actual level measured in lux.

The range between the levels of light must not however be so great that we have a sense of being in a dark space looking at brilliantly lit objects. The kind of display which places dramatically illuminated exhibits in a black room can never create the feeling of an illuminated space; only of dramatically highlighted incidents.

The effect of colour temperature, the sense of 'coldness' or 'warmth' of light, on the perception of brightness is more debatable but suggests that we find light at the red end of the spectrum more acceptable at very low levels. Or to put it another way, that for equal levels of illumination 'warm' light will appear brighter than 'cool' light; that we will find candlelight brighter and pleasanter, for example, than light from a daylight fluorescent tube giving the same performance in lux. This clearly suggests that when lighting vulnerable exhibits – watercolours, stuffed birds, textiles – it is advisable to use tungsten sources and that if fluorescent tubes must be used their colour temperature ought to be around 3000 K.

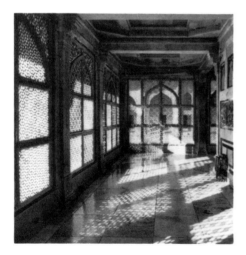

209. The Tomb of Salim Chishti, Fatehpur Sikri, India. Late 16th century. Window screen of pierced marble.

210. Galleria di Palazzo Bianco, Genoa. Franco Albini, 1950/51.

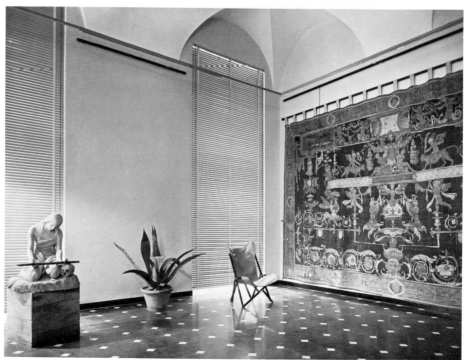

211. Side lighting, normally from the north (south in the southern hemisphere), which can be controlled by louvres, blinds or shutters.

212. Skylight producing primarily downward light which can however be deflected by baffles; the light can be controlled by manual or automatic devices such as louvres or blinds.

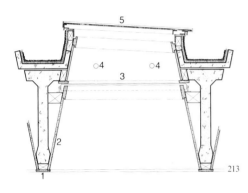

Each of these considerations has direct design implications. Adaptation and glare control, for example, both suggest that the view of a courtyard should be shielded, that the paving of the court should not be highly light reflective and that a deep courtyard cutting out a view of the sky from most positions is likely to be preferable to one revealing large areas of bright cloud or sun. The traditional window with white deep splayed reveals grades the brightness from the opening to the wall and thus reduces the effect of glare. In more extreme lighting conditions the pierced screen of Moghul architecture, for instance, performs the same task. The venetian blind or a series of vertical louvres not only reduce the amount of light but equally reduce the contrast between the source and the adjacent surfaces. All these devices are, significantly, aimed at making seeing more comfortable yet in effect reduce the levels of illuminance.

These particular problems become even more acute in the case of overhead skylights. These are the most frequent way of lighting galleries since they are able to provide the most even illumination of walls. The lighting geometry is at its simplest: a linear source of overhead light with a wall running parallel to that source. A simple skylight placed centrally in a gallery is able to light the two walls on either side but is clearly less effective as far as the two end walls are concerned. If the position of the walls or screens is not known, as in a gallery for temporary exhibitions, the linear skylight ceases to be an effective light source. The normal alternative is to produce a coffered ceiling, in a sense a series of point skylights. As these however no longer direct the light sideways but downwards, the floor rather than the wall will be the brightest area in the room.

The shielding of skylights and their optimum geometry has concerned architects over a considerable period. Historically two basic principles have been employed: either producing a secondary diffusing layer below the skylight or creating a

213. Commonwealth Institute, London. Robert Matthews Johnson-Marshall and Partners, 1960–62. Section through skylight. Key: 1 softwood strip, with a recess along the centre of each length to take top of screen post, 2 plasterboard, 3 blackout roller blind, 4 fluorescent fittings, 5 glass in aluminium frame.

214. Duveen Gallery, Tate Gallery, London. Section. Arrangement based on investigations carried out by the National Physical Laboratory, 1927. Key: 1 glazing, 2 reflector screen, 3 viewing area.

215. Haags Gemeentemuseum. J.C. Eymers, 1932–36. Two alternative designs for top lighting. Key: 1 obscured glass rooflight, 2 adjustable louvres, 3 opal glass, 4 dense white glass velarium, 5 artificial lights, 6 prismatic glass.

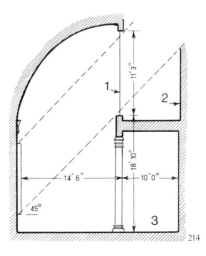

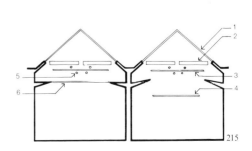

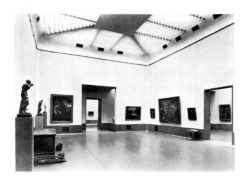

216. Museum Boymans-van Beuningen, Rotterdam. A. van der Steur, 1931–35. The artificial lighting is positioned between the louvres and the skylight.

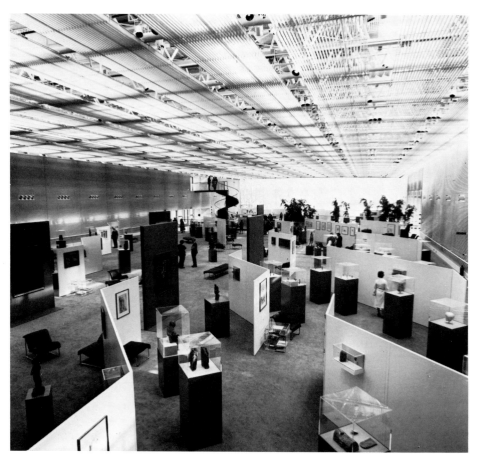

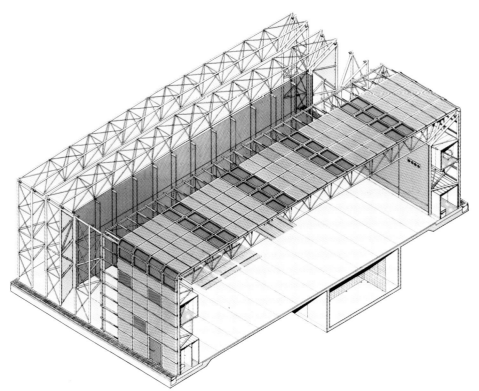

217, 218. Sainsbury Centre for the Visual Arts, University of East Anglia, Norwich. Foster Associates, 1977. View of main gallery and axonometric section; natural and artificial lighting occurs above the adjustable perforated aluminium louvres. (A section is shown in 73.)

solid central area with the skylight as it were hidden from most viewpoints occupied by the gallery visitor. Thus Edward Middleton Barry's design of 1872–77 for part of the National Gallery in London shows a laylight of diffusing glass below the skylight with lines of open grillework in the laylight to allow for ventilation while the design for the addition to the Tate Gallery dating from places the skylights as a run of high level windows above the solid ceiling plane.

Later designs have used variations on these two themes: both the Museum Boymans-van Beuningen of 1935 in Rotterdam and the Sainsbury Centre for Visual Arts at the University of East Anglia at Norwich of 1978 use a suspended layer

216
217, 218

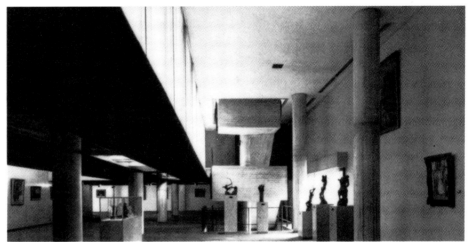

219. New Galleries, Birmingham City Museum and Art Gallery. Birmingham City Architect (A.G. Sheppard Fidler with John Bickerdike), 1957. Key: 1 existing roof light, 2 metal vane, 3 aluminium egg crate.

220. National Museum of Western Art, Tokyo. Le Corbusier, 1959.

of diffusing louvres; both Le Corbusier's lines of lighting galleries at Tokyo in his design of 1959 and the Birmingham City Architect's adaptation of the Birmingham Art Gallery in 1957 produce an opaque ceiling area surrounded by light coming in from high level.

220
219

The problem with both variations is that they do not reveal the source of light the way in which the simple skylight of an artist's studio or of an old gallery, only occasionally obscured with a cloth blind, is able to do. We feel this absence perhaps particularly acutely because it is often hard to tell whether the light behind the diffusing laylight is a series of well controlled fluorescent tubes or actual daylight. There is also often the sense of an anonymous space as if it were at the foot of a lightwell; we perhaps feel cheated of understanding the position and nature of the light.

250

Some recent attempts have been made to solve this difficulty by either reflecting the light from a surface within the gallery or of adapting the simple skylight by using deep reveals or large baffles. Both notions apply the traditional devices of the window to an overhead light. Both methods also owe a great deal to the ways of controlling daylight which were worked out by the architects of the Baroque and especially by those of Central Europe.

221. Fundación Joan Miró, Barcelona. Sert, Jackson and Associates, 1974. Half-barrel vaults with vertical glazing placed on either side and above ribs with small barrel vaults; the bottom of each rib has a groove for recessed lighting track.

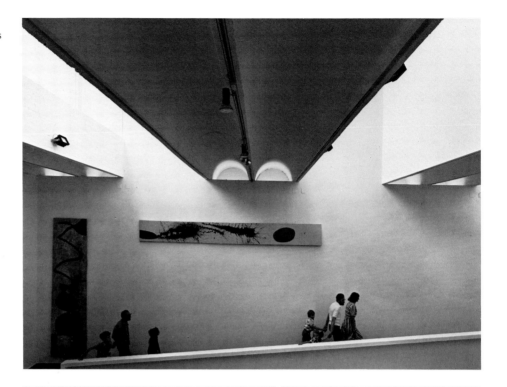

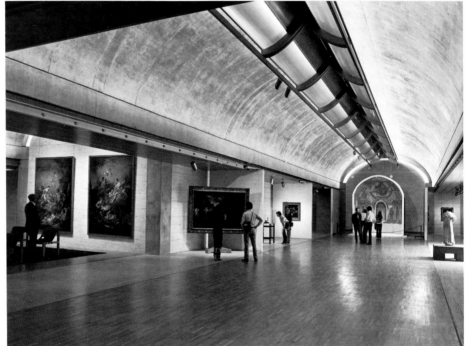

222, 223. Kimbell Art Museum, Fort Worth, Texas. Louis Kahn, 1972. Perforated metal diffusers spread daylight below an opening in the crown of the vault.

Sert's curved concrete vaults at the Fondation Maeght at Saint-Paul de Vence and his similar later Fundación Joan Miró in Barcelona follow a well established mediterranean tradition of barrel vaulting. These are combined with lines of overhead glazing which throw direct light on the curved surfaces. These in turn reflect daylight into the room. The source is visible but not obtrusive and the light has not gone through any diffusing layers to be modified. Kahn also uses a barrel vault at the Kimbell Art Museum but splits it at the crown in order to suffuse both sides of the vault with light. Alvar and Elissa Aalto and Jean-Jacques Baruël in the Museum of Art at Aalborg suspend a curved ceiling baffle below a monitor roof light. The baffle reflects the light but still allows the glazing to be seen occasionally. There is even a deliberate decision to let the sun strike the floor for brief periods so that the changing and varied nature of daylight can be experienced as directly as possible. 221 222, 223 224 125

Modifications to the traditional north-facing sloping glazing found in so many roofs have often the same aims in mind. The deep aluminium fins placed below the skylights in W.G. Quist's addition to the Rijksmuseum Kröller-Müller at Otterlo in Holland reflect the light as well as obscure the glass from many positions in the gallery. 225

224. Nordjyllands Kunstmuseum, Aalborg. Elissa and Alvar Aalto and Jean-Jacques Baruël, 1958–72. Gallery for temporary exhibitions.

225. Extension to the Rijksmuseum Kröller-Müller, Otterlo. W.G. Quist, 1971.

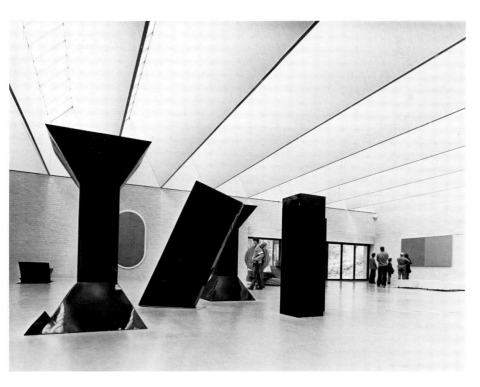

226. Conversion of the Cooper Art Gallery, Barnsley. Michael Brawne & Associates, 1980.

227. Greek and Roman Galleries, British Museum, London. Russell and Goodden, 1968.

228. Different forms of incandescent lamps. Left: domestic bulb; centre: PAR (parabolic) sealed spot or flood lamp; right: ISL (internally silvered) lamp with a diffuse beam; below: strip light.

Some conversions of existing galleries with central skylights have also tried to keep the means of control as simple as possible so as to maintain a sense of natural light. Venetian blinds placed immediately below the glass are an alternative to the cloth blind on rollers and allow for more control. They preserve the proportion of the original space. Often, however, the room appears to be too tall for present day ideas of exhibiting all objects close to eye level height. Large suspended vertical planes at right angles to the direction of the skylight as in the Graeco-Roman galleries of the British Museum cut off upward vision, scatter the light and, moreover, suggest a new lower ceiling plane at the base of the baffle. 226 227

None of these solutions can in any way be described as definitive. They are always part of our general way of looking at architecture. The control of light and especially of daylight is so deeply and essentially embedded in the making of architecture, that there will always be new adaptations as well as changeable notions on the appropriate means of manipulating those parts of a building which let in the light.

Quantitatively the problems of artificial light are, as a rule, different to those of daylight; qualitatively they are very much the same. Occasionally even they are more acute because a point source may, for example, produce quite exceptional glare. Perhaps the great difference, however, is that in the case of artificial light it is possible to choose the power and colour temperature of the source as well as its shape and immediate enclosure. As a result there is a tendency to control daylight by means which involve least parts of the building while artificial light is simply varied by the choice of the fitting itself; daylight thus becomes part of the architectural concept, artificial light very often a later and less permanent adjunct.

The range of choice is determined by the state of technology and currently the lamps most applicable to museum use are tungsten, tungsten halogen and fluorescent.

The incandescent lamp in which a tungsten filament is heated to around 2700 °C by an electric current is the cheapest and most readily available of all the lamps. It comes in a number of different forms and at various wattages. Because of its shape, the tungsten bulb can be placed in a fitting which can become a point source with a cone of light determined by the design of the housing of the lamp. The fitting itself can be rotated so that light can be directed at an object. Such directional light will provide modelling or will allow only a given area to be lit. 228 232

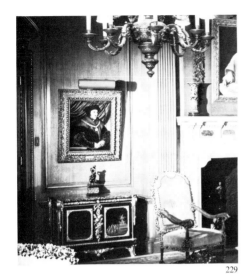

229

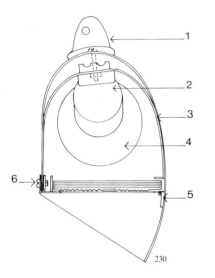

230

A number of tungsten bulbs can in some cases be combined within a fitting and the wattage of the lamp can also be selected so as to provide the precise amount of light needed for a particular situation. The ultra-violet component of the lamp is low so that normally a filter is not needed. These attributes make incandescent sources highly versatile. Their disadvantage is a high heat output and an efficiency which is lower than that of fluorescent tubes. More electricity will thus be consumed to produce the same amount of light.

The tungsten halogen lamp is a short linear bulb, more efficient than the ordinary tungsten bulb, producing somewhat whiter light. It is as a result a powerful source often used for small scale flood lighting or general outdoor illumination. In the museum it can light a large part of a wall from a distance. Its ultra-violet component is high and the fitting must include a heat-resistant glass filter when UV can in any way cause damage. 236

The normal fluorescent lamp is a linear source consisting of a glass tube which has the inside coated with a powder and the tube filled with mercury vapour and argon. When electricity is passed through a tungsten wire electrode at the ends of the tube, the radiation emitted by the mercury is absorbed by the phosphor powder and re-emitted as visible light. The colour temperature of this light can be close to that of an overcast sky, about 6 500 K, or as red as that of a tungsten lamp at 3 000 K, depending on the chemical composition of the materials used. This ability to vary the degree to which the artificial light will seem 'blue' or 'red' is an important feature of fluorescent lighting. 237

229. Frick Collection, New York.

230. Section through the picture lighting units placed above the paintings shown in 229. Key: 1 swivel mounting bracket, 2 angular porcelain socket, 3 polished reflector, 4 40 watt bulb, 5 hinged lens door, 6 door screws.

231. J. Paul Getty Museum, Malibu, California. A large number of very small tungsten fittings is partly recessed in the ceiling.

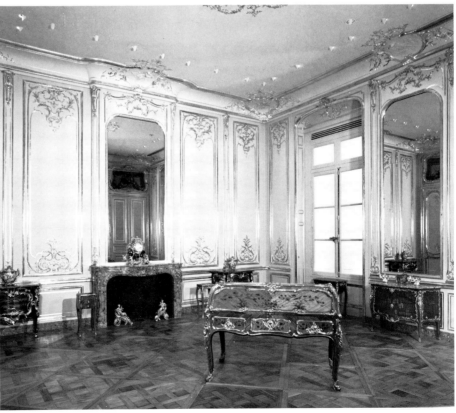

231

150W PAR 38
Spot 15° **Flood 40°**

Lux	Lux	m
7300	2650	1
3250	1180	
1830	660	2
1170	430	
810	300	3
600	220	
460	170	4

2 1 m 1 2

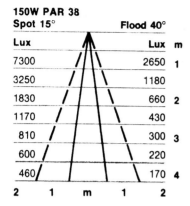

21W-12V automobile SCC
8°

Lux	m
3850	1
1710	
960	2
620	
430	3
315	
240	4

2 1 m 1 2 232

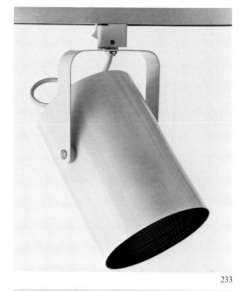

233

234

235

236

232. Light distribution and size of beam for a 150 W PAR bulb in the fitting shown in 233 and for a 21 W–12 V lamp in the fitting shown in 235; lux values are those at the centre of the beam, at the cone edge they are 50% of centre values.

233. Adjustable drum housing for tungsten bulbs (*Multigroove* of Concord). The bulb is well recessed and shielded from most view points.

234. Adjustable fitting giving an elliptical shaped beam with a 300 W PAR 56 bulb for large installations.

235. Miniature high intensity low voltage narrow beam spotlight with a built-in transformer.

236. 'Wallwashing' tungsten halogen fitting with a 300 W linear bulb.

The ultra-violet component of fluorescent tubes is excessive for many museum uses and the lamps will require a filter. So far only one lamp, Philips 37, is available which has such a small component that a filter is not needed in most circumstances. Because of its much lower heat emission, the fluorescent tube becomes useful where this is critical, such as within or near showcases. Heat is however produced by the control equipment inevitably associated with a fluorescent lamp and this equipment should therefore be placed outside the space where heat may cause damage.

The usual fluorescent lamp is best suited to provide general diffuse light. The fittings associated with it may direct the light to a certain extent but will never localise light to the same degree as a tungsten point source. Because of their ability to provide such diffuse light efficiently, fluorescent lamps are the normal source of illumination behind a laylight or an egg crate when an attempt is being made to provide general light or to duplicate daylight. 238

A new development in fluorescent lamp design has created a small bulb, very like the domestic tungsten bulb, which fits into ordinary lampholders. These bulbs, such as Philips SL, provide considerable energy savings and have a service life of about 5000 hours. Their colour temperature is about 2700 K. They are likely to make a considerable impact on the design of fittings.

237. Section through a typical fluorescent bulb. Key: 1 tungsten-wire electrode, 2 phosphor (fluorescent powder), 3 mercury vapour and argon.

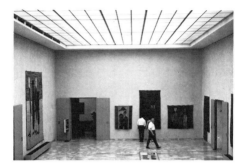

238. Staatsgalerie, Stuttgart. Gallery with laylight.

A great deal of museum lighting involves the lighting of walls or screens for it is on these vertical surfaces that so many exhibits are displayed. The six examples from Erco show the effect of different light fittings on a wall 3 m (10′) high and 6 m (20′) long with a reflectance value of 0.5. In every case the average vertical illuminance is given. Lower values but with very much the same distribution could be achieved by connecting these fittings to a dimmer. It ought however to be remembered that at very low light levels, probably below 50 lux and certainly below 30 lux, it becomes difficult to recognise colour easily and correctly. 239–250

Recent and as yet unpublished work by David Loe at University College, London suggests that a high proportion of museum visitors prefer some slight unevenness of lighting both on the wall and between the wall and the rest of the room. Such an effect can, as a rule, be achieved with the fittings shown in these illustrations.

Fluorescent fittings fitted below the ceiling and angled towards the wall would produce an effect which would be close to that of the last illustration; unevenness of lighting is, however, very much more difficult to reproduce. The tubes considered most acceptable for museum use, such as Thorn Kolor-rite and Philips 84, have a colour temperature of 4000° K and are thus slightly bluer (cooler) than tungsten sources.

In the case of tungsten lighting in particular it is important to consider that objects may not only be damaged by light energy but also by the radiant heat emitted by such lamps.

Most museums and galleries are open when daylight is inadequate and are thus necessarily faced with installing artificial light. The issue whether natural light should be provided as well is thus immediately posed. The desire to exclude daylight will be reinforced on capital cost grounds since windows or skylights are expensive and also increase the load on any heating and cooling system. In addition to this, daylight is much more difficult to control if lighting levels are to be kept below 150 lux.

Yet despite these difficulties the desire to provide some natural light, even if only as occasional sidelight from windows, continues and has if anything been reinforced by the experience of those galleries which have rigorously excluded it. The design problem for most museums is therefore most likely to be one of controlling daylight over certain areas and relating this to an installation of artificial light over the entire volume of the building. It is exactly this situation which seems the crux of the lighting problem both at The National Air and 251–253 Space Museum as well as the new addition to the National Gallery on the other side of the Mall in Washington, to take two quite different kinds of exhibition spaces. Since daylight is more difficult to control and is also in a sense a more permanent architectural feature, some recent museum designs such as the east wing of the National Gallery in Washington or the Yale Center for British Art, 289–303 have made the pivotal spaces of the building into daylit courts and allowed the galleries with their more changing display to be lit artificially.

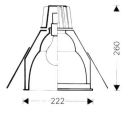

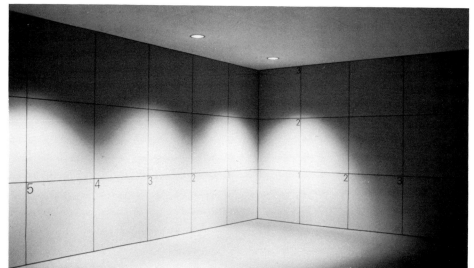

239–250. Six examples for lighting a wall (Erco Leuchten GmbH, Lüdenscheid, Western Germany).

239, 240. Downlights recessed above the ceiling; the fittings using 150 W lamps are 1 m (3′4″) from the wall and 2 m (6′8″) apart; the scalloped effect is inevitable with this arrangement.

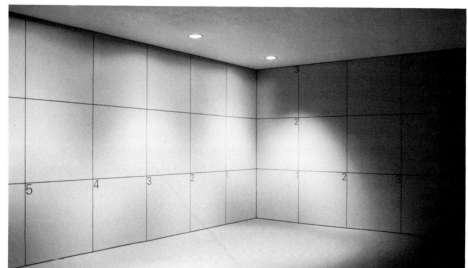

241, 242. Wallwasher recessed above the ceiling; the fittings using 150 W lamps are 1 m (3′4″) from the wall and 1 m (3′4″) apart; average vertical illuminance: 100 lux.

243, 244. Wallwasher with an elliptical reflector directing light on to the wall instead of the floor; the fittings using 300 W lamps are 1 m (3′4″) from the wall and 1 m (3′4″) apart; average vertical illuminance: 400 lux.

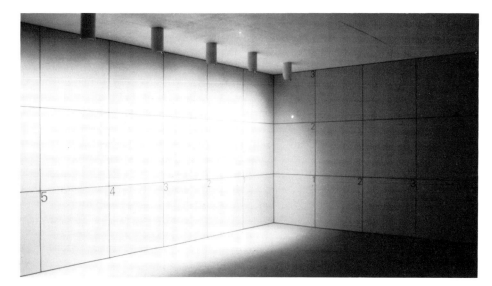

245, 246. Wallwasher with a dispersion lens and reflector blade surface mounted on the ceiling; the fittings using 150 W PAR 38 Flood lamps are 1 m (3′4″) from the wall and 1 m (3′4″) apart; average vertical illuminance: 250 lux.

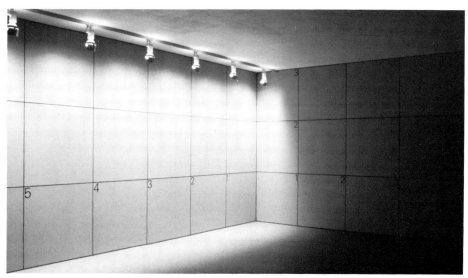

247, 248. Wallwasher surface mounted and adjustable; these fittings use the same lamp, lens and reflector and produce the same illuminance as in the previous example; their ability to be adjusted makes it possible to produce the highest level of illumination on the object being displayed.

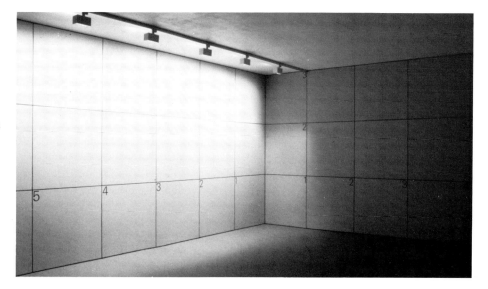

249, 250. Wallwasher surface mounted below the ceiling; the fittings using 150 W tungsten halogen lamps are 1 m (3′4″) from the wall and 1 m (3′4″) apart; average vertical illuminance: 350 lux.

251–253. National Air and Space Museum, Washington, D.C. Hellmuth, Obata & Kassabaum, 1972–76.

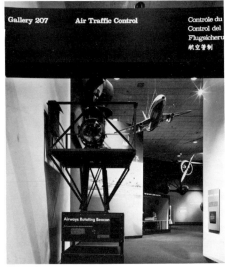

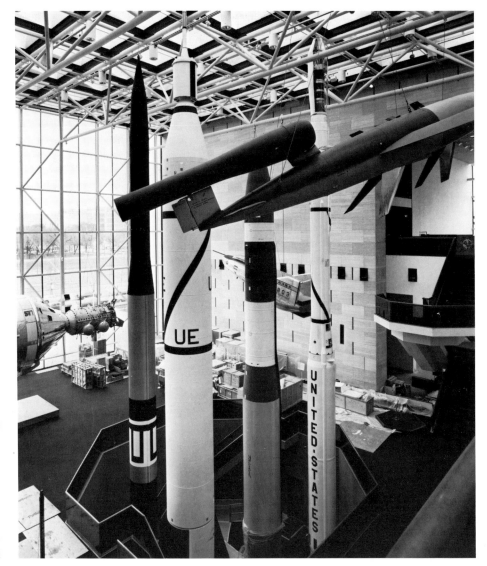

254–256. East Building, National Gallery of Art, Washington, D.C. I.M. Pei & Partners, 1976–78. The daylit inner court and the large daylit gallery for sculpture by David Smith; the smaller artificially lit galleries can be seen in 81. The plan shows the relation between the main building and the east wing.

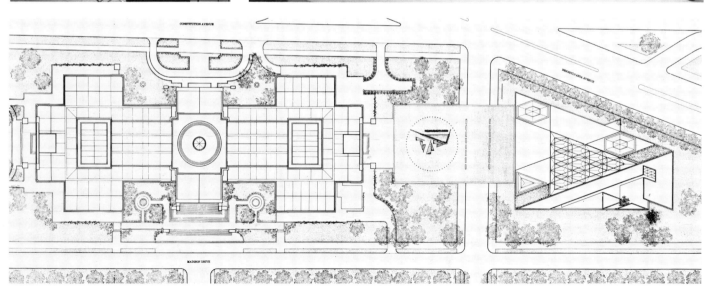

Temperature, Humidity and Air Pollution

Both temperature and humidity affect a great number of museum objects but normally only at the extremes likely to be found in buildings in a temperate climate; the effect will therefore be much less pervasive than the damage caused by exposure to light. Perhaps even more to the point, the temperature and humidity conditions found comfortable by people slowly walking through a space or sitting down are also those which will be safe for all but a very few museum exhibits. There is thus very little conflict between the conditions which are usually provided by mechanical or natural means inside buildings for people and those needed by the vast majority of objects. The greatest danger comes from excessive humidity causing mould growth, metal corrosion and some chemical reactions in textiles and paper as well as extreme dryness, often the result of heating, producing shrinkage and brittleness.

Within the recommended limits of temperature and humidity most objects are also tolerant of an amount of variation. Stable conditions are, however, very important since static levels of relative humidity and temperature avoid the movement of material and particularly the frequently damaging effect of differential movement between parts of the object. Stable internal conditions have often to be provided by mechanical means but can also be greatly assisted by architectural design. Building mass can provide a reservoir with considerable thermal capacity which can reduce the variations in temperature between day and night and possibly even between seasons and the lining of walls with timber or fabric or other moisture absorbent material can stabilise relative humidity to a considerable degree. Even stone will absorb moisture and it has been shown, for example, that the 2000 or so visitors who come to King's College Chapel, Cambridge, daily during the summer produce enough moisture which is stored in the stonework to raise the internal relative humidity in the winter at 10 °C from 33% to 57% (R.E. Lacy, 1970, quoted in Thomson, 1978). The chapel was thus thought safe for Rubens' panel painting *The Adoration of the Magi*. Traditional massive construction with low levels of winter heating in the temperate zone has in fact in the past produced highly desirable conditions for many quite delicate museum exhibits.

Internal conditions are of course extremely dependent on the external climate and some serious problems arise from the difference between the weather outside and the indoor climate considered desirable. Garry Thomson has in *The Museum Environment* suggested a division of the world into four climatic zones and the choice of appropriate levels of relative humidity related to these.

Choice of RH Level according to Climate

65%	Acceptable for mixed collections in the humid tropics. Too high, however, to ensure stability of iron and chloride containing bronzes. Air circulation very important.
55%	Widely recommended for paintings, furniture and wooden sculpture in Europe, and satisfactory for mixed collections. May cause condensation and frosting difficulties in old buildings, especially in inland areas of Europe and the northern parts of N. America.
45–50%	A compromise for mixed collections and where condensation may be a problem. May well be the best level for textiles and paper exposed to light.
40–45%	Ideal for metal only collections. Acceptable for museums in arid zones exhibiting local material.

Note

International exhibits and loans require international agreement on RH levels, and introduce a bias towards the median levels 50–55% RH.

257, 258. Evaporative humidifier shown in the closed position and with the drum raised for cleaning; the water reservoir is in the base.

In many parts of the world – India, Malaysia, Indonesia or parts of the USA during the summer, to take only two typical regions – the relative humidity will be above 70% and can only be brought down to 65% by mechanical means. In other parts of the world – inland Europe and North America in the winter for instance – the outside winter temperature and relative humidity will be such that if this air is heated to an acceptable indoor temperature, the relative humidity will fall to a dangerously low level. For example, if in the middle of winter on an average day, outside air brought into a building in Berlin, Moscow or Chicago is heated to 20 °C, the relative humidity will drop to below 20%. Mechanical humidification becomes necessary if many objects are not to suffer.

Air pollution is a problem which has bedevilled museums for a long time and is not, as might be thought, only a phenomenon of the twentieth century city. It has only been compounded by the motor car and particularly in those areas of strong sunlight, such as Los Angeles, where ozone is produced photochemically. The pollution of the air is the result of the combustion of various fuels which give off solid particles as well as gases. Both can be harmful to objects in museums as well as to human beings. It is fortunate from the point of view of the museum therefore, that the health hazard is being seen as sufficiently serious for various control measures to be enforced which are dramatically lowering pollution and particularly the weight of solid particles found in a given volume of air.

Within a building mechanical means may be necessary to keep conditions within acceptable limits. The closer those limits are defined, the less variation is allowed, however infrequently it may happen, the more expensive will the installation become. The simplest mechanical device consists of a heating system distributing hot water to radiators or fan convectors; the kind of installation which produced cast iron floor grilles or large box-like enclosures with perforated sides in the middle of many old museum galleries. In certain climates this may produce excessively dry atmospheres in the winter and additional moisture may have to be introduced through humidifiers, electrically operated atomisers which spray the air or, preferably, those which blow air through a damp material allowing the 257, 258

121

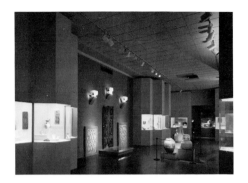

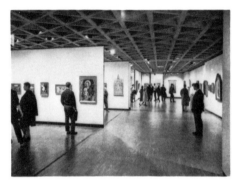

259. Islamic Galleries, Metropolitan Museum of Art, New York.

260. Yale University Art Gallery, New Haven, Connecticut. Louis Kahn, 1953. Tetrahedral concrete coffers with air ducts above these.

261. Centre National d'Art et de Culture Georges Pompidou, Paris. Piano + Rogers, 1971–77.

moisture to evaporate and thus increasing the water vapour content of the air. The latter are a mechanical version of the large moistened cloth moved by a *punkah wallah* in India during extremely hot periods.

A more complex and space consuming system is to move heated air from a central source to the individual spaces. In view of the much lower thermal capacity of air as compared to water, this needs much bigger ducts and therefore requires a very definite allocation of space to a continuous run between plant room and gallery. It does however introduce the possibility of filtering the air and thus reducing the solid particle content.

The next step is a full airconditioning system which controls temperature, relative humidity and is able to remove solid particles and polluting gases. It cleans the air by passing it over filters to remove solids and either through water sprays or activated carbon filters to take out gaseous pollution. (Not by electrostatic precipitation since this produces ozone which destroys almost all organic material by acting on the chemical bond of carbon.) A reasonably stringent specification for a picture gallery might be as follows:

Temperature	20 ± 2 °C
Relative humidity	$53 \pm 7\%$
Solid particle removal	at least 60% efficiency on particles below 1 micron ($^1/_{1\,000}$ mm)
Sulphur dioxide content	not more than 10 micro grams per cubic metre
Nitrogen oxide content	not more than 10 micro grams per cubic metre
Ozone content	reduced to trace levels; 0–2 micro grams per cubic metre

Air conditioning systems need a considerable allocation of the total volume of the building. The first need is for a central plant room connected to a primary system of trunking which distributes air throughout the building; these represent the heart and arteries of the circulation. The second need is for a more local distribution of smaller ducts, the capillaries, which bring air to the individual outlets. Finally there is a return system, the veins, which carry air back to the plant room where a high proportion of it, around 80–90%, together with some outside air is cleaned, and brought to the correct temperature and humidity again and then recirculated.

Such a system requires a continuity of hollow spaces linking each individual room outlet all the way back to the central plant room. These spaces are normally encased in vertical and horizontal ducts. They make their greatest impact visually if the ducts occur at ceiling level and they are then obscured by a false ceiling punctuated by air grilles. The ceiling becomes, as a rule, a lightweight suspended plane which tends to look more insubstantial than the remainder of the building. 259 Yet in many museums the ceiling is the most permanent element of the building interior against which variable screen and showcase arrangements are set. Kahn's 260 design for his first art gallery for Yale tried to achieve an overhead plane which was both structural and visually permanent as well as being able to provide a continuous void for ducts. Other solutions, such as that at the Centre Pompidou, leave the whole duct system exposed and attempt to create out of it almost 261 a work of art. Whether this is a solution which is really applicable to a museum of art, is another matter.

122

262. Chart of relative humidity over a number of weeks in a room, the variable line, and in a showcase, the near straight line; the case contained a wooden musical instrument and a cloth-covered cork base and thus incorporated a useful buffer. (From: Garry Thomson, *The Museum Environment*, London, 1978.)

Temperature and humidity as well as particle content can of course also be controlled by very much more simple means when only small volumes are involved. A closed showcase which is not directly under a window or below spot-lights will, without any further control devices, have a much more stable internal environment than the gallery in which it is placed. This will be especially true if the case contains a material such as wood which can act as a moisture absorbent buffer. If the case is well sealed but has an opening with a filter in it, the particle content can also be dramatically reduced. 262

It is also possible to use very small mechanical means of control. A series of showcases at the Royal Courts of Justice in London display historical legal costumes and a small pump in the base of the cases blows filtered air into the case. The air seeps out, maintaining positive pressure within the volume of the display. Small humidifiers or dehumidifiers can be used to control relative humidity when this is a critical consideration. Humidity can also be controlled within a showcase by chemical means. The most common agent is silica gel which acts as a highly efficient buffer. 170–172

Under very exceptional circumstances, an object can be stored in a vacuum. This needs, of course, a very specially – and expensively – designed case so that the seal is not broken. The American Declaration of Independence is kept in such a glass fronted case.

Whether control occurs as part of a general system involving the entire volume of the building or only as a highly localised event within a small showcase, it will always be affected by the design of the building in its entirety. The scarcity of energy, which has become apparent in the last decade, has focussed attention on those aspects of design which are able to reduce the need for energy input in order to maintain an equable and comfortable indoor climate. There has been a reduction in the area of glass in buildings and an emphasis on using double or even triple glazing or double windows, on reducing cold bridges between the outside and the inside, on shading and reflective roof surfaces in order to minimise solar gain and even on using double forms of construction, particularly in the tropics, so that there is the maximum isolation between internal and external surfaces. All these considerations which apply to most buildings are doubly important in the case of museums.

Security

The museum, like every other building and especially like every other public building, must deal with the security of its occupants. What this means in practice is that it is built of incombustible materials or, in certain cases, materials with a low spread of flame, so that those within the building can, in case of fire, escape quickly to staircases and exits which are in smoke-free zones or lead directly to the outside. The quick and direct evacuation of the building is essential in case of fire and the inevitable panic which this causes. In many ways however this is in immediate conflict with the security of objects from theft which makes it desirable that there is only one entry and exit point, that openings are barred and that there are no panic bolts on doors operated by the public. The installation of automatic sprinkler systems also conflicts with the preservation of objects since such a system may come on, drenching a whole space, when there is only a local fire which can be put out by chemical extinguishers or fire blankets or even water from hose reels aimed at the source of fire rather than the exhibits. Fortunately fires are relatively rare in museums, partly perhaps because of the no-smoking rule, partly because of the well understood need for electrical safety and maintenance. Nevertheless a fire alarm system is an essential part of any

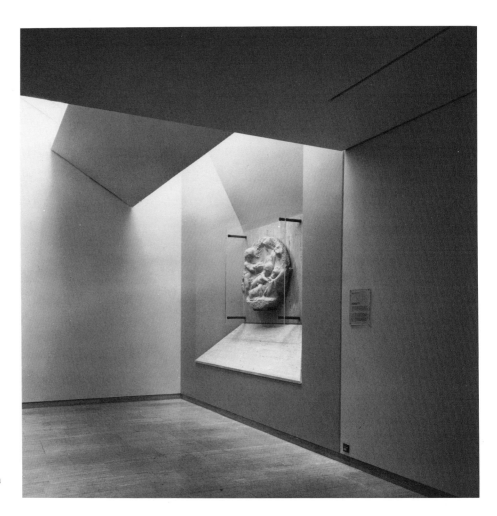

263. Annex for Michelangelo's Tondo, Royal Academy of Arts, London. Robin Wade Design Associates, 1975.

264. *Multiple Art* exhibition, Whitechapel Art Gallery, London. Michael Brawne & Associates, 1970.

museum installation. It must set off an alarm within the building but should also be linked to the local fire brigade or to a central security control station which immediately informs both the police and the fire brigade that a fire has occurred. This is clearly particularly important if the museum is unattended at night or during holidays.

The main and most worrying security problem of any museum is however with theft and vandalism, not least because the precautions which need to be taken are more complex and are also in conflict with the normal demands of museum going for access and for the least amount of visual interference between object and viewer.

In terms of its implication on design, security can perhaps be considered most conveniently under three headings: prevention of damage and theft while the museum is open to the public; prevention of entry into the building when it is closed to the public; prevention of removal of the objects themselves.

During the hours in which the museum is open to visitors it is in many ways just as vulnerable as when it is apparently securely locked and even patrolled by warders. Vandalism is obviously the first hazard: a knife cut in a canvas or a stuffed natural history specimen, the canister of spray paint released over a sculpture or a vintage motor car. Warders in galleries, security checks on entry, the compulsory leaving of sticks and bags in a cloakroom all help but cannot ensure that damage will never happen. Thefts of objects have also occurred in the past while the museum was open to the public either because some remote section was not under scrutiny of a warder or because a group of thieves is able to cause a diversion while one of them removes the object. Closed circuit television is no help whatsoever and does not even have a psychological deterrent value since its failings are so well known.

Invigilation is made easier when barriers or guardrails are installed since anyone stepping into the forbidden zone stands out from the rest of the public and is immediately under suspicion. Such a barrier also prevents people from touching out of curiosity rather than any intention to do harm. Even the simplest rail, however, by definition distances the viewer from the object and is thus contrary to the ideal intentions of the museum; the design problem must therefore be how to keep the visitor at a safe distance without that action becoming disturbingly obvious. 263
264

The problem of securing the museum when it is closed to the public has two quite separate aspects: the first concerns itself with making any entry extremely difficult (to make it impossible is highly unrealistic), the second with setting off an alarm system which detects any attempt at entry as well as the presence of intruders within any space. The fact that guards may be patrolling does not avoid the need for an alarm system since they clearly cannot be in every part of the building at the same time.

The traditional methods of stopping a burglar still have their value even if the most elaborate electronic detection is installed since devices such as grilles over windows, heavy doors, shutters or skylights which cannot be unscrewed from the outside, all delay the intruder and thus give more time for any security force which has been alerted by the disturbance of the electronic detectors to act and thus prevent a valuable or even irreplaceable exhibit from being removed. It is this, rather than arrest, which must always be the prime objective of any security system in a museum.

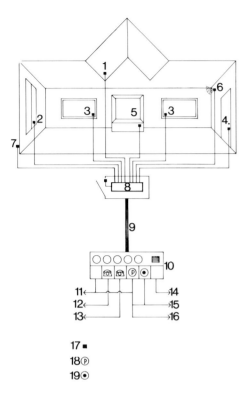

265. Security diagram for a typical gallery. Key:
1 rooflight, 2 window, 3 picture, 4 door, 5 show-
case, 6 space surveillance, 7 perimeter, 8 collec-
tion panel, 9 multicore cable, 10 central control,
11 automatic call to police through exchange,
12 manual call to police or security station
through exchange, 13 manual call to police over
private wire, 14 alert of staff in building,
15 alarm such as roof siren, 16 automatic call to
police or security station over private wire, 17 se-
curity contact device, 18 personal attack button,
19 push button.

Most electronic systems are likely to have two main types of detectors: those which are sensitive to vibration or the breaking of a contact and are thus set off when a door is opened, a glass broken, a shutter forced or a wall being hammered away and those which detect movement within a space by scanning it with infra-red or ultra-sonic rays. The first group reinforces the restraints which thick doors or window bars provide, the second detects the intruder who has succeeded in avoiding the other deterrents or who has somehow secreted himself in the museum while it was open to the public. Both forms of detection and their links to the relevant control stations are shown in a diagram for a hypothetical 265 picture gallery.

Preventing the actual removal of any museum exhibit is the ultimate hindrance to any burglar and is equally important whether the gallery is full of visitors or empty at night. Again two methods are important, fixing the object or protecting it in a case. It is advisable that valuable pictures are screwed to the wall, for example, rather than hung on chains or rods; that pieces of small sculpture are bolted or screwed down with metal plates or other fixing devices; that small objects in general are put behind glass or in showcases. The construction of walls (see pp. 39–53), of pedestals (see pp. 86–89) and of showcases (see pp. 90–99) are all influenced by such security considerations. In addition to these physical barriers, electrical contacts can be provided for individual paintings or single objects or a showcase which set off an alarm if they are disturbed. The kind of linings which were described in the section on walls, for instance, allow wires to be routed to the backs of pictures without showing anywhere on the face and thus drawing attention to a security system quite apart from being visually obtrusive.

The installation of any museum security system should be discussed with specialist advisers. This is particularly important if the museum is to have travelling exhibitions, many of which can only be set up in buildings which meet a specified level of fire and intruder security. Like conservation, security is ultimately a question of moral responsibility for the safety of objects which form part of the world's heritage and which ought to be guarded in the most effective way consistent with the need for them to be seen and understood.

Verbal Communication

To say that museums are primarily devoted to non-verbal communication is to state a truism. When words appear in some form we see them properly as subservient to the image on display; we have, after all, come to look, not to read. Yet inevitably words are needed in order to explain, to give either additional clues or simply to provide those facts which we expect to have in order to be able to make a quick reference, to place an object in context. The label with the artist's name and date and subject matter or the species and habitat of a bird is the minimum factual description to which we are accustomed.

But even the simplest and most demure label immediately poses a whole set of problems. The first is cultural and is particularly acute in museums of art. Few museum visitors are so innocent as not to know that the works of Giotto or Michelangelo or Rembrandt are generally thought to rate higher than those of Girtin, Maclise or Reynolds. There is thus an immediate and inevitable predisposition to make value judgments on the basis of previously acquired knowledge rather than on current observation. We of course do this all the time and not only in museums. Visible labels on clothes which are presently in vogue tell us not only something of the cost of the garment but are equally meant to colour our judgment of it. Both the Gucci and Levi label are highly emotive. Visual innocence is impossible even if it were desirable.

The second problem is a more directly visual one. If we are to be able to read words at about the same distance at which we are viewing the picture or sculpture or natural history specimen, there is a minimum size below which the print cannot go if it is to remain legible. The label may therefore become a visually important object in its own right. This is particularly true if, for example, it has black lettering on a white ground yet is fixed to a dark background which may be appropriate to certain paintings. Legibility is in direct conflict with a desire to subdue the label in order to give primacy to the object. The greater the message on the label, the larger it becomes and the more likely is the conflict with the display if both are in the same field of vision.

The frequent answer is to increase the separation of the verbal message from the object being displayed so that these are not in the same view. The label is put low on the wall so as to be unobtrusive but it at once becomes more difficult to read. Another method is to bring it forward and place it on a guardrail at an inclined plane or to embed it in the floor as a plaque as in the Graeco-Roman rooms of the British Museum.

When more information is to be conveyed – a school of painting is to be described or the geographical area of some exhibits is to be defined – there is normally recourse to panels which punctuate the display or act as an introduction to it. The amount of information which can be put across is however strictly limited.

We are not accustomed to reading and absorbing complex information while in the process of moving through spaces looking at objects. The average time which most gallery visitors will devote to looking at a picture is probably a good deal less than the time it takes to read say 200 words; perhaps 40 seconds to read a text of that length but only 20 seconds or so for a great proportion of the pictures in a gallery. The act of reading becomes therefore a disproportionate intrusion upon our time and we perform it reluctantly or possibly not at all.

One alternative is of course not to provide any of the verbal information as

266. Project for guard rails and information holders, National Gallery, London. Michael Brawne & Associates, 1979. Bent metal supports which can be fixed at any position along the guard rail carry blockboard panels for labels. Key: 1 board for label on metal plate, 2 tubular rail carrying bracket, 3 tubular post bolted to floor.

267. Greek and Roman Galleries, British Museum, London. Russell and Goodden, 1968.

266
267

part of the display but only to number the exhibits and to give all the information in some printed form such as a catalogue or a single broadsheet. This solves the perceptual problems of looking at a single surface which has visual images and words closely related. It has the added advantage that it provides a permanent record of an exhibition or the contents of a museum and thus becomes an important resource for art historians or other specialists. The way in which it is organised graphically also makes it possible to distinguish between primary and secondary information so that we can choose quite readily how much of the information we want to absorb while in the gallery and how much at a later stage.

Yet despite these advantages, the catalogue or even the 'petit journal' – the folded sheet of basic information often arranged by room sequence frequently found in French galleries – is an unwieldy instrument which is unpopular with a large number of visitors. The simple switch from looking at an object to reading words on a page is always something of a disruption. It is not made less by the fact that most exhibition catalogues print their entries in a sequence which does not necessarily correspond with the sequence of display; a difficulty caused by the need to go to print long in advance of any final decision about the hanging of the pictures or the placement of sculpture. The subsequent use of the catalogue for art historical research also makes arrangements such as those by artists in chronological or alphabetical order in many ways more sensible.

Permanent display does not have quite these difficulties yet even in a gallery with a permanent collection new arrangements are often made and in any case in a room devoted to a particular school of painting, for example, pictures by the same artist would not always be next to each other but might well make groupings with the work of other painters depending on subject matter or size or emphasis within the room itself. There is no certainty therefore that the way we see objects in sequence while moving through spaces can readily correspond with the sequence in which information is printed in a catalogue.

The problem can be eased though hardly solved by providing information related to specific works within a given space and allowing visitors to have access to it room by room. Such information sheets are often printed rather simply and left in boxes for visitors to pick up or mounted on ping-pong type bats which the gallery visitor takes out of a holder and replaces again when he has finished. The National Gallery in London, for instance, has introduced just such a system as have many other institutions.

The method works well for those anxious to make the effort and when the number of visitors is such that the sheets can be replaced quickly enough or the number of bats is sufficient to cope with all those wanting this additional information. It functions much less well on a crowded Sunday afternoon when there is a continuous row of people facing a wall of pictures.

These and other devices of a similar kind remove the verbal information from the same field of vision as the object being shown; they however still demand an act of seeing. A totally different alternative is to provide verbal information through the spoken rather than the written word. The visitor carries a small handset and earphones which receives a broadcast on ultra-short frequency providing a continuous commentary directing the visitor or which is linked to a coil embedded in the building which broadcasts a particular commentary within a small radius. Although such audio-systems seem, on first consideration, to remove many of the objections which are associated with the visual display of information,

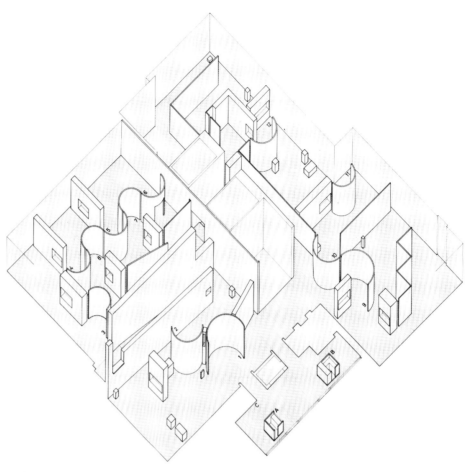

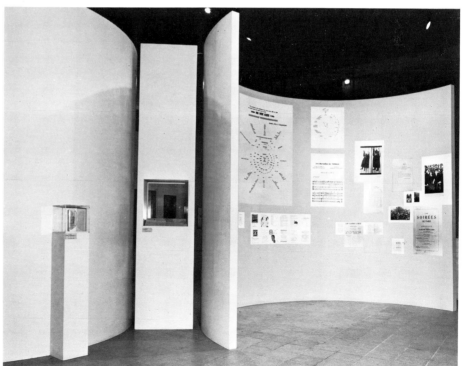

268, 269. *Dada and Surrealism Reviewed* exhibition, Hayward Gallery, London. Colquhoun & Miller, 1978. Axonometric of a floor layout and view of an introductory section.

270. *The Genius of China* exhibition, Royal Academy, London. Robin Wade Design Associates, 1973. The catalogue number and description are inscribed on an acrylic sheet placed outside the bottom of the case.

they in fact suffer from an almost equal number of disabilities. To start with they feel like an alien accessory which has an insistent existence of its own and which, for many people, appears to come between the viewer and the work, not least through the personality of the speaker who has recorded the commentary. They also suggest a pace of viewing which may not coincide with the preferred pace of the visitor nor can they be used to provide information which is not translatable into words such as maps, diagrams or chronological charts. In many ways, therefore, the standard problems of the personally guided tour are repeated in its mechanical version.

If it is true to say that many visitors to galleries and museums are anxious to have secondary information about a great deal of the display – are simply not satisfied by being told the name of the artist, the date and title – and if it is also true that there seem to be appreciable difficulties in providing such additional information without interfering with the primary function of viewing objects, then it may be opportune to consider more fundamentally the methods which we use and to scan the range of possible alternatives which may be viable. The need for this additional verbal and visual explanation presumably did not exist – or at least was not acknowledged – to anything like the same extent when galleries were only visited by an informed public. Equally there must be many visitors today who having seen, for example, a series of television programmes on the subject of an exhibition, require very little further guidance beyond certain brief reminders. One frequently repeated statement heard from gallery visitors is that they would like to have read the catalogue *before* coming to see the work on show. What we seem to demand, therefore, almost intuitively, is that we should be prepared for the act of seeing; that our understanding of the intellectual aspects should precede our sensory perceptions. It may well be that this is just one particular and highly modified case of the general statement that we need models against which to relate visual information.

Given that there is such a preferred sequence, then the layout of the display ought to take account of this problem. Given also that dissociation of extensive information from the artifact appears to be advantageous in many museums and particularly museums of art, then it would seem sensible to plan on the basis of creating enclaves of additional information which come before the areas of display on the route through the building. To create, in other words, a plan in which there are specialist zones: major ones for the showing of objects and subsidiary ones for the communication of aspects related to the objects and intended to help our appreciation and understanding. Each zone can then have characteristics which aid its own particular function. The frequency of such zones would always depend on the nature of the display as well as the methods of display used in these secondary areas.

The possibilities of such introductory spaces were hinted at in the curved areas of the *Dada and Surrealism Reviewed* exhibition at the Hayward Gallery in 1978 268, 269 which contained enlarged copies of pages from contemporary publications and which preceded each section. In a similar way, the multi-screen audio-visual show on Islamic architecture which formed part of *The Arts of Islam* exhibition at the Hayward Gallery in 1976 so that one could more readily imagine objects of the exhibition within their architectural setting, suggested the possibilities of more elaborate explanatory sections. Both the impact as well as the expense of such more complex means of providing information imply that they occur

271. Museum für Völkerkunde, Berlin-Dahlem. Exhibits and large illustrations.

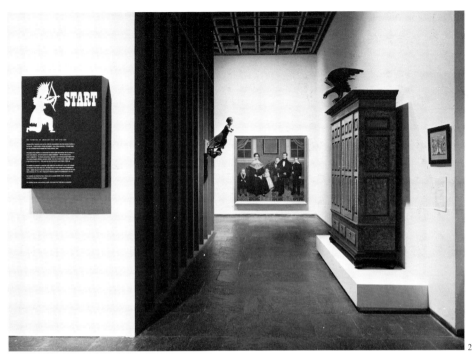

272

272. Cowell Hall of California History, Oakland Museum, Oakland, California. Gordon Ashby, 1964. Words as exhibits and as information.

273. *American Folk Art* exhibition, Whitney Museum of American Art, New York. Marcel Breuer and Associates, 1974. The directional sign is adapted from an exhibit.

274. Maritime Museum, Kingston-upon-Hull. Robin Wade Design Associates, 1976. Conversion of the old Town Dock offices. Model, text and illustrations explain the historical development of fishing and substitute for exhibits which would be too large for a small museum.

273

274

275. *American Arts and the American Experience* exhibition, Mabel Brady Garvan Galleries, Yale University Art Gallery, New Haven, Connecticut. Cambridge Seven Associates, 1973. Words, illustrations and exhibits combined to make an introductory section.

276. Fox Talbot Museum, Lacock Abbey, Wiltshire. Robin Wade Design Associates, 1975. A display on the invention of photography.

277, 278. New England Aquarium, Boston. Cambridge Seven Associates, 1962–68. Drawings, back-lit text and illustrations provide supporting information without competing with the exhibits shown in relatively dark spaces.

275

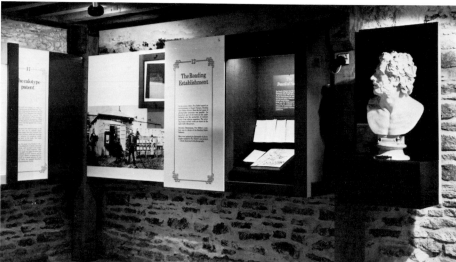

276

277

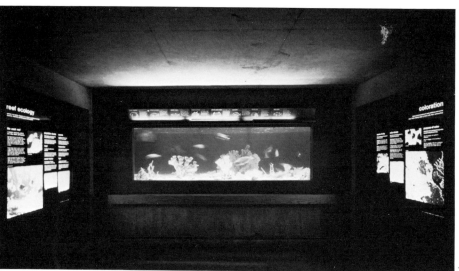

278

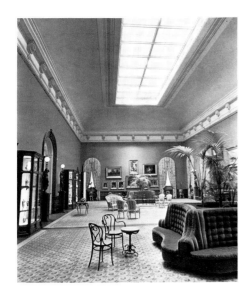

279. Renwick Gallery, National Collection of Fine Arts, Washington, D.C. The grand salon recognised as a total display in its own right needing only minimal and discreetly placed verbal information.

only once or twice within any one area of display devoted to a particular theme. The technical problems of audio-visual installations are discussed in the next section.

The most worked out example of such a guide can be found in the proposal made by Charles and Ray Eames in 1976 for the Metropolitan Museum of Art in New York. It exists in model form and as a short film describing the idea of providing a key to the collection and its purpose so that the intention 'of furnishing popular instruction' to the community which was part of the Museum's charter can be reinforced. The project has, unfortunately, not been carried out and cannot therefore be tested in use.

What the Eames' plan and other similar proposals suggest is that museums and galleries may need introductory spaces which become preparatory zones devoted to helping us to understand, and therefore probably to enjoy, the works of art. In some ways museums of science and technology have acknowledged this need for a long time and especially in their children's section where basic physical and mechanical principles were demonstrated to the great benefit of visitors of all ages. It is an analogous placing of objects in a context – social, stylistic, technical – which would enlarge our understanding of a painting or sculpture so that we see it both as an object with a visual impact and as an object rooted in a tradition, arising out of certain forms of patronage, made with specific materials and levels of craftsmanship as well as exerting certain influences once it has been created.

Crucial to the argument in the case of works of art, however, is also the notion that such communication, which must always be secondary to the communication of the object itself, should take place in specific and defined areas and that it cannot readily take place in the same area as that devoted to showing the works of art. It is as if these two forms of communication are not compatible; art is always ill defined, is open to a variety of interpretations, and the richness of meaning lies precisely in this ambiguity while the explanatory and secondary communication is specific and always given with certain defined intentions. Such differences are probably best resolved by housing each in its own space.

Audio-visual Media

The prime function of any museum must undoubtedly be to show the real object whether this is a painting or the first steam engine. This has historically been its task and the proliferation of media of communication has not significantly altered one of the main reasons for its existence. There are occasions however when assistance may be needed in order to interpret the actual objects being shown or when in fact it may be impossible to house the real object in the museum yet its message is extremely important to our understanding. A display of comparative anatomy showing the skeleton of a horse will be greatly aided by a film of the movement of a horse across open grassland, or an exhibition of the art of a period may need an audio-visual representation of the architecture of that period in order to provide a sense of the setting. In each case these aids to our understanding have to be created and then housed within the layout of the museum. Both these aspects are important and need to be analysed.

The most obvious ways in which audio-visual techniques can contribute to the interpretative function of the museum are: setting a context, developing an idea, allowing comparison with material not in the museum, showing movement, changing the environment, creating an atmosphere, solving language difficulties and simplifying an explanation.

As a rule such presentations will take place in one of three ways: first as an integral part of an exhibit and usually therefore on a small scale; secondly in a special space created within the museum route and near the relevant exhibition area and thus having only informal seating or leaning rails for the audience; finally in an auditorium set aside for such shows or, most ambitiously, in an auditorium specifically designed around a particular audio-visual presentation.

A number of different audio-visual media are available and can most usefully be summarised in a list.

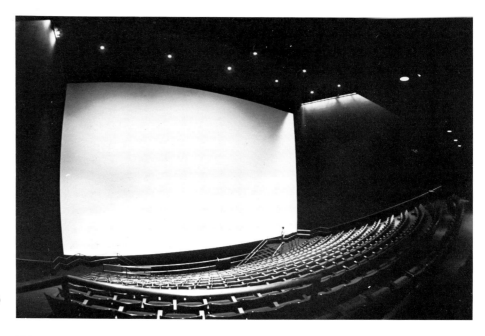

280. National Air and Space Museum, Washington, D.C. Hellmuth, Obata & Kassabaum, 1972–76. The auditorium in which the film *To Fly* using the *IMAX* 70 mm projection system is used; the screen is 15 m (50′) high and 23 m (75′) wide.

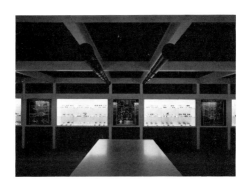

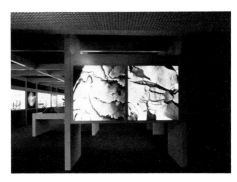

281, 282. Optisches Museum, Oberkochen. Visual explanatory information directly related to exhibits; back-lit slides between two sheets of glass 1 m (3′4″) square showing optical diagrams and between sheets of acrylic showing electron microscope enlargements; the outer sheet is clear, the inner milky white.

1. Sound accompanying static exhibits
A sound commentary is in a sense an extended caption to a static exhibit and which must be written in such a way that it is obvious from the words which object is being described; the technique is ideal for giving an overall description and has been used particularly successfully in outdoor museums.

2. Synchronised Sound and Light sequences
Used on a large scale this is the technique which is familiar to many as 'Son et Lumière' but it is capable of being used on a much smaller scale within a museum where individual sections of display are illuminated in synchronisation with a commentary; it can also be extended to activate anything electrical such as small motors or solenoids. The technique is particularly suitable for explaining complex models or processes such as those of an oil refinery or for theatrical sets which might occur in a costume gallery or which dramatise events such as the recreation of the Battle of Trafalgar at Madame Tussauds in London.

3. Motion picture film
This is the most familiar audio-visual medium and its uses are well known and firmly established. Three standards are applicable for use in museums:
Super 8 mm – at first intended for amateur films shown in the home but now widely used professionally
16 mm – the most common format for educational purposes but also used in small cinemas
35 mm – the standard size used in cinemas.
Very rarely, as in the special auditorium of the National Air and Space Museum in Washington, D.C., 70 mm film has been used to create effects which rival those of the more spectacular efforts of the film industry. 280

4. Filmstrip with Sound
Individual images are carried on a continuous piece of film, 16 mm or 35 mm, and are projected a frame at a time in synchronisation with a sound track.

5. Single Screen Slide and Sound
Very similar to the filmstrip but using individual slides; except in the very smallest installations it is now usual to use two slide projectors linked by a dissolve unit which fades one image into the next to give a much smoother presentation.

6. Multi-screen Slide and Sound
This uses more than two slide projectors synchronised to a sound track. It is used both for spectacular effect and for practical reasons such as the ability to make comparisons. It is equally possible to use it on a small scale on three screens with simple compact equipment or as an enormous 'multivision mosaic'. 283

7. Video
In practice this means that programme material is stored on magnetic tape in a cassette or on a video disc and is shown on a television set or monitor; it is becoming possible to project television to give an image larger than that seen on the set.

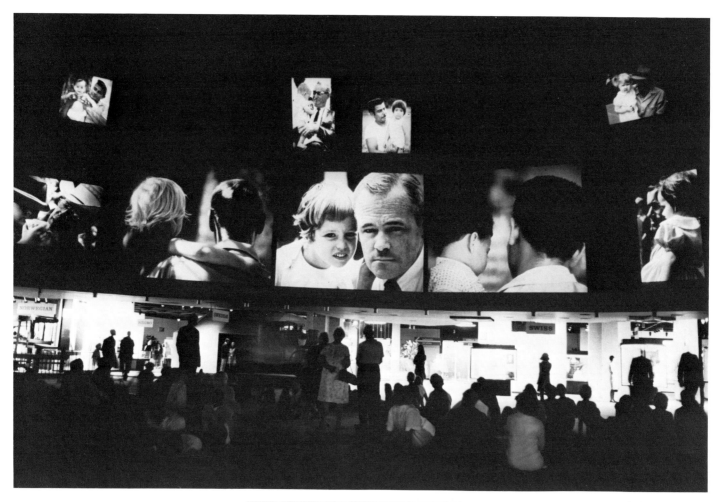

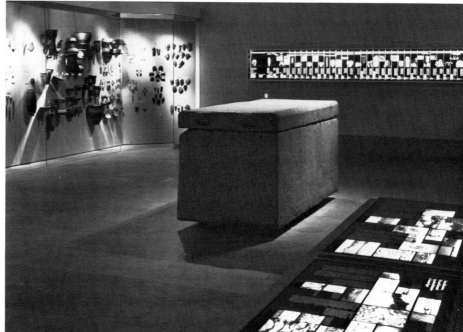

283. Institute of Texan Cultures, San Antonio,
Texas. Gordon Ashby and John Follis and Asso-
ciates. A 360° screen with back projection from
44 projectors; the screen structure is suspended
from the ceiling.

284. Egyptian Galleries, Metropolitan Museum
of Art, New York. Back-lit information tables as
part of the introduction to the collection.

136

8. Multimedia presentations

This description should only be used for a display where more than one of the techniques which have been listed is used; an example would include a sound and light show which also incorporated slide projection.

The choice of a particular medium or a combination of several will depend on the effectiveness with which a message can be conveyed as well as the reliability and cost, and the simplicity of installation and operation of the technique. All media will have two components, one dealing with sound, the other with vision.

The two tables on page 139 set out the various advantages and disadvantages of the available means. Filmstrip has been omitted from the table dealing with visual techniques since it has no advantages over the single screen slide projector which will produce clearer images at a lower cost.

It ought to be emphasised that the impact on the visitor varies a great deal not only due to the manner in which the presentation is made but also depending on the medium selected. Viewing a television screen will have all the familiarity of an everyday event, seeing a multi-screen presentation in which a number of images are seen simultaneously and in which they can vary in size and shape will have the effect of surprise and may thus hold the attention in a markedly different way.

Audio-visual systems need to be created, installed, monitored and maintained. Each of these is a specialist function often outside the normal capacity of a museum and particularly the first two require skills which are unlikely to be found among museum staff. Programme producers and specialist contractors for the necessary equipment should be engaged to deal with these aspects of the presentation. Wherever possible standard rather than special equipment should be used to make replacement or repair simple and quick.

What is of immediate interest to those working in the museum and to those designing its layout is the effect of such audio-visual presentations on space and circulation patterns. Clearly if 200 visitors are expected to flow through a particular part of a museum per hour, an audio-visual space seating 50 for a show starting every half hour is not likely to be satisfactory. The same is equally true even for quite small and short displays related to particular exhibits which may only hold five or six people. Audio-visual shows should on many counts be kept short to be effective: 3 or 4 minutes for those related to individual exhibits, 10–15 minutes for those in separate small auditoria. It is likely that the needs of flow along the museum route will in any case force such programmes to be short.

The amount of space required will depend on the number of people to be accommodated and the size of image to be projected. The tables of different lenses give some maximum individual projected image sizes for an installation using back projection. Whichever method is eventually selected, either singly or in combination with others, to form part of the communication on the visitor's route through a museum it is, I believe, important to recognise that such audio-visual methods are aids to our understanding and not the primary reason for the existence of the museum. It is tempting but, I would argue, wrong to think of the museum as an assemblage of television and cinema screens. Its primary function should focus on providing information which is not duplicated by other media and this in effect means putting the real object on display.

Projected picture sizes
for different lenses and distances (metres)

slide size	24 × 36		
focal length	35	90	180
Distance (m)	Projected picture size in mm		
1.0	650 × 1000	230 × 360	
1.5	970 × 1470	360 × 550	160 × 240
2.0	1280 × 1950	480 × 740	220 × 340
2.5	1590 × 2420	610 × 920	290 × 440
3.0	1910 × 2900	730 × 1110	350 × 540
5.0	3160 × 4810	1230 × 1870	610 × 920

Projected picture sizes
for different lenses and distances (feet)

slide size	24 × 36		
focal length	35	90	180
Distance (ft)	Projected picture size in inches		
3	24 × 36	8 × 13	
4	31 × 47	11 × 17	5 × 7
6	46 × 70	17 × 26	8 × 12
8	61 × 93	23 × 35	11 × 17
10	76 × 116	29 × 45	14 × 21
16	121 × 185	47 × 72	23 × 35

285–287. Schnütgen-Museum, Cologne. Heinz Micheel. In a number of places in the museum a table unit can respond to a visitor's requests for information classified under several headings; the information provided is both verbal and visual.

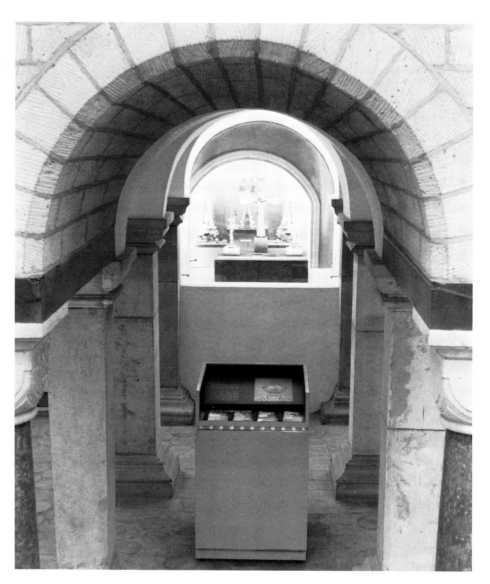

Table 1: Sound

Method	Advantages	Disadvantages
Loudspeaker	most reliable least expensive best for effects best for groups	sound overspill more difficult for language choice
Handsets	ideal for language choice allow close spacing of exhibits simple and reliable	need to integrate into exhibit some maintenance not for groups
Cassette recorders	good for big areas e.g. outdoors visitor self-paced allows for special interest programmes good for language choice	high running cost possible user difficulties impossible to synchronise with other media
Wire-less handsets	least impact on exhibit environment good for language choice	high running costs high capital costs visitor must wait to get 'into synchronisation'

Table 2: Vision

Method	Advantages	Disadvantages
16 mm Movie	displays movement and 'dramatic' sequences reasonable image size good use of existing material	high running costs regular maintenance required equipment space needed
Video	displays movement and 'dramatic' sequences good reliability with correct equipment reasonable running costs easy transfer from existing material	standardised small image difficult to incorporate in design high original production cost audiences familiarity with 'the box'
Slides	ideal for the single situation programme greatest flexibility of programming best image quality steady image reasonable production costs reasonable running costs wide range of formats easy to incorporate	some maintenance required equipment space needed
Sound and light	wide range of possibilities 'theatrical' presentation	need for specially built display or environment

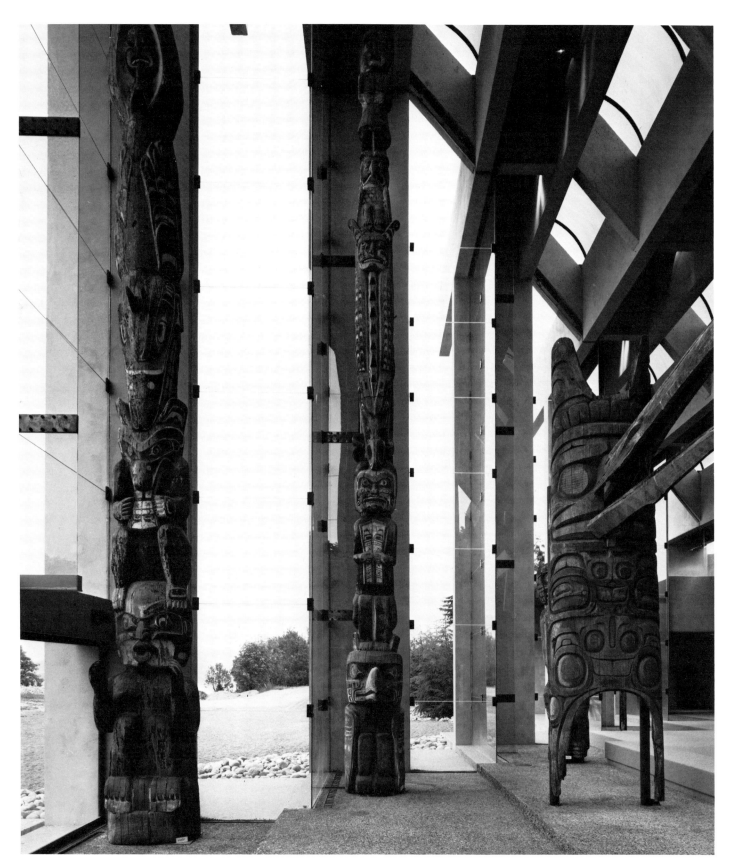

The Museum Experience

The various aspects which have been discussed and illustrated in the previous sections of this book form for any visitor part of the experience of going to a museum; they can never, however, make up its totality. This will inevitably be conditioned by a great array of other influences: by the quality and extent of the collection; by the level of interest and enthusiasm of the visitor and the preconceptions which already exist in his mind as well as a number of seemingly trivial aspects such as the quality of the food in the museum restaurant or the attitude of the gallery warders. The totality is thus always complex and invariably difficult to analyse. That design cannot solve all the problems of a museum or control the entire experience must be accepted by the architect/designer from the outset. This is not an exercise in modesty but in realism; it only acknowledges the specific contributions which an architect/designer can make and the role which he should be allowed to play from the inception of the project.

This role extends perhaps beyond the immediate boundaries of visual design. In most groups involved in the design of a museum or an exhibition, the architect/designer is probably the only non-museum specialist. The others are, by training, most likely to be art historians, museum administrators or in some way specialists with considerable knowledge of the material to be shown; they already understand its message. The architect/designer becomes, therefore, in one sense the representative of the general public and ought to be able to argue the point of view of the visitor unfamiliar with the meaning of the exhibits, of someone who will be experiencing that display for the first time. Specialists too often understand the literary background of exhibits – the scientific or art historical importance of objects – which is then reinforced for them by visual impressions. The normal visitor's first impression, on the other hand, is visual throughout his stay in the museum despite labels or charts or other verbal information. This is the nature of the medium which needs acceptance and, eventually, exploitation.

All architectural design deals with the solution of highly enmeshed problems, many of which depend on value judgments strongly guided by cultural and historical awareness. The museum is no exception; on the contrary, if anything, it carries an even heavier burden of cultural overtones than most other buildings. Its design and the design of its interior and display cannot escape those specific issues. However much very special conditions may be governed by the limits set by conservation or the need to accommodate large numbers or the strict demands of security, the final problems will always be architectural and will of necessity involve a series of interlocking design decisions. The notion that the museum is a repository of objects which we value and whose visual messages we believe to be important must continually guide these decisions and remain dominant.

288. Museum of Anthropology, University of British Columbia, Vancouver. Arthur Erickson Architects and Hoping Kovach Grinnell Design Consultants, 1976. Great hall with a collection of totem poles. Outside there is a recreation of several Indian villages around a pond.

Yale Center for British Art, New Haven, Connecticut, 1969–77

Architect: Louis Kahn

The museum which houses the Paul Mellon Collection of British Art, a library and a photographic archive was still under construction when Kahn died suddenly in the spring of 1974. The building was completed by Pellecchia & Meyers (Marshall David Meyers had worked with Kahn for fifteen years). It stands nearly opposite the Yale University Art Gallery which Kahn designed while teaching at Yale twenty years or so previously. The building is on a street that has both shops and university buildings and its exterior continues that mixture of urban New Haven; the entrance is on the corner but beyond it are ordinary shops. Above street level is a simple framed facade of pewter coloured stainless steel panels and windows; meticulously detailed and precise yet at the same time ordinary and just part of the enclosure of the street.

Jules Prown, the first director of the Yale Center, wrote at the time of the appointment of the architect: 'Louis Kahn is, in my opinion, the greatest American architect of our time, uniquely equipped to respond to the opportunity afforded Yale and New Haven by Paul Mellon's gift. He is a remarkable human being, sensitive both to the inner world of art and the external world of everyday existence. Kahn's previous accomplishments suggest that he will create a building that will be strong and positive, but not monumental. He is a friend of daylight, and a master at introducing it wherever the program requires.'

That early forecast has come largely true in a design which internally focuses on two covered courts. The top floor galleries, lit through highly controlled skylights, open out onto two central spaces, one four storeys, the other three storeys high, which admit the sun and are like the courtyards of a renaissance palace around which the main rooms are clustered. The pictures and sculpture are seen in a calm, ordered setting designed with such care that it never obtrudes on the exhibits.

289. The bays of the concrete frame are clad with a stainless steel sheet which shows the marks of the rolling process; Kahn hoped that 'on a grey day it will look like a moth; on a sunny day like a butterfly'.

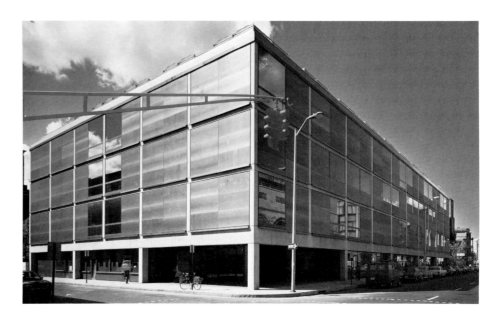

290. Third floor plan; the main exhibition area.

291. Second floor plan; library stacks and exhibition galleries for watercolours, drawings and prints.

292. First floor plan; libraries and special exhibition galleries.

293. Ground floor plan; entrance, shops and ante-room to a lecture room extending into the basement.

290

291

292

293

294

295

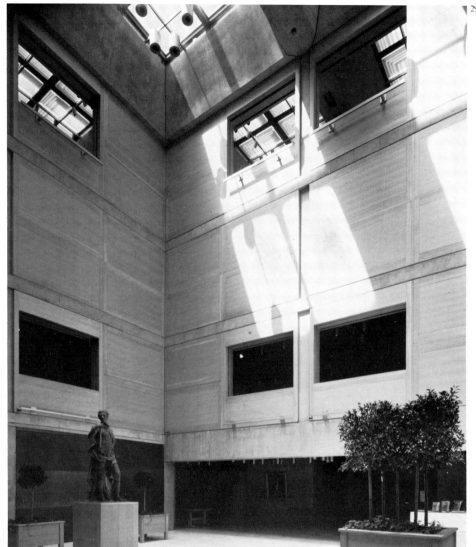

296

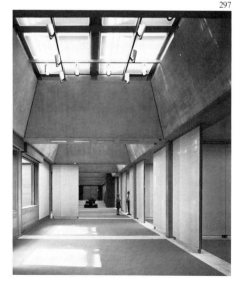

297

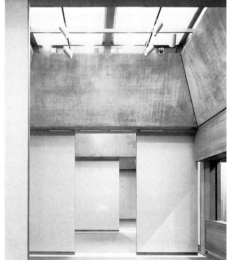

298

294. Kahn's perspective sketch of the entrance court with skylights drawn in October 1971.

295. Typical third floor bay and section through the skylights, developed by Richard Kelly, showing how these are angled towards the south but exclude direct sunlight; the double acrylic dome includes an ultra-violet filter.

296. The four storey high entrance court; walls are made of oak, the floor is travertine.

297, 298. Some of the top floor galleries before the installation of pictures; the bays are 6 m (20′) square and framed by concrete V-shaped beams which carry the skylights; the display panels are covered in natural linen, the floor is an undyed beige wool carpet.

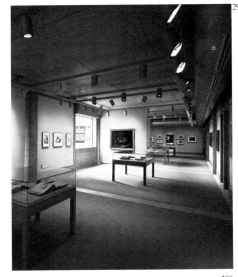

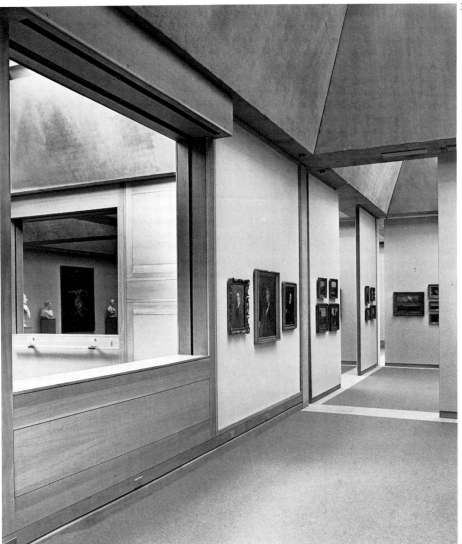

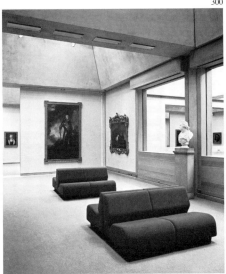

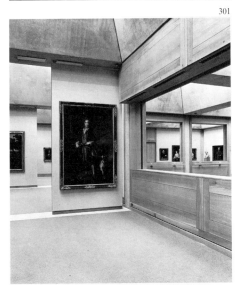

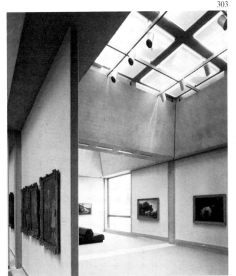

299. A special exhibition (*The Pursuit of Happiness*) in one of the lower galleries showing the relation between these rooms and the court.

300–302. Some of the top floor galleries surrounding the entry court; the small, almost domestic, spaces always still allow long views across the open space and into other galleries.

303. Occasionally there are windows which give a view of the outside and reinforce the daylight from the skylights.

145

Oakland Museum, Oakland, California, 1961–68

Architects: Kevin Roche, John Dinkeloo and Associates
Exhibition design: Gordon Ashby

The building and its gardens stand in the central part of Oakland, across the Bay from San Francisco, in an urban no-man's land close to Lake Merrit. The whole block, surrounded on four sides by roads, is a series of roof terraces and gardens below which there are three museums. Both the inside and the outside are an extension of the city, intended to give pleasure and to provide a landmark to a town which lacked both character and self-respect.

The original commission to design the museum was awarded to Eero Saarinen who however died before even preliminary designs were started. The work was carried out by his former associates and successors who created a building which the people of Oakland have used with great enthusiasm. That parts of the complex were finished clumsily by others because of a law suit between the municipality and the architects over a technical problem is a sad reflection on the insensitivity of the bureaucratic mind and its inability to tolerate experiment.

Several sections of the interior have permanent exhibitions, others are for temporary shows. One of the permanent displays, that on cultural history, was designed by Gordon Ashby who at one time worked in the office of Charles and Ray Eames and who has brought something of the visual density of exhibition design which we associate with Eames to this sequence of historical displays.

The Oakland Museum, with people looking at a temporary exhibition of photography or discovering early Californian history while a community group holds a fair on the lawn among some giant sculptures, becomes as a whole a memorable place. Architecture has made that possible on an urban island.

304. The interior consists of three principal floors which occur at different levels on the hillside; they always open out onto roof terraces and gardens.

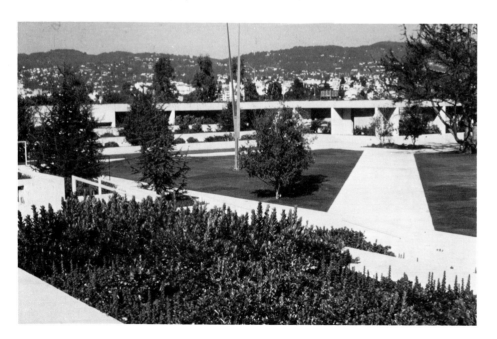

146

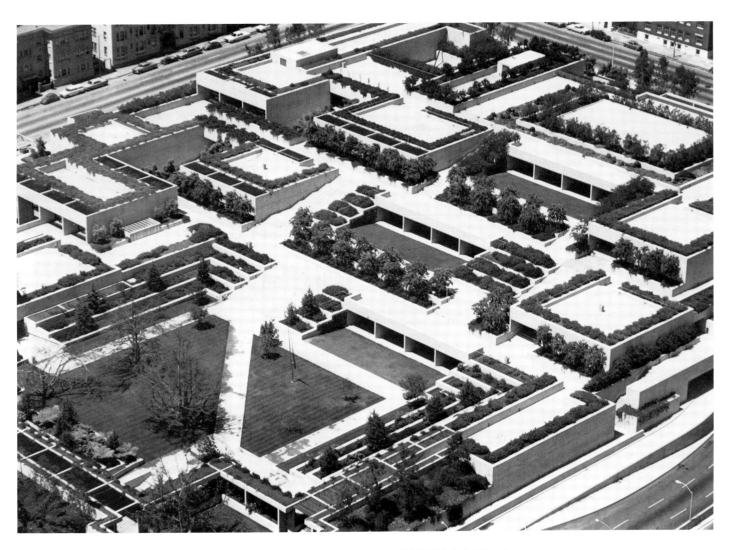

305. An aerial view of the entire museum from the side nearest Lake Merrit; roofs and gardens are indistinguishable and become the top surface of the building.

306. Plan of the Cowell Hall of California History; the historical progression is from the entrance at the left to the modern period on the right.

307. The Indian section near the entrance with a dance house as the central exhibit.

308. The coming together of Indian and Spanish influences.

309. The period of the goldrush; the original 'Assay Office' from Nevada City is the major exhibit.

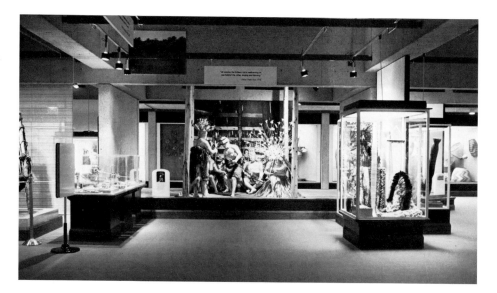

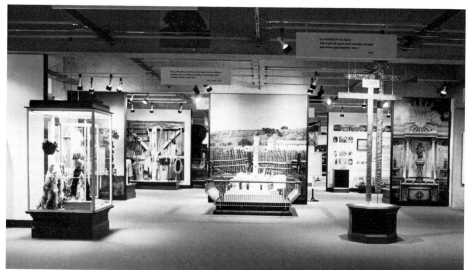

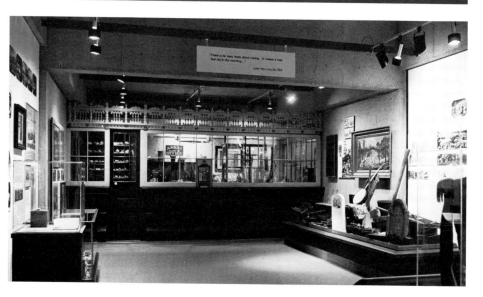

310. The coming of the settlers during the 'American' period; like most parts of the exhibition, the design combines a variety of objects so as to display these and at the same time to re-create something of the flavour of the period.

311. The establishment of statehood during the 'American' period; overhead a framework carries lights and suspended information panels.

312. Parts of a domestic Victorian interior.

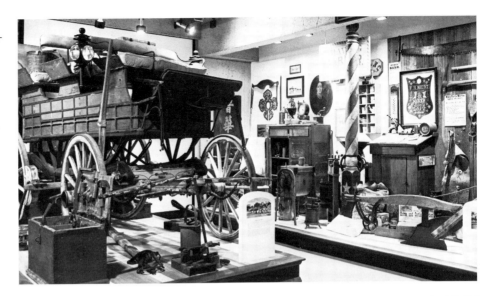

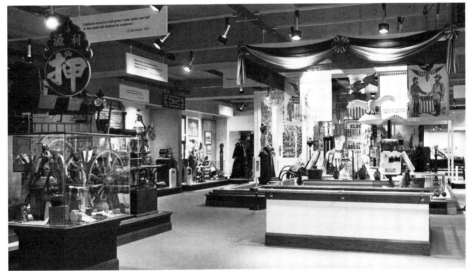

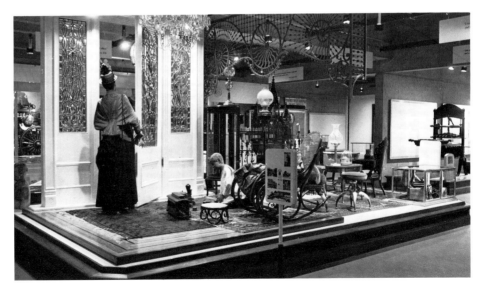

Deutsches Schiffahrtsmuseum, Bremerhaven, 1969–75

Architect: Hans Scharoun

313. View from the sea wall south of the building; the building on the right is the boat hall which is a late addition by Peter Fromlowitz.

314. Site plan; there is an open air exhibition of ships in the old harbour.

The museum occupies a narrow piece of land between the Weser estuary and the old harbour; moored boats and water are its natural neighbours. The design, which was Scharoun's last major work before his death in 1972, creates a building which is not so much like the four-square constructions we associate with ports – warehouses, quays, piers – but much more like the fluid forms of ships made for movement. It is of course a formal vocabulary which is strongly associated with Scharoun and which is also found in his two major buildings in Berlin, the Philharmonie and the Staatsbibliothek. In all these instances in fact the flow of people becomes a strong determinant of the building form; in the case of a museum a highly important and appropriate consideration, in the case of a library perhaps less so.

The most specific and major space of the museum contains the Bremen Cog, a ship dating from about 1380 which was dredged from the harbour in 1962. It is being treated and kept damp for about 20 years before being eventually allowed to dry out. Only then will the galleries around it also be opened up to the rest of the museum to make one continuous group of related but individual and identifiable spaces.

Peter Blundell Jones, the author of a monograph on Scharoun, has written that 'if the Maritime Museum is not Scharoun's greatest building, it is perhaps his most subtle'. This success is probably due to the happy coincidence of Scharoun's liking for an architecture of incident within a non-rectilinear geometry and the nature of ships and harbours which have very much the same characteristics. The building, the setting and the exhibits come naturally together.

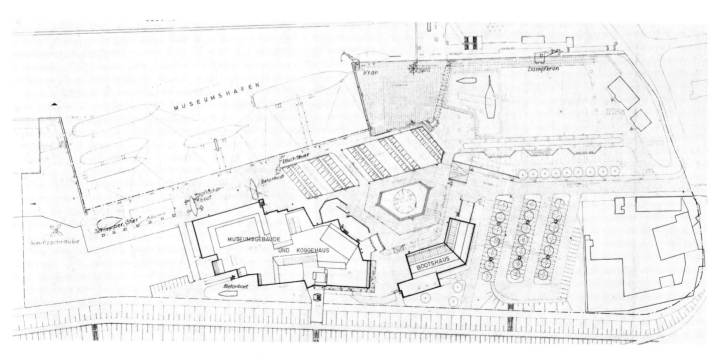

315. Coming from the town centre, the first view is of boats and building completely enmeshed.

316. A series of short flights links the floors along a line which becomes the spine of the museum; it is further emphasised by a large rooflight.

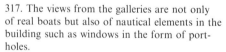

317. The views from the galleries are not only of real boats but also of nautical elements in the building such as windows in the form of portholes.

318. The exhibition space at the eastern end of the building where there is the central section of a paddle steamer.

319. Large windows provide a view of the interior as well as revealing the exhibition of ships in the old harbour from the galleries.

320. The view from the paddle steamer with the reception space on the left and exhibition galleries above; the floors are like the decks of a ship seen from the bridge.

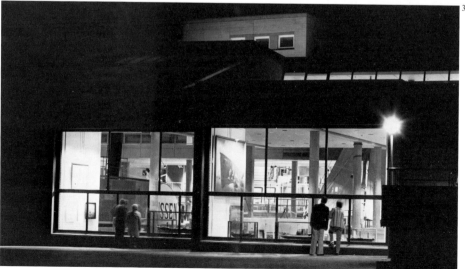

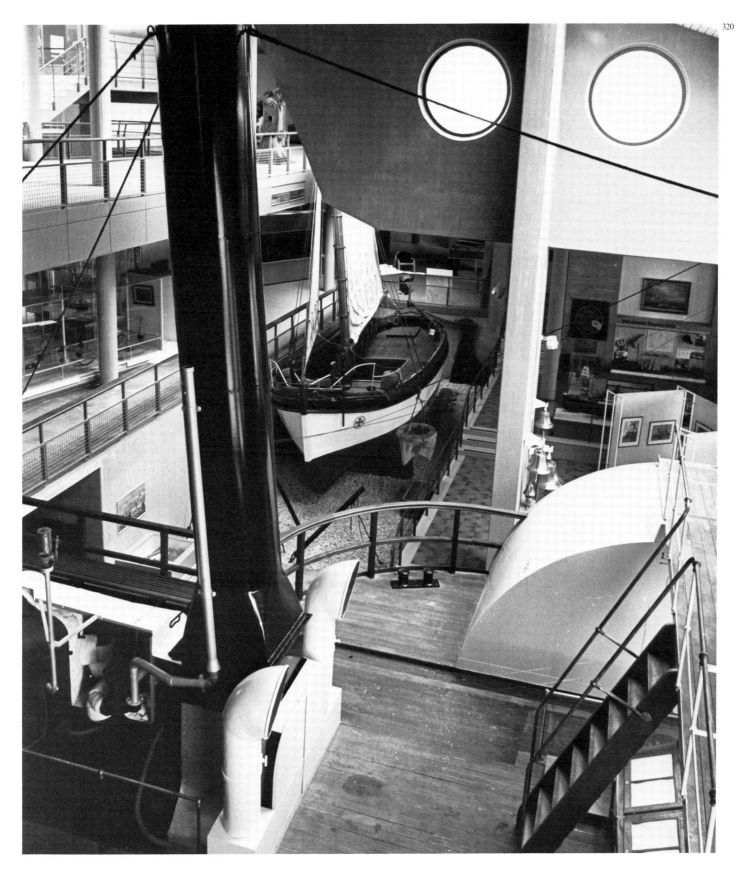

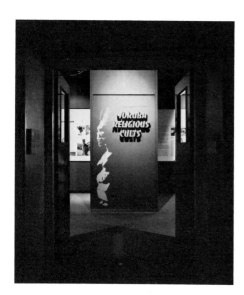

321. The introductory panel which is in dark blue with superimposed red cut-out lettering.

Yoruba Religious Cults exhibition, British Museum, London

Exhibition design: British Museum Exhibition Office, 1973

The Museum of Mankind displays the collection of the Department of Ethnography of the British Museum in London. It does so in a neo-classical building at the back of the Royal Academy in an area renowned for tailors, commercial art galleries and expensive shops selling cashmere sweaters or hand-made shoes. Within the museum the treasures are of a different kind and the transition from a set of streets and an arcade, which for many tourists epitomises London, to the sculpture of Oceania or the Bedouin art of the Arabian peninsula is undoubtedly marked. Yet perhaps in both cases we see the crafted objects which different cultures have made and have regarded highly.

On the upper floor of the museum a King's Palace or Afin of a Yoruba Oba has been reconstructed. The courtyard and some rooms off it are shown. A number of such official residences exist in Western Nigeria and are, as a rule, the most significant building of any town. The reconstruction tries to bring to life the environment which might be found in such a palace and thus shows both objects and background. In addition there are a number of special effects: The strong sun of West Africa is simulated by four 'Sunflood' lamps; the wind which might blow in the courtyard is produced by a centrifugal fan in a near-by sound-proofed room and directed to the courtyard through 600 mm (2′0″) trunking; the noises of a Nigerian compound – drum music, people shouting, cocks crowing – are provided by loudspeakers connected to a twin track loop tape lasting 13 minutes.

The walls of the buildings are made of blockboard covered with a cellulose filler which has been mixed with emulsion paint to simulate mud. This mixture was applied with a trowel, wetted and then finished with bare hands. Similarly the floor was covered with the same simulated mud and, while still wet, was trodden on with bare feet. It was then allowed to set.

The intention is clearly to suggest to the visitor that he is actually in such a palace. It is important therefore that this impression is not weakened by extraneous information. The plan thus distinguishes between the exhibition area with a central courtyard, not accessible to the public, and an ante-room in which there are display cases and information panels.

The Yoruba exhibition is an elaborate and successful version of the reconstructed period room which is found in many museums to show furniture or costumes and which in some ways is also akin to the dioramas which natural history museums use to provide a setting for the fauna of a particular habitat. Exhibition design concerns itself in such instances with the imitation of something that already esists.

322. The ante-room with photographs and panels giving information on Nigeria and the Yoruba.

323. A view into the central courtyard.

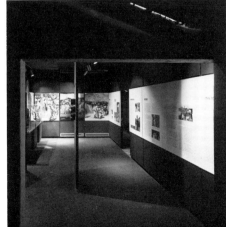

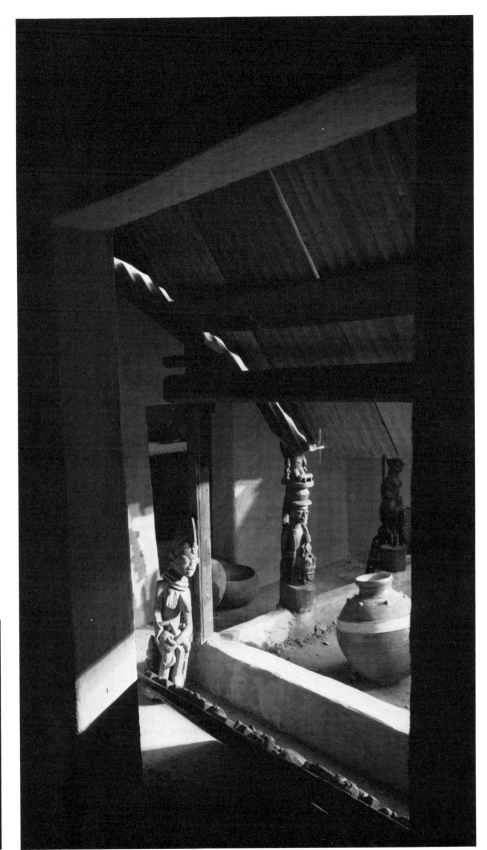

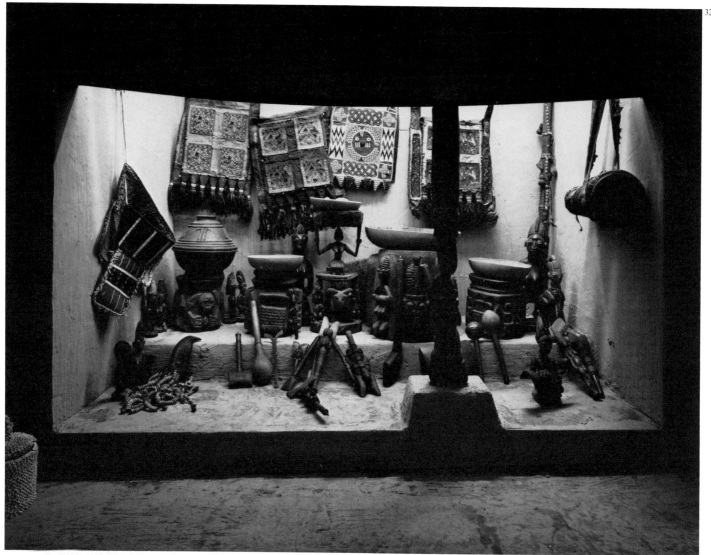

324. The Shango Shrine on the verandah.

325. The entire display alternates areas of deep shadow with brightly lit incidents.

326. The verandah and its shrine seen from the end of the first section of the exhibition.

327. Steps and carved door.

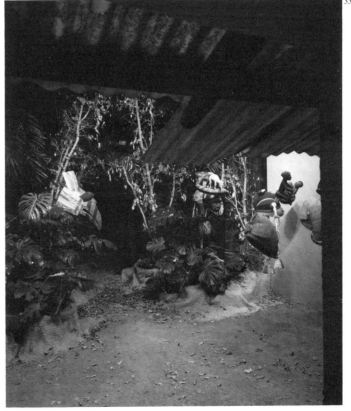

328. Part of the central courtyard which is not accessible to the public; the corrugated iron sheets came from a demolition site.

329. Looking through a small doorway into the courtyard.

330. The second verandah seen as one leaves the exhibition.

Index

All museums are listed under towns. The titles of individual exhibitions are printed in italics. Numbers in paranthesis refer to illustration numbers.

References

Aloi, Roberto, *Musei*, Milan, 1962.

Attick, Richard D., *The Shows of London: a panoramic history of Exhibitions 1600–1862,* Cambridge, Mass., 1978.

Brawne, Michael, *The New Museum*, London, 1965.

Frankl, Paul, *Principles of Architectural History,* Cambridge, Mass., 1968 (originally published as *Die Entwicklungsphasen der neueren Baukunst,* 1914).

Gombrich, E.H., *Art and Illusion*, London, 1972.

Grimm, Claus, *Alte Bilderrahmen*, Munich, 1977.

Heydenryk, Henry, *The Art and History of Frames,* New York, 1963.

Hudson, Kenneth, *Museums for the 1980s: a survey of world trends,* London, 1977.

Illuminating Engineering Society, *Lighting Art Galleries and Museums*, Technical Report 14, London, 1970.

Padfield, T., 'Design of museum show-cases' in *1967 London Conference on Museum Climatology,* IIC, 1968.

Pevsner, Nikolaus, *A History of Building Types,* London, 1976.

Prown, Jules David, *The Architecture of the Yale Center for British Art,* New Haven, Conn., 1977.

Pye, David, *The Nature and Art of Workmanship,* London, 1971.

Rapaport, Amos, *House, Form and Culture,* Englewood Cliffs, New Jersey, 1969.

Royal Ontario Museum, Communications Design Team, *Communicating with the Museum Visitor* (private publication).

Thomson, Garry, *The Museum Environment,* The Butterworth series on Conservation in the Arts, Archaeology and Architecture, London, 1978.

Unesco, *Museums, imagination and education,* Paris, 1973.

Reports on current developments relevant to the design of museums and their interiors can be found in a number of journals. The principal international periodical is *Museum* published quarterly by Unesco in Paris.
Most national museum organisations also publish a regular journal such as *Museums Journal*, London, *Museumskunde,* Berlin, *Museums News*, Washington.
Virtually all architectural magazines carry illustrations and descriptions of new museum buildings or of major conversions of existing museums and galleries. Individual temporary exhibitions are also often illustrated.

Photo Credits

Numbers refer to illustration numbers.

Alinari, Florence 23
Architectural Review 203, 204, 206, 207, 263
Arts Council of Great Britain, London 75–78
Brecht-Einzig Ltd, London 131, 150, 151, 184, 201, 202, 261
British Museum, London 87, 88, 227, 267, 321–330
Thomas Brown 289, 297, 298
F. Català-Roca, Barcelona 221
Martin Charles, Twickenham, Middlesex 20, 274
Geoffrey Clements, Staten Island, N.Y. 158, 163, 273
Chorley, Hyman & Rose, Carshalton, Surrey 153
Concord Lighting International Ltd, London 233–236
Prudence Cuming Associates 269
George Cserna, New York 62, 63, 127, 187
Deutsches Museum, Munich 53–57
Charles Eames, Venice, California 44–46, 48–51
Erco, Lüdenscheid, Germany 239–250
Evoluon, Eindhoven 42, 43
Frick Collection, New York 229
Reinhard Friedrich, Berlin 109, 110, 117, 118, 152, 154, 166, 271
J. Paul Getty Museum, Malibu, California 231
Huwil, Ruprichteroth, Germany 168
Edgard Hyman, London 90, 134, 147, 148, 181–183
Edgar Hyman and Peter Chorley 144, 155, 179
Imperial War Museum, London 68
Philip Johnson Painting Gallery, New Canaan, Connecticut 115, 116
Peter Blundell Jones, London 313, 315–320
Klein, Amsterdam 41
Ken Kirkwood, Norwich, Norfolk 217
Kunstmuseum Hannover mit Sammlung Sprengel, Hanover 66
Sam Lambert, London 121, 122
Lautman, Washington 280
Barbara Martin 129, 130, 251–253
Norman McGrath, New York 92, 95, 275, 277, 278
Metropolitan Museum of Art, New York 259, 284
F. Maurer, Zürich 142
Museu Calouste Gulbenkian, Lisbon 64, 123, 124, 165
Museum of Finnish Architecture 224
Museum of Modern Art, New York 79, 80, 82, 127, 128, 157, 190
National Gallery, London 199, 200
Foy Nissen, Bombay 22
Sigrid Neubert, Munich 119, 120
Lennart Olson, Stockholm 112
Photo Studios Ltd, London 78
Rheinisches Bildarchiv, Cologne 161, 285, 287
Cervin Robinson 149
Royal Academy of Arts, London 75–77
Scala, Antella (Florence) 24
Simon Scott 288
R.D. Smith 300–302
Smithsonian Institution, Washington 279
Staatliche Graphische Sammlung, Munich 84
Stärk, Zürich 126
Ezra Stoller, Mamaroneck, N.Y. 255
Tiroler Landesmuseum, Ferdinandeum, Innsbruck 27
Jan Versnel 13, 14, 225
Victoria and Albert Museum, London 189
John Webb, Cheam, Surrey 34–40, 105, 159, 162, 191
Hildegard Weber, Cologne 194, 197, 198
Bob Wharton 74, 222, 223
Yale Center for British Art, New Haven, Connecticut 289, 296–303